D0792338

Art Center College of Design
Library
1700 Lida Street
Pasadena, Calif. 91103

ART CENTER COLLEGE OF DESIGN

3 3220 00178 0977

AFRICAN ROYAL COURT ART

Art Center College of Design
Library
1700 Lida Street
Pasadena, Calif. 91103

Art Center College of Design
Library
1700 Lida Street
Pasadena, Calif. 91103

709.67
C786
1998

AFRICAN ROYAL COURT ART

Michèle Coquet
Translated by Jane Marie Todd

THE UNIVERSITY OF CHICAGO PRESS

CHICAGO AND LONDON

Art Center College of Design
Library
1700 Lida Street
Pasadena, Calif. 91103

Michèle Coquet is an anthropologist and member of the Systèmes de pensée en Afrique noire section of the Centre National de la Recherche Scientifique. She has published widely on systems of visual representation in West Africa, including *Textiles africains*.

Jane Marie Todd has translated major French works, including Jean Starobinski's *Largesse* (1997), also published by the University of Chicago Press.

The University of Chicago Press, Chicago 60637
The University of Chicago Press, Ltd., London
© 1998 by The University of Chicago
All rights reserved. Published 1998
Printed in Hong Kong

07 06 05 04 03 02 01 00 99 98 1 2 3 4 5

ISBN: 0-226-11575-5

Originally published as *Arts de cour en Afrique noire,* © 1996, Société Nouvelle Adam Biro.

Library of Congress Cataloging-in-Publication Data

Coquet, Michèle.
 [Arts de cour en Afrique noire. English]
 African royal court art / Michèle Coquet ; translated by Jane
Marie Todd.
 p. cm.
 Includes bibliographical references and index.
 ISBN 0-226-11575-5 (acid-free paper)
 1. Art, Black—Africa, Sub-Saharan. 2. Symbolism in art—Africa,
Sub-Saharan. 3. Art and state—Africa, Sub-Saharan. 4. Narrative
art—Africa, Sub-Saharan. 5. Africa, Sub-Saharan—Kings and rulers—
Art patronage. 6. Africa, Sub-Saharan—Court and courtiers—
Portraits. I. Title.
N7391.65.C66613 1998
709'.67—dc21 98-5071
 CIP

This book is printed on acid-free paper.

Contents

Introduction

Every king who ever reigned saw the arts flourish in his court, arts that corroborated the exercise of power, the greatness of the kingdom and of the man who was its master. Conceived within the framework of a hierarchical society, court art has the primary function of magnifying the sovereign's power: his economic and martial power as well as his spiritual and mystic power. The right to use the images and objects thus created, reserved for the chief or king, for his family, and for members of the noble lineage, distinguishes those close to power from those far removed from it, by marking each one's place on the social ladder. Ornaments and particular objects always accompany titles of nobility. Like their counterparts in Europe and elsewhere, the kings and chiefs of black Africa, whether leaders of states hardly larger than a few villages or of true empires, favored the development of these arts.

The diversity and richness of African court arts vary considerably with the society, though one does not find disparities comparable to those that existed in seventeenth-century France, for example, between the arts celebrated in Versailles and those invented by the common people. In the sixteenth century, the first Europeans to visit the kingdom of Kongo, to the north of present-day Angola, were struck by the fact that the king was living in the same simplicity as his subjects and that his material comfort amounted to very little. A few mats for sleeping, a few earthenware pots for cooking food, and a few calabashes for drinking palm wine represented virtually all of his personal property. Nor did the fortune of the king of the Zulu cause his lifestyle to differ greatly from that of his subjects, despite the greater number of wives and homes he possessed. In general, the economy of most traditional African societies never permitted their members any real accumulation of wealth. All the same, though the number of domestic objects in certain monarchies may be small, some of them display a workmanship equal to that of art works created within richer courts. Moreover, states whose economies were based partly in commerce with the Europeans enjoyed a prosperity that allowed the king and the noble classes to become wealthy. Such was the case in western Africa for the old kingdoms of Benin (present-day Nigeria) and Dahomey (present-day Benin), and in central Africa (though briefly) for the kingdom of Kongo. In a few of these kingdoms, the pomp of court arts and ceremonials became quite impressive. Whatever the degree of their splendor, however, all the court arts of black Africa remained attached to their peasant roots.

Different modes of expression of the power of the monarchy and its institutions were privileged, and the objects presented in this book are not the only evidence available—far from it. In the realm of plastic arts, there are some that will appear rarely or not at all here, such as textile and costume arts, body art, and architecture.

Dance, music, and song should also be included within the court arts, as should the gestures and language fashioned by etiquette, which was in no way inferior in its codification to the etiquette of European courts. Certain kingdoms, like those of Rwanda and Buganda, also developed poetic arts; in the court of Rwanda, an education in singing and the recitation of historical and pastoral epic poetry was reserved for young Tutsi nobles.

The objects fabricated by artisans for use by the king and members of the aristocracy cover the entire field of utilitarian objects. In this respect, the set of objects displayed in this book may be considered a kind of inventory, nonexhaustive but fairly representative, of the material culture of African societies. Through it, the reader may catch a glimpse of modes of living and thinking. In addition to the insignia of power (various canes and staffs, flyswatters, ceremonial arms, and crowns), other objects will appear: seats, headrests, containers (makeup cases, snuff-boxes, goblets, gunpowder boxes), elements of adornment (necklaces, pendants, bracelets, combs), and other objects such as pipes. By the quality of their workmanship, the richness of their decoration, or their morphology itself, these objects all express their intended purpose. Within that set of objects are those whose use, wearing, material, or shape are reserved for the king. Regalia are the most sacred objects of the monarchy, since they give material form to its very principle and, by their history and presence, legitimate the existence of the kingdom and its sovereign. And yet, they are not always the fruit of the court's artistic production. Many of them never appear in public and bear no decoration. Certain of these regalia, such as the Golden Stool, on which the sacred character of the Ashanti monarchy in Ghana is founded, can be "reproduced," however; the king and principal chiefs may possess a similar object, which partakes symbolically and spiritually in that unique and original object.

Court artisans, generally professionals—smiths, founders, weavers, embroiderers, sculptors, jewelers, and so on—dedicated their work to the royal family and the aristocracy. In certain large kingdoms, like those of Benin, Dahomey, Ashanti, and Kuba (Zaire), artisans belonged to guilds headed by a chief, whose high status sometimes gave him the right to intervene in the kingdom's affairs, particularly concerning religious matters. The concentration of these artisans in one place and the protection they enjoyed allowed them to produce in quantity works of art with a specific iconography and style that became differentiated from popular arts. The case of the kingdom of Benin in Nigeria and that of the Ashanti confederacy in Ghana are exemplary in this respect. Their artisans left behind an unusually diverse

(facing page)
1. Matubani, one of the wives of Okondo, Mangbetu chief (Zaire), having her body painted. Photo taken in 1910. New York, American Museum of Natural History Archives, 111920. The artificially elongated form of the skull was in vogue among the Mangbetu and the Azande in the early twentieth century.

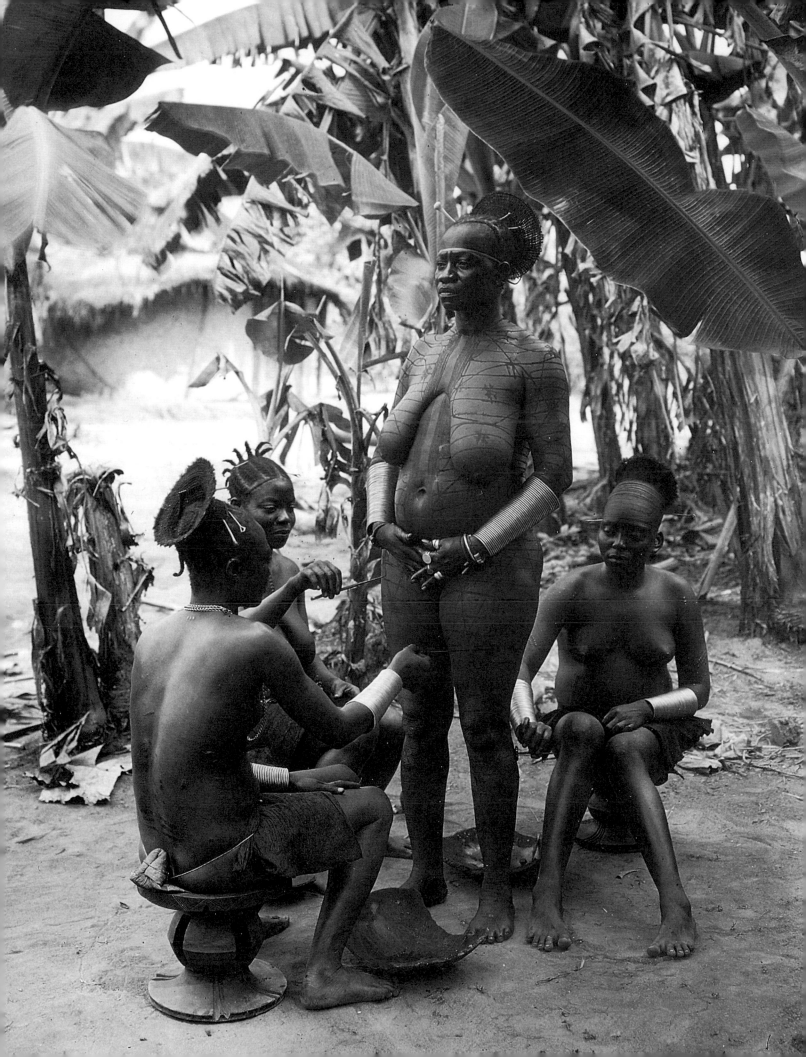

collection of objects, the largest known in Africa. These groups of artisans often had diverse ethnic origins, since, through the fortunes of war, sovereigns always welcomed foreigners, or introduced them into the group by force. This practice facilitated the exchange of technical and aesthetic knowledge, and the introduction of a vocabulary of different forms and motifs and of their related meanings. Numerous authors have noted the influence of Muslim arts on the iconography and even the configuration of Akan arts (Ivory Coast and Ghana), Ashanti objects in particular. The art of filigreed jewels, of sheets of metal fashioned by embossing, and the style of decorative patterns observed on fabrics and various other objects evoke certain aspects of Muslim plastic arts.

The professionalism of court artisans sometimes led them to a virtuosity that found its greatest freedom of expression in ornament. In the fifteenth and sixteenth centuries, the Portuguese exploited the skills of the Sapi,[1] Edo, and Kongo ivory carvers, ordering table utensils such as saltcellars or spoons with very finely sculpted decorations that expressed a pronounced taste for detail. The artists' great skill and sense for the very ornate object were expressed in many ways: in the attention given the particulars of dress in the depiction of figures in the art of Benin; in the engravings on ancient bronzes by the Igbo-Ukwu (figs. 141, 144–46); in Akan gold plate and the sheets of metal decorating Ashanti stools (figs. 120, 121, 125); in the open lacework effect of certain ivory bracelets (figs. 136, 137); and in the interlaced design of Kuba goblets and fabrics (fig. 138). It goes without saying that just as these objects are beautiful to our own eyes, so were they also to their users; they reveal the high level of aesthetic aspiration in the peoples who invented them. In Africa and elsewhere, that dexterity and its corollary, ornamental profusion, have always served the cause of monarchy, since they allow the kingship to impose its hegemony in visual and plastic terms. To speak of profusion is also implicitly to speak of diffusion. Under such circumstances, ornament always has a dual function: on one hand it serves as embellishment, on the other as description. Every motif can become a symbol of royal power, and the abundance of ornaments is often linked to that of emblems. The choice of this mode of expression, characteristic of so many court arts, manifests a clear desire to inscribe the real existence of power on every surface possible and in a manner recognizable to all, and hence to intensify its presence. The modest utensil becomes capable of bearing motifs also found on objects of prestige. The image, then, increases royal power. The different attributes so characteristic of court art, such as profusion and precise detail, did not allow African art works to escape a certain conventionalism. Because it wishes to demonstrate and describe the greatness of the sovereign, court art always runs the risk of becoming

dogmatic; in Benin, the proliferation of nearly identical kings' effigies on brass plaques and in statuary of the same metal is proof of that.

In various locations, such a context facilitated an artistic quest for originality, which was encouraged by the sovereigns themselves. Some of these quests lie at the heart of this book, which is not a monograph on the court arts of black Africa, but rather an iconological reflection on certain conceptions of the image and the object. The emergence of these objects seems to be closely linked to the fact that they were created to serve the principles of monarchy. In fact, African art is indebted to the inventiveness of court artisans and artists for effigies of kings and chiefs in which realist figurative principles are invoked. In these works, the rules of composition and representation follow narrative conventions. It is because of the artists' audacity that these images first appeared, since works of art taking such an approach were largely unknown in Africa. The art of some of these kingdoms made use of types of expression in which the hieratic attitude adopted toward images in other African societies tended to become muted, to the advantage of an attention to reality as it existed. That attention to reality was expressed in the contours of the flesh of faces and bodies and in a transcription of particular events and the body language of human figures. The desire to capture in material form elements of objective reality, which the symbolic order comes to redefine only after the fact, is an adventure of the spirit made possible by African monarchies.

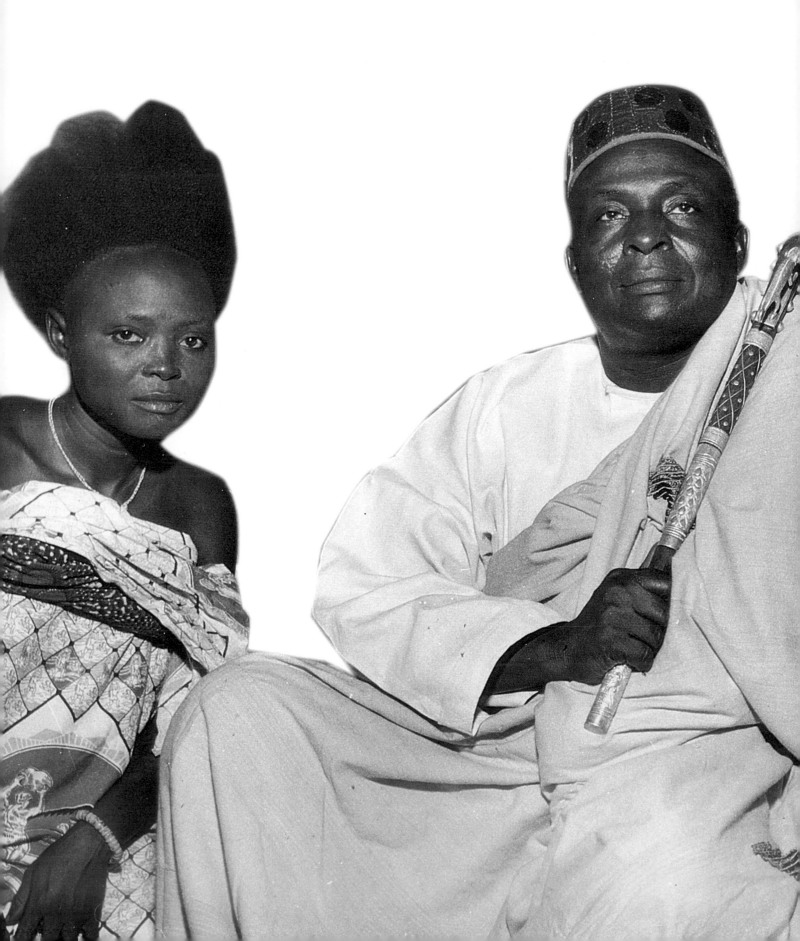

CHAPTER ONE
Empires, Kingdoms, and Chieftaincies: The King's Singularity

Palaces, castles, pomp, courtiers, and conquests: empires call for fortresses, impregnable citadels, vast territories traversed by roads traveled with dispatch by emissaries and warriors. The term "empire" makes us think of Rome and its caesars, Alexander launching his Asian campaigns, the Egypt of the pharaohs, Charles V, the Napoleonic armies, China retreating behind the Great Wall. Only Japan still shelters an emperor within. The same sorts of images, now almost obsolete, are evoked by the word "kingdom": the kingdom of France and of Navarre, Bourbons and Valois, Shakespearean tragedies, wars and marriages between the "houses" of England, Spain, and Portugal. The history of these empires and kingdoms is our own European history: evidence of it inhabits our landscapes, books, museums, even our memory. If more distant and exotic monarchical powers share that renown, it is because, among other things, they have left behind monuments and writings, the tangible traces of their splendor. In contrast, the sovereigns of Africa and their royal art works seem to have been forgotten, as if absorbed by the suffocating heat of tropical forests and the lateritic sands of the savannas.

Numerous African kingdoms existed, however—so many that it will not be possible to speak of all of them here. One need only look at the history of contacts between Africa and Europe to discover a few of the reasons for that relative amnesia experienced by the peoples of Europe about those of Africa. It lies in great part in the peculiar relations they established with African potentates, before and during the colonial era—the demanding and often rapacious commercial relations of merchants hungry for profit. The fascinated, sometimes admiring descriptions of travelers do not suffice to alleviate the threat of oblivion and contempt. There were monarchies, but traces of them would be sought in vain on the sites we are accustomed to find them in Europe. There are no great architectural works as we know them, except perhaps Great Zimbabwe, in the country of the same name, where impressive stone ruins stand even today. For a long time, South African novelists and politicians refused to acknowledge the African origin of these ruins: the builders could only have been Phoenicians, Sabaeans, or Celts. There is rarely testimony written by the persons concerned: In the past, Africans used writing very little. Arabic was useful for a written language of diplomacy, particularly in the Islamized kingdoms of western Sudan[1] and in certain non-Islamized states such as Ashanti (present-day Ghana). A few African languages, such as Haussa and Fulani, reaped the benefit of a transcription into Arabic characters. Original writing systems also emerged: in the early nineteenth century, the Vai of present-day Liberia invented a system of writing that was used within the framework of official correspondence, to take down common laws, tales, and legends. A century later, Sultan Njoya of the Bamum

(previous pages)
2. King Justin Hao, flanked by two of his wives in his palace in Abomey, Benin. Photo by Dominique Darbois, 1954 (detail).

(facing page)
3. Tito Gafabusa Winyi IV, *omukama* of Bunyoro. Ceremony for the thirtieth anniversary of his reign. Photo by George Rodger, 1954. The king welcomes members of the *mpango*, the royal council, to his palace. The sovereign and the other participants are dressed in the ample traditional costume made of the beaten bark of the wild fig tree.

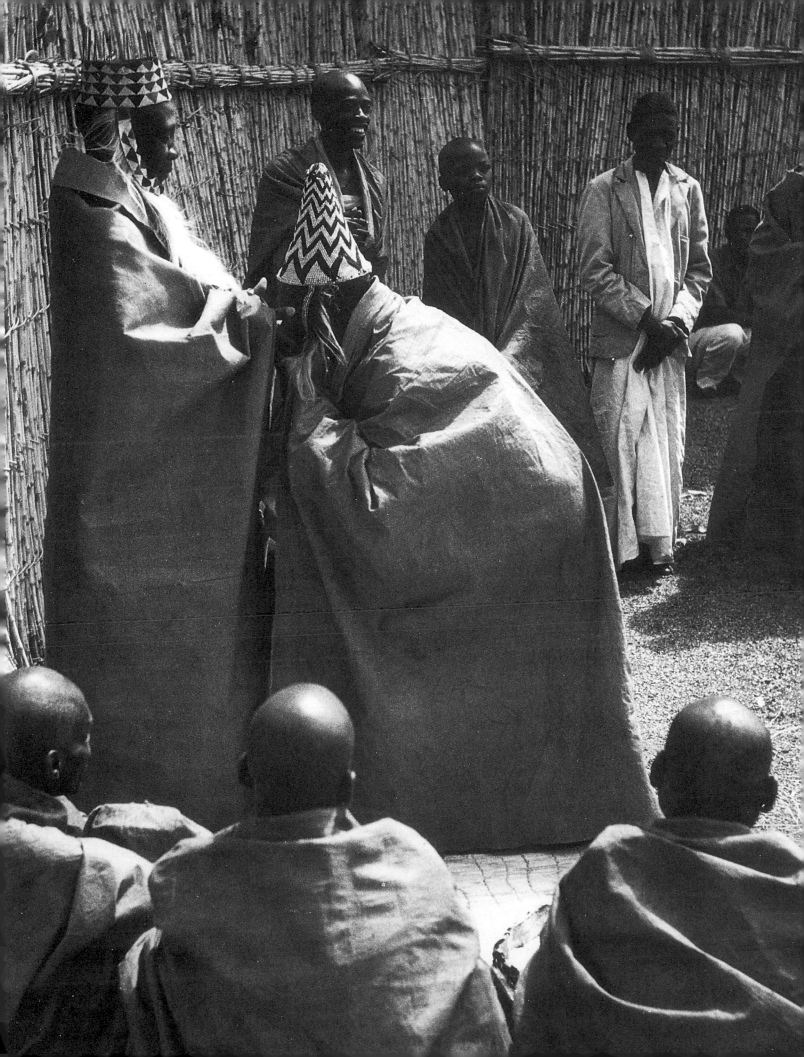

in Cameroon also invented a form of writing. Its use, unlike Vai writing, was reserved for a small number of persons, and with its help he transcribed the history and customs of the Bamum. Writing experiments remained few in number, however, in favor of the oral tradition. In it, the narration of events from the past was less an objective and definitive account than a poetic and epic art, the art of song, and a continuous celebration of a creation ever begun anew.

In contrast, ours is a civilization of books and archives, in which we have for centuries inscribed fragments of our history: edicts, treaties, letters, genealogies, commentaries. European kings and princes built monuments to their glory. What does the African tradition offer us in relation to that abundance of signed and stamped evidence constructed for eternity? Our notion of a royal residence puts us in a quandary when we are confronted with the delicate palaces of African princes, woven of straw or made of clay dried by the sun, dwellings that are often purposely lightweight, designed to be taken apart and reconstructed whenever the occupant happens to change location. In these edifices, where can we find the timelessness we associate with constructions that endure for centuries without damage, emblems of a bygone age but symbols of a history on which our societies depend to construct themselves?

We believe that permanence lies in stone and in the accumulation of evidence fixed in writing. African societies conceived of it differently, however: their kings were also anxious to glorify the great deeds of their ancestors, of their people, and of themselves. Every royal court possessed its genealogists, who sang or recited the acts of the founders of the dynasty, war exploits of heroes, alliances and betrayals; the activity could even be perilous, since, in many cases, royal chroniclers, under pain of death, had to recite their text without any hesitation, comparable at the time to profanation. Every day at dawn, the *criers of the king's pronouncements* in Abomey, capital of the old kingdom of Dahomey (present-day Benin), sang the names and praises of each sovereign, from the founder to the reigning king (Mercier 1962, 48). Commemorative heads and statues celebrating some royal deed were sculpted in wood or cast in bronze or copper. Finally, monarchy, as it was conceived by African societies, was so to speak eternal because sacred, always inherited from a mythic ancestor, a god or demigod. That divine origin meant it lay outside the framework of mere history and intersected that of myth.

Societies with very different social and political organizations long coexisted on the African continent, from small nomad bands, pygmies or bushmen, of hunter-gatherers, to communities of stock breeders or sedentary crop farmers, some of whom were organized into chieftaincies or kingdoms. Despite their number and

diversity, African societies can be classified into two large groups based on their sociopolitical structure: first, societies without centralized authority, also called acephalous or stateless; and second, those possessing a centralized authority in the person of a "king," or at times an "emperor" or "chief" (Fortes and Evans-Pritchard 1947).

The structure of the first type of society relies on the clans or lineages that compose it, and the exercise of power depends on a genealogical and kinship order. Matrimonial exchanges and ritual obligations establish alliances in such a way that members of the society are linked among themselves by a system of interdependence, precluding any important difference in status among individuals. Among farming societies in western Africa, which grouped together into villages, authority is often represented by the eldest member of the village's founding lineage; each village is composed of several lineages, some of them kin, others strangers. This leader plays a political, and especially a ritual and religious role regarding the management of the territory and land of the village, which are conceived less as physical matter than as a spiritual entity. Hence, *lords of the land* are also lords of the air and water; through their ritual acts, they guarantee the community an abundance of rain and harvests, and the fertility of the earth. Other individuals in these communities perform similar and complementary duties in other domains, such as managing the wild areas of the brush, waging war, hunting, or overseeing a particular cult. The eldest member of the founding lineage necessarily depends on the consensus of his peers to make decisions; in such a system, the village represents the largest political entity.

Sometimes, in addition to this shared power of the lineage, which rests on a ritual and religious mastery of the forces of nature and of relations to the gods, there is also a real political power exercised by a single individual. Such a situation contains in germ the structure necessary for the emergence of a monarchy. In the history of many African societies, the actual traces of the emergence of this dual power can be found: the society of the Mossi in Burkina Faso rests on a bipartite social and political organization. The *people of power*, descendants of the conquerors who founded the royal dynasty in which the king was named, hold political power, while the autochthonous *people of the land* hold spiritual and religious power. One of the roles of the *naaba*, the Mossi king, is to see that these two powers cooperate with each other (Izard 1990, 71). The Mossi example is far from unique: many African kingdoms had peoples of foreign provenance as their founders. In the case of Africa, it is not always easy to apply the definitions normally used to determine what a kingdom is. Although the ethnological literature refers to both "kingdoms" and "chief-

taincies," I shall not distinguish between the two terms.[2] The system of relations between kinship groups and the importance granted to ritual events remain the determining factors here. Thus, the chief or king is invested with particular powers that link the political and symbolic realms. The size of a kingdom varies greatly: some are composed of only a few villages and have a sparse population, while others are densely populated and extend over a much larger territory.

In addition to the numerous kingdoms that prospered in Africa, empires emerged as well. The term "empire" refers to a much vaster expanse, in which several peoples, or even several kingdoms, coexist. Certain authors have advanced the idea that, in the case of African political history, it is difficult to determine whether societies were in fact part of empires, in the way we understand the term, since the definition of empire has to do with a centrally organized political unity that controls the territory as a whole. It would seem, in fact, that in black Africa there were rather states composed of a kernel closely controlled by a central government, which became less and less effective as one moved away from the center. The emperor's sovereignty had a tendency to become muted when one reached the border country. In the great Islamized empires of western Sudan during the Middle Ages, the sovereign bore the title "commander of believers," in accordance with Islamic law. The governors of the provinces were also converts. A sort of clergy, composed of Muslim scholars (including Maghrebi and Levantines), oversaw the application of Islamic rules and formed the administrative and political apparatus. The majority of the population remained faithful to its traditional institutions, however.

Several types of kingdoms have been distinguished (Vansina 1962, 331–33). There is the rare case of kingdoms resembling our concept of absolute monarchy, in which the king names all his officials and exercises a despotic power: Rwanda, nineteenth-century Buganda, Bunyoro, and sixteenth-century Kongo meet that definition.

Certain kingdoms have chiefs at the head of their provinces who are descendants of autochthonous chiefs, the king's companions or favorites, and sometimes members of the royal lineage. Another type of monarchy integrates autochthonous chieftaincies, with each one conserving its traditional chief. That is the case for the Bamileke of Cameroon or the Luba and Lunda empires of central Africa. In the least centralized kingdoms, such as the Kuba, all chiefs are descended from autochthonous leaders and, in that case, the kingdom is more like the central kernel's protectorate of the provinces. At court, these chiefs serve as the people's representatives before the king. There is also another form of state, the federation, of which the only known case is the Ashanti of Ghana. The members of Ashanti states feel they

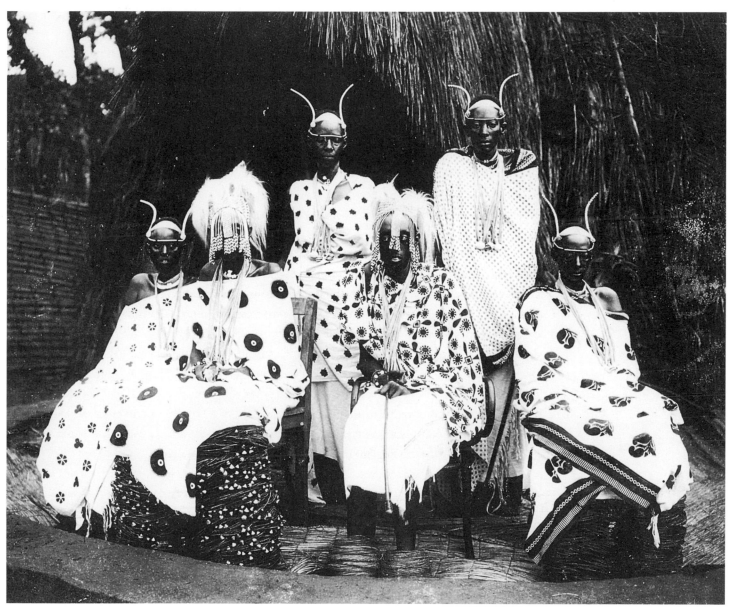

4. The king, or *mwami*, of Rwanda, Yuhi Musinga (deposed in 1932); the queen mother, Kanjogera; and four royal wives. Tervueren, Musée Royal de l'Afrique Centrale, E.P.H. 4811. The queen mother and the *mwami* share the right to the royal headdress fringed with a curtain of beads and edged with colobus fur. The royal spouses wear headdress elements on either side of their heads suggesting the shape of horns. Similar ornaments are placed on either side of the entrance door to the palace, above the awning (fig. 8). Given the ritual and symbolic importance of cattle in Rwanda culture and the prestige value attached to them, it is probable that these appendages reproduce the silhouette of cow horns. Custom has it that the horns of the finest cows, *inyambo*, were shaped while the animals were still growing, to obtain particularly elegant arabesques. In the photo, these six prestigious persons, the wives and the queen mother in particular, have their legs encircled by a thick network of woven strands of straw; these leg ornaments hindered walking because of their weight and width and conferred a particular gait on Tutsi women when they moved, a sign of idleness and wealth (personal communication from Danièle de Lame).

belong more to the federated states than to a united kingdom. The federation includes several geographical areas, each of which has a leader responsible to the king for law, order, and the organization of services and payments. Each state (there are five in all) possesses its own war organization. The *asantehene*, chief of the confederacy living in the capital of Kumasi, could call on each chief's forces to do battle in his name. He named the officials responsible for controlling admittance to the kingdom along commercial roads and for collecting tolls. The boundaries between the metropolitan region and the provinces were marked by stations where travelers were detained and charged a tax.

African monarchies have either a hereditary or an elective system of succession. Sometimes, the sovereign chooses his successor during his lifetime from among his sons. That was the case for the kingdom of Dahomey, where the king designated the crown prince while the latter was still young, to prepare him for his future duties. The Bamileke *fon* (Cameroon) does the same: before his death, he informs the various notables and allied chiefs which son he has chosen to succeed him. In the old kingdom of Benin (present-day Nigeria), the principle of primogeniture in succession was not introduced until the eighteenth century. But such examples are rare. The sovereign's successor, though he has to belong to the same clan and lineage, is not necessarily chosen from among the king's own children. In general, dignitaries to whom this role fell orchestrates the succession. In the Kotoko kingdom of Togo, for example, the king is chosen by turns from among seven lineages of the same clan, that of the founders of the kingdom, who are of Gourma origin. Sometimes the royal inheritance is disputed and the interregnum, as in the kingdom in Uganda, is the occasion for great disorder. In Ankole, where the rules of succession were based on a patrilinear system, at the death of the *mugabe*, the king's sons had to fight one another until only one of them was left alive; he then became the *mugabe*. The mother and sisters of the pretender to the throne turned to magic to achieve their ends. When one son had fewer followers than the others, he was rapidly put to death or condemned to exile. Following that fratricidal war, the *mugabe* governed without any living brothers or uncles. The war could last several months, during which the kingdom was plunged into chaos; the great chiefs, who did not participate in the struggle for power, sought to protect the borders from potential invaders (Oberg 1947, 157–61). The old kingdom of Loango (present-day Congo) also went through a long interregnum during which the key notables of the kingdom fought one another. The country was then controlled by the leading dignitary, the *ma-booma* or *lord of fear*, whose name gives a good indication of the atmosphere that reigned during these periods of conflict (Balandier 1965, 194–95).

The subjects of the African sovereign have partial control over the way the king exercises power. He usually governs by consent and his subjects are fully aware of the duties he owes them, just as they are aware of their own duties toward their monarch. The Zulu king had to follow the advice of his council; if not, it was said the council could take a head of cattle from him. For the Zulu, the prosperity of the country rested on the fact that the king possessed wise and strong advisers ready to criticize him (Gluckman 1947). Even though the territory of the country and the people who inhabits it belongs to the king, who can order them to work for him, can seize the products of their labor, and could even put them to death as supreme judge, the sovereign's power is not unlimited; he always has to act within the framework of rules imposed by tradition and celebrated by ritual. Other institutions, composed of religious associations or councils, including territorial chiefs, dignitaries, and specialists in religion, seek to balance royal power. In theory, the king's decisions have to be approved by the councils, just as those of the council have to be agreed to by the king. In short, neither the council nor the king can govern on its own.

Among the Moundang of Chad, two collegia of notables assist the sovereign: one, the Council of Elders, is composed of the elder members—*lords of the land* and *rain-makers*—from the principal Moundang clans; the other consists of men representing the sovereign's subjects (Adler 1978, 30). A counterpower can come to oppose the king's power, so that the sovereign's freedom of action is limited. The king of Porto-Novo (present-day Benin) shared certain of his powers with the "king of the night," called more precisely *zunon*, which means "lord of the brush." The king could put the *zunon* to death if he met him during the day, and the *zunon* had the right to do the same if he met the king during the night. These two individuals symbolically divided the kingdom into two complementary and antagonistic parts: the king reigned over inhabited, human spaces, the *zunon* over areas of brush, where powers dwelt that would be dangerous for the king should he come into contact with them. The monarchy of Abomey included a comparable duplication. There was a "king of the countryside," who shared responsibility for the kingdom, again in the symbolic mode, with the king of Dahomey (Mercier 1962, 130–31).

In distributing certain powers to the provincial chiefs of his state, the king neutralizes or satisfies the ambitions of members of the royal lineages or of autochthonous chieftaincies, and rewards those who support him. This principle sometimes had the result of multiplying the posts within the administrative apparatus, producing a bureaucracy of great complexity, the organization of which might appear confused to us. Paul Mercier links the function and status of the great dignitaries of

African monarchies to those of royal officers in the early Middle Ages of Europe. He describes the role of the seven *Uzama*, the principal Edo chiefs officially responsible for electing the new king: some also have priestly duties; one guarantees the security of one of the gates of the city; and another is also the main army chief (Mercier 1962, 140–41). The Ashanti confederacy offers an edifying example in this respect: The dignitaries, in accordance with their administrative and honorific role, are organized into guilds in which duties are totally hierarchical. It is through them that the *asantehene* manages the confederacy. At the top of the state hierarchy, after the *asantehene*, sits the guild of king's linguists or messengers, who speak in his name on public occasions, in particular during the enthronement of provincial chiefs and in delicate court matters. They serve as intermediaries between the king and the guild and provincial chiefs subordinate to him. Each chief, in fact, has his own linguist. Certain palace officials accumulate several posts: for example, the king's drummers and horn players also compose the guild of the *asantehene*'s merchants. They accompany singers celebrating the names of royal ancestors and, every night at midnight, play a sort of national anthem in which the king thanks his officers and his people. The chief of the horn players and of merchants receives advances in gold powder from the *asantehene* to purchase foodstuffs for the king's benefit. This chief had to see that commercial deals among the Ashanti were conducted properly, and he organizes the human caravans necessary for transport. A caravan might involve as many as two to three hundred persons. The *asantehene* controlled the flow of gold, which served as currency throughout the confederacy and, more generally, in the Akan world. In the eighteenth century, under the influence of commerce established by the Portuguese, which increased the economic importance of that metal, gold truly became the symbol of the *asantehene*'s authority and divine essence. The *asantehene* oversaw the production of gold deposits, and the lineages holding a share of power all hoarded a certain quantity of gold proportionate to their power. Another guild, which included more than a thousand persons, managed the royal revenues of gold powder. Yet another was made up of founders of gold, who reduced the nuggets to powder. In about 1870, one hundred persons were employed at that task. The members of another guild weighed gold powder. Others assured the upkeep and oversight of the roads necessary for the Ashanti's economic prosperity. One of them levied taxes and secured the preeminence of royal commerce. At one point, there were five to six hundred armed men at each of the stations controlling the roads leading to the capital of Kumasi.

The payment of a tribute of allegiance is often the only link existing between the center of the kingdom and its provinces. That tribute, offered by the regional chiefs,

has more symbolic than economic value; in general, it consists of bits of animals considered emblems of royalty because they possess qualities shared by the person of the king, such as strength, cleverness, or imposing size. Leopard or lion skins, bodies of pangolins or eagles, elephant tusks, hippopotamus teeth, or buffalo horns are the elements making up the tribute sent to the king (Vansina 1962). When the Tswana (South Africa) took down an elephant, they sent the king the first tusk to touch the ground (Vansina 1962, 327 n. 2). In addition, each village community collects a certain quantity of goods, for the most part produced locally—shares of crops, meat, products of the forge, fabrics—which it sends to the king. Other forms of tribute consist of hostage pages sent to the court or the obligation to give the king certain girls as wives. The Azande king (Zaire and Central African Republic) had pages, sons of nobles of his kingdom, for his companions. The youngest among them were free to enter the domestic quarters, from which all other men were excluded; they participated in the king's private life, accompanied him when he went to wage war, hunt, or consult the oracle. During journeys, they slept within range of his voice. They brought bowls of food prepared every day for people of the court, and served as messengers and spies. Some even cultivated the royal fields: The youngest helped the royal wives in their gardens. When the king died, some of them followed him to the grave. In the case of a rebellion by their kin, these pages were likely to be killed. Under King Glele during the nineteenth century, six hundred girls the common people had given as a gage lived in the palace of Abomey in Dahomey. The king supported them and offered them to certain of his subjects. The daughters resulting from these unions then returned to the royal house.

The sovereign's wealth is proportionate to his power, whether measured by the dimensions of his home, the number of his wives, the expanse of his fields, or the size of his herd. In the 1950s, the treasury of the Bushoong *nyim*, king of the Kuba (Zaire), included more than five storehouses stocked with "embroidered fabrics, precious sculptures, masks, clothing, leopard skins, elephant tusks, pottery, knives, and baskets" (Vansina 1964, 106). His harem at the time numbered about six hundred wives. The *nyim* had to be the richest man in the kingdom; thus he was brought numerous gifts that increased his wealth, in addition to that coming from the tributes paid by villages and the labor of his slaves and wives. Above all, however, that king's treasury belongs to everyone and, every year, new acquisitions provide the occasion for a public exhibition (Cornet 1982, 29). Much of the royal wealth is redistributed, serving especially to support visitors and persons of the court: the products of fields and herds and the labor of slaves, sharecroppers, or warriors are

often hardly adequate to provide daily support for the court and army—when a regular army existed, as among the Zulu—for the organization of large ceremonies, and for the hospitality and aid the sovereign owes his people. Among the Azande, the prince's gifts had to be divided among his subjects: "If raw beans went into the royal residence, they ought to return to court as cooked beans. . . . If the subjects cultivated their masters' eleusine, the harvest ought to be pounded, ground, and cooked as porridge for those same subjects to eat at court" (Mair 1977, 95, quoting Edward Evans-Pritchard). It seems there was no economic monopoly by the sovereign except in kingdoms engaged in long-distance commerce. The *mansa* of Mali reserved the commerce in gold nuggets for himself, while panners for gold kept only the powder. The *asantehene* in Ashanti controlled the flow of gold and had the privilege of trade in slaves and firearms, as did the sovereign of Dahomey and the Kotoko king of Togo.

Slave labor was an important factor in the economy of African kingdoms because it allowed an increase in the production of foodstuffs and goods necessary for trade. Domestic slaves were usually prisoners of war or their descendants, and were often assimilated after a few years by the lineage that had originally acquired them. These "captive" slaves formed a class of workers in the service of the monarchy. They are to be distinguished from slaves acquired in trade, who were veritable commodities, even playing the role of currency. At least before the establishment of the slave trade by Europeans, they were for the most part political or common law prisoners. Within Islamized states, slaves generally came from unconverted populations. In the empires of Mali and Songhai (present-day Mali), they grew grain on royal farms dispersed throughout the territory. Gao, the capital of Songhai, had a large slave market—visited by traders from Maghreb—which occupied a significant place in the economy of the empire. In the fifteenth century, these slaves were even very much in demand in the south of Morocco; many of them also left for the north, to Tripoli, Egypt, Turkey, Sicily, and a few Italian cities—Naples, Genoa, and Venice. In the old kingdom of Benin, slaves were brought together in villages, where they worked the lands of their masters. Among the Ashanti, they were engaged in building plantations, where they produced food for the great houses of the city, raised fruit and vegetables for sale, and even watched the children of their owners. Their principal task, however, was to work in gold mines, since the Ashanti, for ritual reasons, could not extract the gold themselves. The slaves of the court had a particular status, at once privileged in relation to many subjects of the kingdom and hardly enviable in view of certain customs. Although they were allowed to occupy important posts, they became victims in the sacrifices that accompanied certain great ceremonies, such as royal funerals.

(facing page)
5. The king, or *nyim*, of the Kuba, Kot a-Mbeeky III, covered in his regalia. Photo taken in Nshyeeng (Zaire) in 1970 by Eliot Elisofon. Washington, National Museum of African Art, Eliot Elisofon Archives.

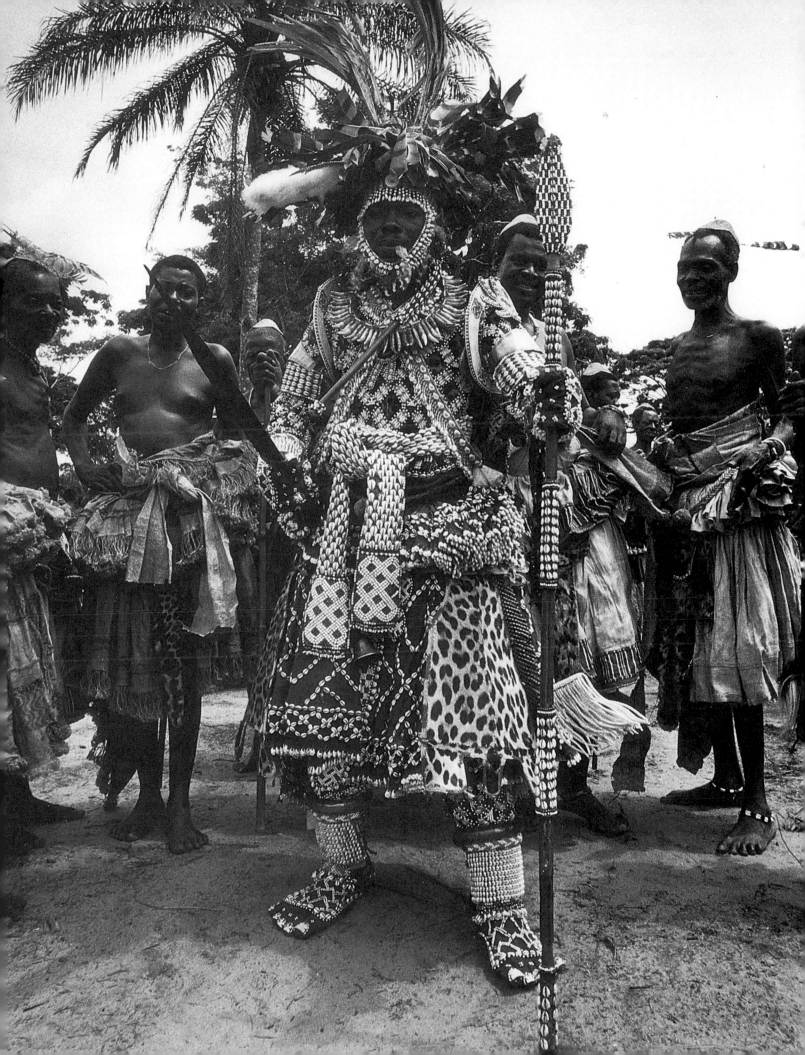

The peoples of black Africa did not build cities comparable to those that have risen up in Europe over the past centuries. The capitals of African kingdoms, though some had a more advanced urbanism than others and may have been home to several thousand residents, ought rather to be compared to large villages. In the eyes of the first European visitors in the fifteenth century, the capital of the kingdom of Kongo appeared to lack "aligned streets" or "avenues lined with palm trees or ornamental trees"; they were traversed by "narrow paths" running "in every direction through tall grass, with dwellings arranged in accordance with the taste and caprice of each individual" (Balandier 1965, 142). Most of the capitals, however, in their size and the number of their inhabitants, could be differentiated from the small village agglomerations where the common people lived.

The palace is composed of a set of buildings housing a population that might exceed that found elsewhere in the kingdom. It represents the administrative and religious center of the country. In the organization of its space—the cardinal orientation of entrances, the layout of buildings—and in the decoration of its dwellings, the palace ought to be read as the cosmogonic transcription of the universe, at its center the person of the king, guarantor of the order of the world. Maps of palaces are found on certain textiles used during royal ceremonies, when they adorned the walls of the palace or were worn by people of the court. These include Bamum fabrics dyed indigo or the embroidered gowns of the Kotoko princesses of Cameroon (Coquet 1993, 46–47).

In the early twentieth century, the capital of the Bamum kingdom, Fumban (Cameroon), numbered between fifteen and twenty thousand residents. A wall several meters high and twenty kilometers long, defensive in nature, encircled the city. The royal palace, built in the center of the constructed space, included hundreds of buildings housing the king's wives, servants, and children; in itself it covered seven hectares (fig. 9) (Tardits 1992, 45).

In 1817 Kumasi, the capital of Ashanti, had twenty-seven principal streets; the largest of them, used for parade processions by the *asantehene*, was more than a hundred meters wide. In the late nineteenth century, the city had seventy-seven sectors, each bearing a name. The palace, the most imposing building in the city, covered a surface area of about two hectares. In the courtyard past the main entrance, piles of skulls, and drums adorned with the same macabre decoration, greeted visitors, reminding them of the exploits of Ashanti armies. Another courtyard followed the first; there dignitaries in charge of the *asantehene*'s affairs met. That space measured thirty-five meters long and fifteen meters wide. Ornamental whorl motifs were modeled in the clay covering the pillars and base of the buildings (fig. 11) (McLeod 1981, 42–44).

The palace of the *oba*, the sovereign of Benin, in itself reached the proportions of a true city: as many as fifteen thousand persons lived in it. A broad avenue separated the palace proper from the quarters housing numerous guilds of court artisans and priests in the service of the rites associated with the monarchy. The palace itself was divided into three quarters, the first reserved for the king's wives and young children, the second set aside for royal servants, and the third containing numerous storehouses, sanctuaries, meeting rooms, and working areas for artisans. "In the Oba's palace there is never silence," the Edo used to say (Ben-Amos 1995, 12).[3] The "palace chiefs," who lived in the royal sector of the city, Ogbe, managed the royal dwelling and were divided into three associations. The first took care of the regalia, including the throne and ceremonial wardrobe, and secured transactions with Europeans; the second took care of the *oba*'s wives and children; and the third was in charge of the king's domestics—pages, cooks, and servants. The "city chiefs," who lived on the other side of the city's main artery, were responsible for the different territories of the kingdom; they collected tributes and mediated between villages. The king's receiving room was imposing in size, about thirty meters long and twenty meters wide. In its center, an impluvium, supported by pillars covered with bronze plaques adorned with figures in bas-relief or high relief, allowed daylight to illuminate the room. All wooden parts of the building were completely sculpted. In principle, each *oba* had to build his own palace; there were thirty-three palaces within the royal enclosure. In the end, however, the old buildings of the deceased *oba* fell into ruins (Mercier 1962, 178).

The palace complex of the Dahomey kings in Abomey (present-day Benin) also give a sense of the kingdom's history: as in the former Benin, every king was buried in his residence, and his successor had to have a building constructed in turn, next to the one that had preceded him. The palace of the deceased king continued to be inhabited by his soul, present in the altars erected in its honor, and ceremonies to royal ancestors took place one by one in each of the palaces, built by members of the dynasty as a whole.[4] In the nineteenth century, that vast collection of palaces, housing both the living and the dead, covered an area of about forty hectares and was enclosed by a wall whose perimeter was nearly four kilometers (Mercier and Lombard 1959, 7). During that time, the population of the palace was estimated at eight thousand residents, the vast majority of them wives in the royal harem and their slaves. The palace had two main courts, in which a few buildings stood. In the first court, which looked out on a square extending beyond the palace, sentries, servants, messengers, dignitaries, and the king's drummers, who accompanied him when he went outdoors, were permanently stationed. In the second court, beyond the first, the king presided over ceremonies and dances, and consulted with his ministers.

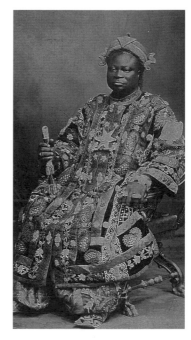

6. Gbadebo, King Yoruba of Abeokuta (Nigeria), predecessor of Ademola II. Early twentieth century, Lyon, Musée Africain.

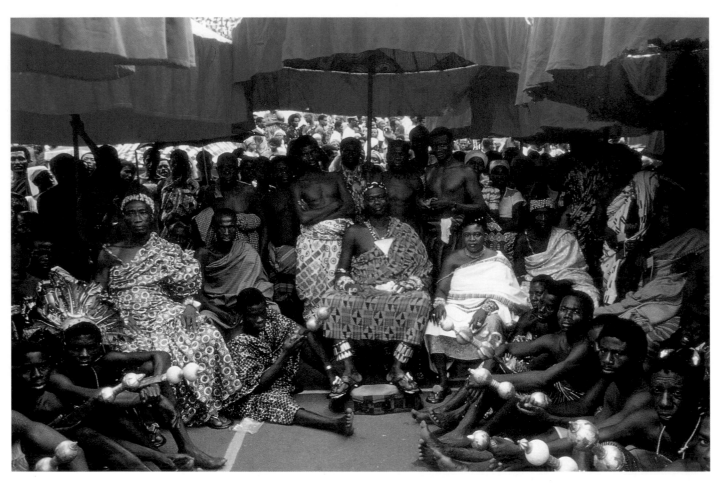

7. Ashanti chief. On his throne in ceremonial costume, his feet on a footrest. Above him, a forest of parasols. Ghana, Kumasi, "Golden Jubilee of the Restoration of Asanteman." Photo by René and Denise David, 1985.

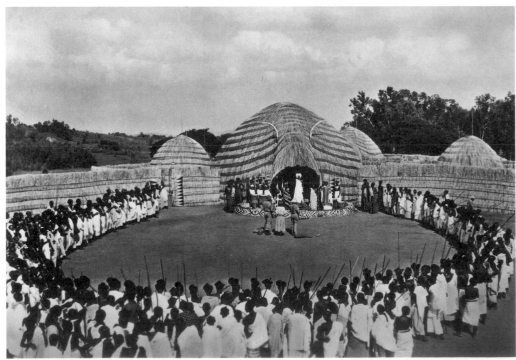

8. The *mwami* of Rwanda receiving Europeans at his court in 1953. Vienna, Museum für Völkerkunde, D.25.099.

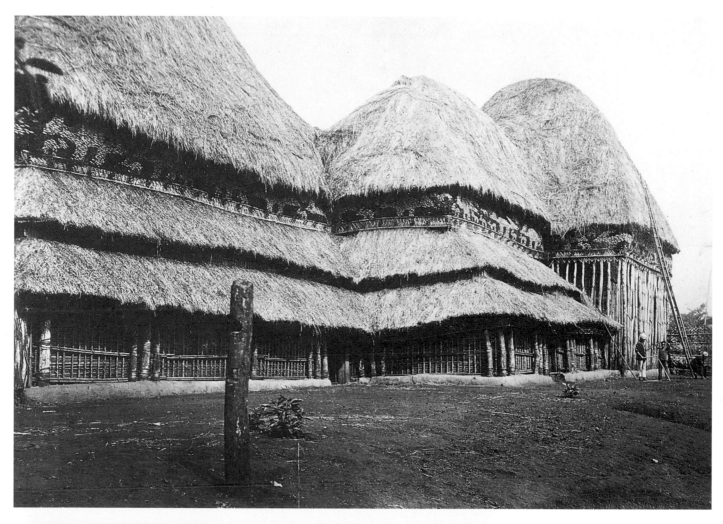

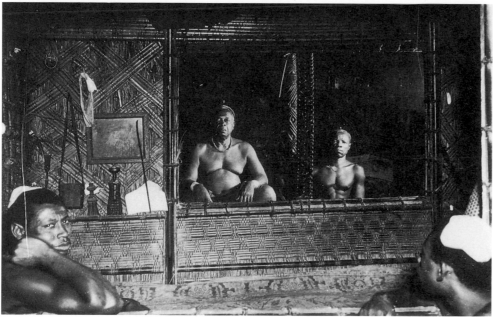

9. View of the palace of Sultan Njoya in Fumban, the capital of the Bamum kingdom. Photo by Oldenburg, 1923. Vienna, Museum für Völkerkunde, B.17.176.

10. The king, or *nyim*, of the Kuba, Mbope Mabiinc. Photographed in one of the houses of his palace in Nshyeeng (Zaire), capital of the kingdom, about 1950. Tervueren, Musée Royal de l'Afrique Centrale, E.P.H. 8044.

Beyond these courts was the private part of the royal residence, where the king would be buried, and the apartments of his favorite wives, the *kposi*, or "panther wives." The dwellings of the other wives, princesses, and servants were arranged around them in no precise order. These included the dwellings of the famous women soldiers in the king's service, whom the Europeans called "Amazons," a reference to the legendary women warriors of antiquity. In both the palaces of Benin and those of Abomey, an intricate network of lanes covered the entire space between these buildings.

Not all palaces displayed the same prestigious characteristics as those of Benin or Dahomey. Some were simpler in their structure and architecture, but just as complex in their use. The royal quarters of the Azande sovereign, for example, were composed of buildings of unbaked clay, round in form and covered with a straw roof, comparable to ordinary houses but built with more care. They had a public section, a sort of square reserved for people coming to attend a ceremony or judgment. About twenty meters farther on lay a reserved space called the *court of whispers*, where the king discussed matters of secrecy with his close advisers. Along the path connecting these two squares stood the houses of royal pages, overlooking the entrance to the court. Military companies lived on one side. The residences of the king and his wives were separated from that group of buildings by a long expanse of grass. Every wife had a separate house, surrounded by a garden; the king's residence stood in the middle. At some distance from this complex was the house of the royal diviners. The Azande palace was a rustic, country dwelling, but the etiquette observed within it and the power of its royal occupant were in no way inferior to those of its counterparts in Benin or Dahomey.

> The ancient kings spent their day in idleness; they were forbidden to work. Servants rubbed them with oils and fed them. They spent most of their time with children and young people. . . . The pomade with which they were covered was made of oil extracted from roasted palm seeds. . . . The king's entire body was covered with it. His beads and gold bracelets were rubbed with white powder made from forest mushrooms. . . . The king wore gold, a great deal of gold. His arms were laden with bracelets. . . . He wore precious beads, red in color . . . as leg and arm bracelets. He was girded in an orange-colored [breechcloth], and draped in a pagne the color of brick. (Perrot 1982, 103)

That is how an Anyi king, Nana Bonzu II, described in 1964 the clothing regulations and the conduct imposed by tradition on the Anyi of the Ivory Coast. The ornaments and garb that covers the king, the cosmetics he uses, the care lavished on him, and the gestures he has to make indicate his extraordinary nature to all eyes.

11. Buildings of the palace of the *asantehene* in Kumasi, 1901. Basler Mission. The decorative motifs seen on the façade—painted or cut into the clay—and the longitudinally cut bands of thatching for the roof were reserved for royal and religious buildings.

The king of the Kuba, the *nyim*, has his personal clothing maker. Only he and great notables wear pagnes descending to the ankle; the many pleats of these articles of clothing sweep up and absorb the evil caused by human actions (Cornet 1982, 183). Certain sovereigns, such as the Yoruba kings in Nigeria or the *mwami* in Rwanda, veil their faces with a curtain of beads when they appear in public (fig. 4). Among the Bamum (Cameroon), tradition held that a particular language was to be spoken at court, composed of a few hundred words, which the wives and servants had to learn upon their arrival (Tardits 1980, 748). Every morning at dawn, the sovereign of Bunyoro, a pastoral kingdom of Uganda, touched the foreheads of young bulls that were presented to him and asked them to protect him and his kingdom; a young virgin brought him milk in the morning and at noon. In the evening, his cook fed him pieces of meat, which had to enter his mouth without brushing against his teeth; otherwise, the cook would be put to death. The king had to eat alone, away from onlookers.

In the seventeenth century, Olfert Dapper described comparable customs observed at the king's court of Loango (present-day Congo):

> One finds very amusing laws regarding the king's eating and drinking. He eats only two meals and there are two houses set aside for them. In one he does nothing but eat and in the other nothing but drink. . . . Neither man nor beast may see the king eat or drink, under penalty of death. That prohibition is strictly observed, as the following will demonstrate. The Portuguese made a present to the king of a very beautiful dog, which delighted the prince. One day, this little animal escaped from the hands of his guard while the king was having dinner and scratched open the door to his room, thinking he would leap onto the lap of his master and eat with him. He received sorry payment for his caresses; the king, having called his people, had him taken and killed on the spot. (Dapper 1686, 329)[5]

The different rules of behavior and of life that govern the king's existence are indicative of his singular identity. At first glance, the etiquette to which European monarchs submitted does not seem so distant in its principle, though it was less severe and rested on rules that were the reverse of those prevailing in African courts. The cult of the royal person conceived by Louis XIV organized the sovereign's daily life as a spectacle: the most common acts—rising, dining, taking walks, having supper, going to bed, and so forth—were part of a meticulously regulated public ceremony, which a hundred persons or so always witnessed. The spatial layout of the king's chamber, as it can still be seen in Versailles, was invented as a way of dramatizing the royal activities of rising and going to bed. A "stage" with the

royal bed in the place of honor faced a "parterre" demarcated by a small railing, where the crowd of courtiers thronged.

Things are completely different for the African sovereign. It seems that everything that brings to mind his human nature in too precise a manner has to be obliterated. The king has to submit to a strange destiny, which dictates that the country be identified with his own body; that mystical relation between the two requires very strict modes of behavior on the part of the sovereign, behavior that seems strange to our eyes. The *mwami* of Rwanda, for example, could not bend at the knee, since that gesture might have led to a reduction in the size of the kingdom (Maquet 1954, 147). The monarchy possesses the king. The king is a sacred being, since cosmic energies are lodged in his person; often, he is of divine origin, in that dynasties frequently traces their genealogies to a divine founder.

The notion of divine kingship, as analyzed by James G. Frazer, defines the king in African societies as someone who, in his being, possesses a power over nature, whether exerted voluntarily or not. As a result, he must submit periodically to rites of rejuvenation. The king is the guarantor of the well-being of the kingdom and the balance of the world. "Our grain! Our beans! Our rain! Our health! Our crops! Our riches!" sing the Jukun of Nigeria to their sovereign when he leaves the palace (Muller 1990, 65). All the king's acts, the progress of his existence, and even his emotions are likely to affect the course of events and the stability of the kingdom. For that reason, the king's body must be in good health and whole, must display no physical infirmity. Anyi kings were subjected to periodic ritual examinations of their bodies to verify that they bore no traces of blows or wounds; they were not allowed to hold sharp instruments, since a cut would have brought catastrophe on the kingdom itself. Their grooming, shaving in particular, was reserved for certain servants who were skillful at the task. Kings avoided taking risks and were excused from combat during wartime. They were not even allowed contact with the dead; when one of their wives died, a close friend was designated to play the role of widower in their place (Perrot 1982, 103 and 105). Similarly, the *naaba* of the Yatenga (Burkina Faso) never carried weapons, not even during military expeditions; everything that manifested his human nature had to be concealed. If he sneezed, coughed, or blew his nose, the noise was immediately covered up by the snapping of his servants' fingers (Izard 1985, 112).

The king is a thaumaturgist: he can make rain fall on cue, heal the sick, or cause famine by putting his bare foot on the ground. When an Anyi king was angry, he pretended to take off his sandal (Perrot 1982, 106): the contact of his shoeless foot would dry up the earth. The same is true for the Bushoong sovereign, the *nyim*. His

title and the praise made of him reveal his power and divine origin: He is "king of the Bushoong, God on earth," the one who "dispenses births, the life of all Bushoong" and "the god who passes through the capital, the god who creates plains and forests" (Vansina 1964, 101). He is not allowed to sit on the ground either, or to cross a field, because of the risk of scorching the earth (Vansina 1964, 100). He possesses powerful charms that allow him to transform himself into a leopard and to kill. This power, which the king carries within him, and over which he does not seem to have full mastery, makes him a redoubtable being:

> When the king dances, no one can go up to him and embrace him. All lift their arms to the sky. He is in the middle, no one approaches him. Others far from him dance. People try to calm him . . . "Gently, gently," so that he doesn't get going too strong. "Everything belongs to you, don't quarrel." He holds out his arm . . . designating by turns the sky, the earth, then himself: "The whole world, I am the one who commands it, except for earth and sky; trees and men, it is I who command them." (Perrot 1982, 105–6)

The Jukun king (Nigeria) controls the rain and wind. That particular skill comes to him from a charm consisting of a part of the body of one of his predecessors, the heart reduced to a powder, which he feeds on from time to time. The power over nature exerted by the queen of the Lovedu of southern Africa stems from a comparable charm, made up of fragments of skin and "filth" taken from the cadavers of previous queens (de Heusch 1990, 9).

The cycle of agrarian festivities of the Moundang in Chad seems to reflect the sovereign's life cycle (Adler 1978, 37). The advent of the monarchy is celebrated simultaneously with the feast of the first fruits, the first annual feast on the Moundang calendar; the king presides over that ceremony, during which a sacrifice is offered to the regalia. During the second feast, which marks the end of the getting in of crops, emblems of the king's power, which allow him to make rain fall or stop falling—an iron hoe, a miniature throwing knife, and a sickle—are invoked and present during the rite. During the third feast, called feast of the guinea fowl, a collective hunt takes place: the king, stripped of his garments, dressed as the most modest of his subjects, participates in the hunt, condemned to submit to the mockery of his people. That feast prefigures the end of the sovereign's reign and symbolically depicts his death (Adler 1978, 35–37). The role of metonym of the kingdom assigned to the person of the king, and more particularly to his body, the intimate connection he maintains with the cycle of vegetation and hence with the prosperity of the community as a whole, must be linked to the practice of regicide in many African kingdoms. Regicide is one of the principles defining "divine" kingship, as proposed by

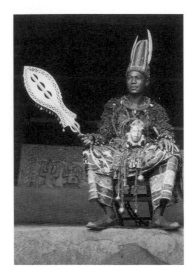

12. Oludasa, the chief, or *olowo*, of Owo (Nigeria). Photo by William Fagg, 1958. London, Royal Anthropological Institute, 1958 (58/58/10). On his chest, the *olowo* Oludasa wears a brass pendant from Benin (cf. fig. 124) and brandishes a ceremonial sword, *eben*, in his right hand. In Benin, that insignia is reserved for the dignitaries of the *oba* and for the *oba* himself (cf. fig. 103). Numerous chiefs or kings in the Yoruba world possess objects of Edo origin, a sign of the close relations once maintained with the Benin monarchy.

James G. Frazer: according to that principle, the king cannot die a natural death, since, in a system that establishes a correspondence between the king and his kingdom, the physical degeneration of one is liable to lead to that of the other. To keep the order of the world from being disturbed and falling into chaos, the king was put to death at the end of his reign, the length of which was predetermined or decided as a function of the sovereign's physical condition. Thus, certain inhabitants of the Jukun kingdom still habitually establish the genealogy of their kings by counting by intervals of seven years (Muller 1990, 58). In the event of catastrophe (famine, drought, a serious military defeat), accident (a fall from a horse), or ritual transgression, the king could also be put to death. The *iwembe* of the Nyakyusa of Tanzania was strangled or buried alive as soon as he fell seriously ill. Before he was killed, his nails and locks of his hair were removed from his body and then buried in the mud of a river. They were believed to preserve the well-being of the country. When the *reth*, king of the Shilluk of Sudan, could no longer satisfy his wives because of old age and impotence, he was strangled, since his debility threatened the fertility of human beings and domesticated animals and the success of crops. The *reth* incarnated the founder of the royal dynasty, Nyikang, whose spirit was the object of a cult throughout the country. Yet the Nyikang spirit was by definition incorruptible; as a result, it had to inhabit a body full of vigor. The body of the king, whose good health guaranteed the wealth of the kingdom, functioned as an object through whose intermediary society attempted to intervene in the world, to master the forces that governed it, which were joined together in the corporal envelope of the sovereign (de Heusch 1990, 11).

Thus, tradition works to make the sovereign an uncommon being, through the mystic power that inhabits his body and that destines him for an extraordinary fate. The etiquette that regulates all the actions of his life, the number of his wives, the size of his palace, and his necessary physical perfection openly displays his singularity. In order for that singularity to become effective, however, certain rites have to be performed during the period of enthronement. These rituals transform the future king into a being who is definitively different from all others, abnormal, a being almost on the margins of society because his identity is marked or defined by the commission of acts of transgression against the ordinary laws of the community. For example, when the Jukun kings periodically eat pieces of the heart of their predecessor, they are committing a dangerous act, anthropophagic in nature: eating the hearts of their dead is not among the usual practices of the Jukun. The Rukuba chiefs (Nigeria) acceded to power following a ritual of investiture that included the same provisions. After drinking beer from a calabash in which the skull-

cap of one of his predecessors had been immersed, the future chief was led to consume, without warning, pieces of flesh of a baby from his own clan, which was mixed in with the meat of a ram. Through these two acts, the second of them a rite of endocannibalism, the Rukuba chief integrated the wisdom of those who preceded him and the power of one who might have succeeded him, a child of his own clan. In adding the generation of the sacrificed child to his own, the chief was supposed to live to a very great age, but at the cost of a terrible act, abhorred by his subjects as a whole, and which made him a being lying outside normality and possessing ambiguous powers, both beneficent and maleficent (Muller 1990, 55–57).

Other rites establishing the king's singularity are associated with the choice of his wife. The sovereign's relation to his wife frequently appears to be marked by the seal of incest, real or symbolic. That particular practice tends to affirm that the king, alone at the top of the social hierarchy, can only lie outside the system of alliances organizing society. Many myths explaining the origin of the royal dynasty and of the monarchy depict a couple composed of a brother and a sister, whose incestuous union gives birth to the first king. Woot, the first mythical ancestor of the Bushoong dynasty among the Kuba of Zaire, slept with his own sister. At his coronation, the *nyim*, personifying Woot, reenacts that incestuous union by marrying the daughter of his mother's sister, contrary to the exogamic matrimonial rules in place (de Heusch 1987, 132). In the kingdom of Bunyoro, the victor in the tournament between the sons of the deceased sovereign in the war of accession to the throne, similar to that practiced in Ankole, marries a half-sister, daughter of the same father. The nuptial ritual is marked by great beauty: on the day of the ceremony, all the half-sisters are brought together at the palace. The king chooses from among them the one who will be his queen. The young woman steps forward and takes her place on the throne. Objects symbolizing the future queen's authority are brought to her: a sword, a four-pointed spear, and a spearhead, which is placed to the right of her seat; its two points are covered with bleached palm leaves. A small basket containing coffee beans is suspended above her. The young woman is then led to the sovereign, followed by a dignitary carrying the two-headed spear, which he thrusts into the ground in front of the king. While she is seated on a skin, a cow and a calf from the princess's former home appear at the threshold of the room. The king looks at them for a moment, then extends both hands, palms up. The future queen, on her knees, kisses them, then goes into her house, which is built to face the royal enclosure (de Heusch 1987, 66). She will not truly become queen until she has performed the milk ceremony, during which she consumes milk from one of her own cows brought as a gift to the king. After two or four days, she will bring the king a cow

and a calf from her house. The presence of these animals during a rite so solemn ought not to be surprising. Among a pastoral people such as the Bunyoro, the gift of a cow, like the rite of drinking milk, must be interpreted as an act celebrating the anticipated future prosperity of the union of the sister to her brother (de Heusch 1982, 68). The king, however, will choose other half-sisters to be his concubines (only the king is allowed to have concubines), and it is they, not the queen, who will give the kingdom an heir (de Heusch 1987, 66 ff.). The queen is condemned to sterility.

The daughters and sisters of the Shilluk king (Sudan) cannot marry. They belong to the king, who also lies outside the system of matrimonial alliances organizing Shilluk society. Thus, the king's daughters have sexual relations with the sovereign himself or with their own half-brothers (de Heusch 1987, 100). As in the case of the Bunyoro, however, half-sisters on the mother's side are forbidden the king and the king's sons. Among the Lunda of Zaire, the royal harem included the monarch's half-sisters, aunts, and nieces. Among the Jukun of Nigeria, the king reigns with an official "sister," daughter of a former sovereign. She is responsible for a cult on which the king's health and that of the kingdom depend. She is the only one authorized to enter certain parts of the royal enclosure and sees to it that the ground in the room where the king spends the night is always covered with fresh sand. According to the traditions of the kingdom of Dahomey, the first king reigned with his twin sister, but since then the heir to the kingdom can only be born of a woman of nonroyal blood.

These unions will no doubt bring to mind the matrimonial customs of the royal families of ancient Egypt; however, there are few examples in black Africa of a union with a sister of the same mother. The matrimonial rule prevailing in the kingdom of Mutapa (present-day Zimbabwe) seems to be an exception: the future king of Mutapa, while still only the heir presumptive, had his own sister for his mistress. Once king, his sister became the official wife, responsible for lighting and tending the new royal fire; the rites of lighting the fire are linked to the myth of the monarchy's foundation (de Heusch 1982, 312–13, 320). There are numerous examples of the specific quality of royal weddings, which establish that the king is a being who can in some way form an alliance only with women of his own blood.

The king's sisters have a very particular role to play — that of his wives. The same is true for the king's mothers; the copper and brass sculptures of the heads of queen mothers in the former Benin attest to the importance of the role granted these women in the Edo kingdom, by the mere fact that they were depicted (fig. 36). Very frequently, at the enthronement, the king was ritually joined to his mother or to a woman of his clan who came to perform that function. Within that close relation-

ship, the destiny of one appears to have been linked to that of the other. In the kingdoms of Bunyoro and Ankole, during the war of accession to the throne, each candidate prince had to attend to his mother's safety, since the mother was condemned to follow her son to the grave if he ever lost the battle. It seems that rule prevailed not only in Bunyoro and Ankole; mothers always played an important role in the affairs of succession, in that they had to defend and aid their son by any means possible in his effort to take the throne. The queen mother of the Bunyoro lived in a home specially constructed for her and turned to face her son's house. She protected him with an amulet supposed to assure him a long life; like her son, she possessed a double-edged sword, and like the sovereign's wife, a four-pointed spear, emblems of power. In case of her death, the royal mother was immediately replaced by one of the women of her clan (de Heusch 1982, 65 and 66). Among the Swazi of Transvaal, the king and his mother govern together in such a way that they are called *twins*, even though the mother resides in a village far from the capital. That was also true in the kingdom of Rwanda, where the monarchy was occupied by two persons, the *mwami*, or king, and his mother, who were designated by a single term, *abami*, the kings, thus demonstrating the force of the union of that particular couple (Maquet 1954, 148).

Among the Ashanti, where a system of matrilinear succession prevails, it is through his mother rather than his father that the king acquires his right to the Golden Stool, symbol of Ashanti royalty. The woman with the title "mother of the *asantehene*" is not the king's real mother, however; she is chosen from among the women belonging to the lineage of the sovereign's mother. The true mother, however, accompanies her son at great annual feasts, where certain rites are performed to request the future abundance of wealth in the country. It would seem that she is in reality the true mistress of the country, because she is "mother of all." She may represent the moon, while her son is assimilated to the sun on earth (de Heusch 1987, 142). As a respected member of the council, she presides when the *asantehene* is away at war or when he visits his provinces. In cases of the sovereign's absence, the king's mother can thus perform her son's duties. A German traveler visiting the Cameroons in 1907, in Fumban, the capital of the Bamum kingdom, reported that he was welcomed by the mother of Sultan Njoya, who was away on a distant military expedition:

> The queen mother was seated in front of the porch. . . . Beside her stood two large slaves with parasols and ostrich plume fans attached to the end of a long handle. Chained to each side of the throne were two large birds, living eagles or vultures, who squawked and beat their wings in a threatening manner. Around the throne,

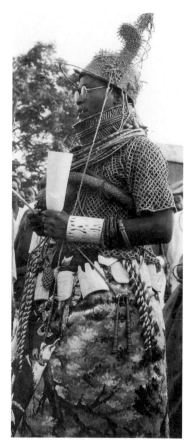

13. The king, or *oba*, of Benin (Nigeria), Akenzua II. Photo by William Fagg, 1958. London, Royal Anthropological Institute, 1958 (58/65/5). The king is wearing his royal insignia of coral beads, at the ceremony called *emobo*. He strikes an ivory bell to chase the powers of evil from the kingdom. The whiteness of the ivory is associated with purity. The motifs adorning the bell all depict animals living in an aquatic environment—crocodiles, fish, turtles, etc.—from the world of the god Olokun (Ben-Amos 1995).

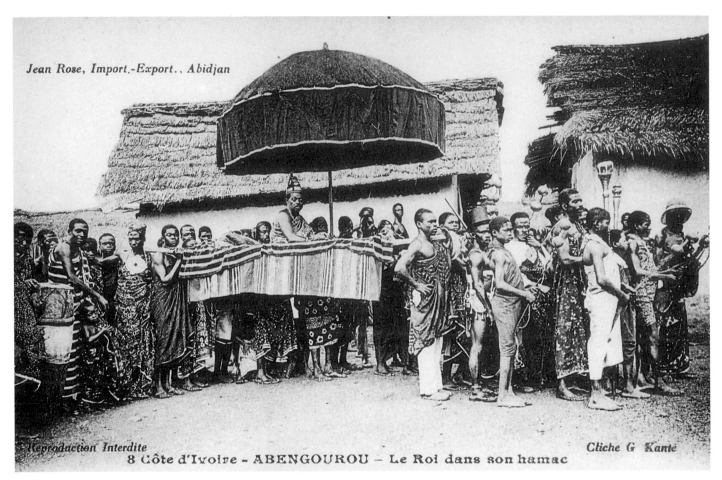

Jean Rose, Import.-Export., Abidjan

Reproduction Interdite Cliche G. Kanté
8 Côte d'Ivoire - ABENGOUROU - Le Roi dans son hamac

14. Old postcard, Chief Ndenye, Abengourou (Ivory Coast), moving with his retinue. At the head of the march, the spokesmen and their insignia. Paris, Karen Petrossian collection.

15. Queen Njapndunke, mother of Sultan Njoya of the Bamum, and her retinue. The Cameroons, 1913. Photo Basler Mission. Beside the queen mother, two royal wives. Behind them, the wives of her retinue lift pipes with clay bowls, insignia of authority.

members of the court formed semicircles in close ranks. There were several hundred men, armed with spears and bows. . . . She moves very little on foot. For greater distances she used a sort of palanquin carried by six slaves. . . . For the entire duration of the reception, which lasted more than an hour, the servants remained squatting, silent and respectful in the burning sun. (fig. 15; Geary and Njoya 1985, 92)

In Oyo, a former city-state of Nigeria, not only the *alafin*, the king, but every palace official had a "mother": These women assumed ritual responsibilities for the palace altars, and the most important of them were also the "mothers" of the principal cult organizations in the city. The official "mother" of the king (not the real mother who, in this case, was put to death at her son's accession to power) reigned with her "son"; the heir presumptive, the eldest son, had to be accompanied by two "mothers" when he visited the palace. Similarly, the "mother" of every minister was present when the minister was received by the king. In the kingdom of Dahomey, every man at court also had an official mother. These women exerted their authority over all the women in the palace. In the same way, "mothers" were assigned to European visitors: it was their responsibility to remember what had been said during audiences. The king's mother, the *kpodjito*, or "panther mother," lived in a palace adjacent to that of her son and governed with him. Even today, there are "king's mothers" who care for the altars and thrones of their supposed "son" (Mercier 1962, 284). The words of Olfert Dapper regarding the king of Benin attest to the great age of that custom: "This prince honors his mother in the extreme, and does nothing of weight without taking her advice. However, by virtue of some unknown law, they are not permitted to see each other; that is why the queen mother dwells in a lovely house outside the city, where she is served by a great number of women and girls" (Dapper 1686, 311). Dapper's remarks are consistent with reality: once enthroned, the *oba* could no longer come into contact with his mother. She possessed a palace, however, a court with its dignitaries organized on the model of her son's court, and participated in the affairs of the kingdom.

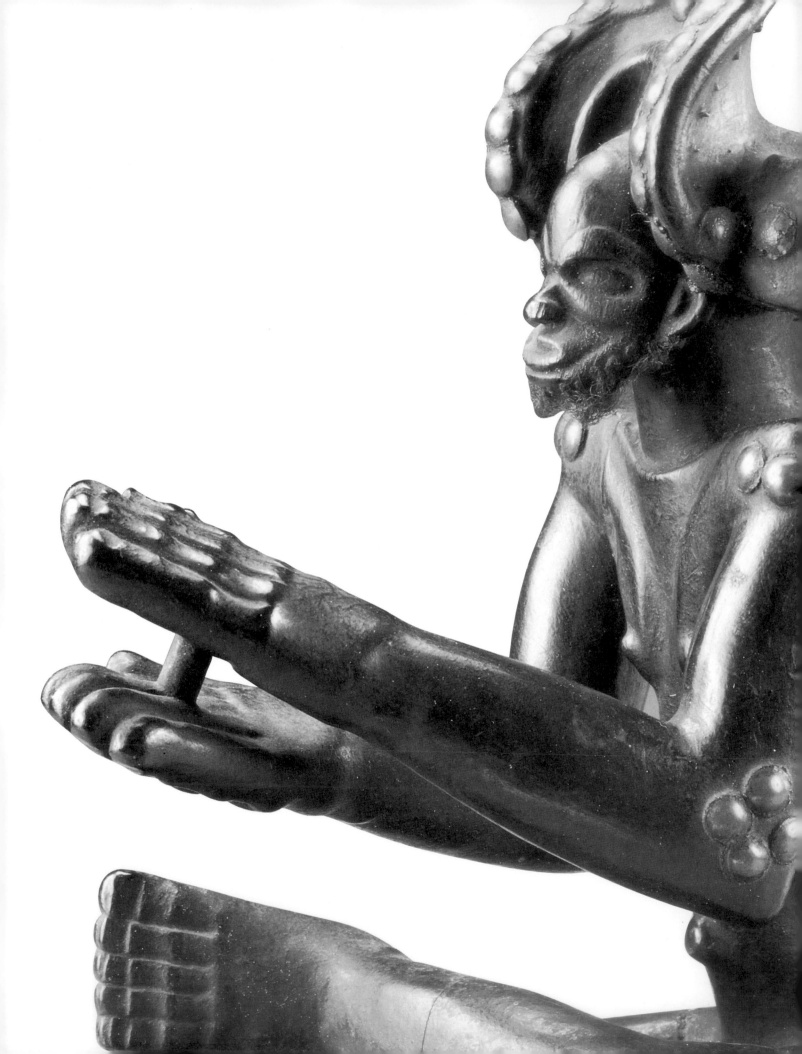

CHAPTER TWO
A Few Conceptions of the Portrait

The extolling of monarchical virtues has always found one of its privileged modes of expression in the arts, whether in the form of the sung or recited text, in dance and music, or in painted or sculpted images. Whatever the age or civilization, court iconography has favored certain themes, such as the representation of the sovereign and members of his entourage, or of events linked to palace life, or of the monarch's exploits, war exploits in particular. What we admire in Egyptian art is not so much the art of the common people, which remains quite unknown to us, but architectural feats, tomb frescoes, sculptures and objects that have come down to us from artists and artisans in the service of pharaohs and dignitaries. There are numerous representations of sovereigns, either painted or sculpted, and images relating their activities: the pomp and leisure activities of the court; funerary rituals; the industrious agricultural or pastoral work of peasants and herders, representative of the prosperity of the empire; the work of artisans; and the military victories of kings. What we know of the old Mesopotamian kingdoms such as Assyria and Babylonia is due in great part to the steles and sculptures adorning royal dwellings—that of Nineveh in Assyria, for example, where scenes of hunting and war, delicately carved in bas-relief in alabaster, celebrate royal glory. The vocation of the classical art of imperial Rome, borrowing from that Middle Eastern tradition, was to demonstrate to the Latin, Italic, and barbarian peoples under the empire's domination the power of its founders, through portraits of its emperors and figurations of scenes relating their exploits. The famous Trajan's Column in Rome comes to mind in this context.

The court art of certain African kingdoms took similar paths, though it never reproduced tableaux of time spent at war, at court, or in the fields comparable to those offered in the arts of ancient peoples. African artists were not concerned with a descriptive transcription of human activities. The iconography they imagined seems to have been entirely concentrated on the royal person; the particular conception African societies have of monarchy and of the person who incarnates it has determined how royalty is expressed in visual representations. Whether in wood, stone, copper, brass, gold, or terra cotta, African statuary offers numerous effigies of kings or chiefs, whose strange status we have just described; at times, it also represents their close relatives—mother or wife—dignitaries, and, more rarely, people of the court, soldiers, pages, musicians, and priests. This last case is essentially limited to the art of the former kingdom of Benin.

Even though these portraits treat their subject schematically, in certain cases they offer some degree of realism. Schematism is requisite throughout African art, and so can be found in these particular genres. But what can be called realism within

(previous pages)
Detail of figure 52.

(facing page)
16. Head. Seventeenth to eighteenth century. Terra cotta. Ile-Ife, Ita Yemoo. Height: 25 cm. Ife, Museum of Ife Antiquities, 79.R.7. The headdress of five rows adorned with beads may indicate this is a queen. Traces of red paint are still visible on the ears, forehead, and lips. The head was part of a full-length statue.

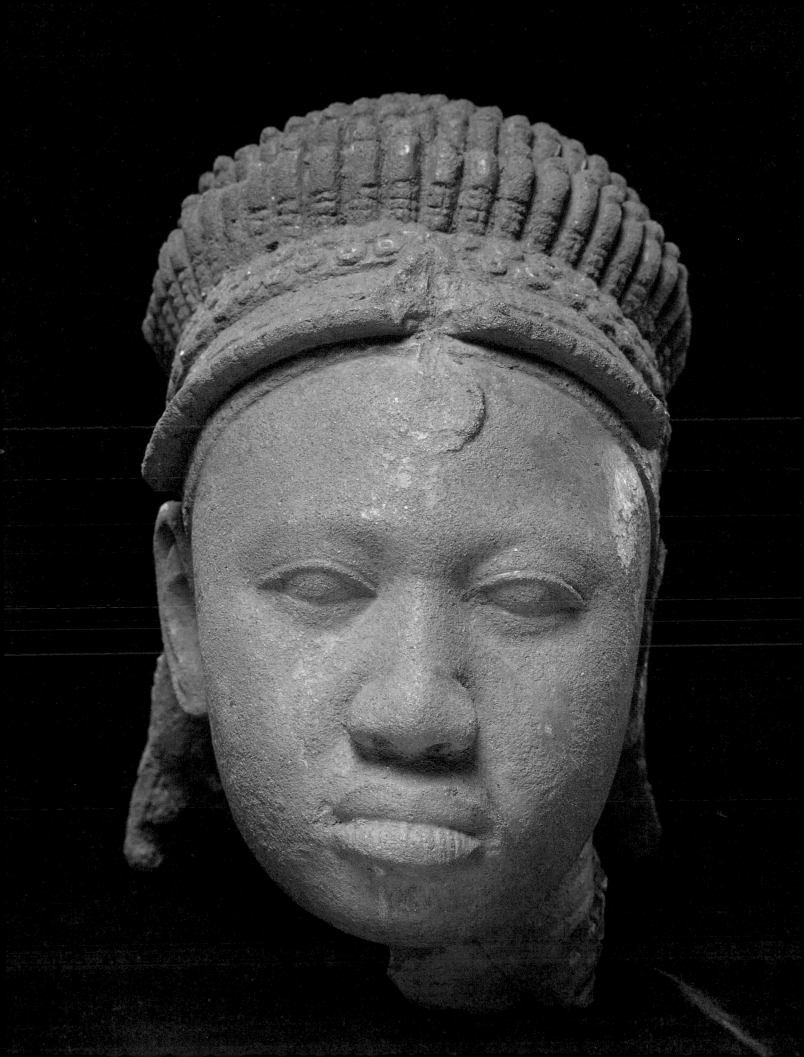

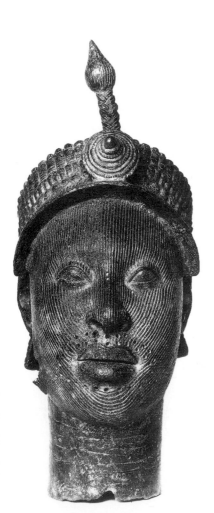

17. Head. Twelfth to sixteenth century. Brass with zinc content. Nigeria, Ile-Ife. Height: 21 cm. London, Museum of Mankind, 1939. AF 34 1. Portrait of an *oni*.

the framework of African creations? Black Africa has a wealth of statues of gods—supernatural beings or ancestors, which are used especially in the cult of the dead—and of masks. Although masks sometimes depict imaginary forms, representational human and animal masks are also abundant. They are rarely realistic, however, in that they are not the result of a quest for resemblance. One reason is that they seek to express an idea not of the human world but of the world of gods and spirits. In contrast, certain examples of court art are attempts at a faithful transcription of certain elements of reality, as if the celebration of the monarchy could not do without such an observation of the world. Even though, as we have seen, the figure of the king is more god than man, and every effort is made to obliterate his too human nature, his portrait may sometimes have a degree of realism, which paradoxically restores to him a "humanity" elsewhere denied. The same attention to the expression of real details may be found in the representation of the attributes and emblems of the monarchy, those that the sovereign wears in public and that are handled on ceremonial occasions. The figuration of court pomp, particularly detailed in the art of the kingdom of Benin, is designed to demonstrate not only the king's power but also that of the kingdom, by evoking its social and political organization. That desire to transcribe the details of reality through plastic means is what I shall call "realism." In African art, and in particular in its court arts, there is no illusionist representation, the models of which are to be sought in the art of trompe l'oeil as it developed during the Renaissance. In the brass plaques in high relief of the kingdom of Benin, however, one finds certain tendencies toward perspectivist figuration. Such tendencies ought to be linked, no doubt, to the particular conditions of the birth of that art, which was created during contact with the Portuguese and with the images they brought with them. African court artisans did not seek faithfully to transcribe what they saw. To borrow the expression of André Leroi-Gourhan, the realism I shall speak of is a "partial realism of form, of proportion, of detail, of movement," with strong tendencies toward schematization (Leroi-Gourhan 1943, 91 and n. 1). Realism, the desire to faithfully transcribe reality, never has to do with the representation—image or sculpture—in its totality, but only with one or several of its parts.

Beginning with the Renaissance, several centuries of painting and sculpture and a century and a half of photographic art have accustomed Westerners to a certain conception of the image and of representation. Grounded in a search for a mimetic expression of the real world, these arts have relied on the experience of perception and, in particular, on the mathematical discovery of the perspectivist representation

of space. Even though twentieth-century art has assumed the task of questioning and even destroying that vision, it has not been able to transform a culture of the "image," in the broad sense of the term, which in Europe is grounded on the principles of making and matching. In all probability, it will never be able to do so. African societies used different modes of transcription, which reveal other ways of conceiving the expression of reality in images and objects.

It may be surprising to hear African art works discussed in terms of the portrait. The notion of "realist portrait," as it took root in Western art, refers to an artistic and literary genre in which the artist seeks to render as accurately as possible the individual physiognomy and specificity of a particular person. The portrait is also supposed to express the psychological interiority of the person who appears in the image or sculpture. For a long time, in fact, the photographic portrait did nothing more than replicate the poses and techniques of the pictorial or sculptural portrait. A brief look at Western art, however, teaches us that there too the notion of portrait, and the place reserved for it in society, have changed over the centuries. Many civilizations never made use of the individual portrait in the sense we understand it. When we consider the experiments in this area by the peoples of antiquity, we see that the notion of portrait took on various meanings depending on the culture. It is instructive to look at these meanings in relation to African portraits and the preliminary questions they raise regarding the problem of human figuration. I shall refer to art works in the round, since there has been no art of the pictorial portrait in Africa (at least until recently).

In Egypt, the role of the portrait was to ensure the survival of the physical bodies of the pharaoh and of the dignitaries in the service of the court and temples. The pharaoh's portrait—in the round, on frescoes, or in bas-relief—was conceived as his double, and portraits of dignitaries followed royal models. The Egyptian portrait did not really seek resemblance, but combined "personalizing realism" and "plastic idealization" (Yoyotte 1968, 24). Despite a certain fidelity to reality in the expression of anatomy, and sometimes even of physiognomy and the effects of time and age, more pronounced under the reign of Amenhotep IV, the Egyptian portrait obeyed an intellectual realism and a mystic representation of royalty, which fixed the figuration of the sovereign in a calm hieratic pose. In Egypt, gods, kings, and Egyptians themselves were depicted, generally full length, in posed and harmonious attitudes. Conversely, the plastic interpretation of enemies of the kingdom and of wild animals depicted an attitude of agitation and disorder (Yoyotte 1968, 63). When portraits represent very different versions of sovereigns, in which they appear now young, now old, they are not so much proposing naturalistic images as

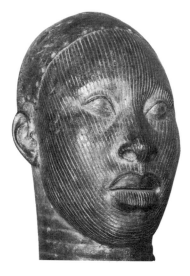

18. Head. Twelfth to fifteenth century. Copper. Nigeria, Ile-Ife, Wunmonije Compound. Height: 30.4 cm. Ife, Museum of Ife Antiquities.

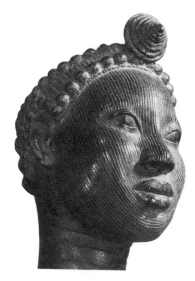

19. Head. Twelfth to fifteenth century. Brass with zinc content. Nigeria, Ile-Ife, Wunmonije Compound. Height: 24 cm. Ife, Museum of Ife Antiquities, 19 (79.R.11). Traces of red paint in the headdress.

conveying the notion that the pharaoh must be full of vigor and passion, and yet also rich in experience, which only great age brings.

As heirs to Greek naturalism, the Romans pushed the principle of physiognomic resemblance even further, to the point of breaking with the idealization of forms characteristic of Greek statuary, in which parts belonging to several different models, chosen for their plastic perfection, were combined to create a single figure of total beauty. Among the Romans, the history of the portrait began with wax imprints made from the faces of the dead; this *imago* was then exhibited during funeral rites and the rites of ancestor cults. Most Roman portraits were in marble, however, depicting illustrious men whose greatness and earthly merits were celebrated and remembered. Other portraits represented the emperor: made during his lifetime, they stood in all public places. The artisans of imperial Rome sought to make their portraits lifelike and easily identifiable, at times not even yielding to relative idealization, which the unforgiving nature of certain faces might have called for. Every lover of classical art will recall the series of imperial heads exhibited in European museums, representing men and women with the unformed features of adolescents or, on the contrary, marked by the ordeals of adulthood and the exercise of power, and displaying the face nature gave them: prominent jaw, elongated nose, receding chin, hollow cheeks, ugly fat deposits. The head makes up the greater part of the Roman portrait, at the expense of the body, which is treated in a stereotypical manner. Even though these portraits were individualized and realistic in their aim, parts of them, such as the hair, were treated schematically.

The question of the mimetic transcription of reality was at the core of the ancients' debates regarding the definition of art. The skill and virtuosity of the painter Apelles were thus measured by his capacity to produce images giving the illusion of reality, which led to legendary stories about him. Pliny reports this anecdote: "He . . . painted portraits so absolutely lifelike that, incredible as it sounds . . . one of those persons called 'physiognomists,' who prophesy people's future by their countenance, pronounced from their portraits either the year of the subjects' deaths hereafter or the number of years they had already lived" (Pliny 1947, 327 [35.88]; cited in Reinach 1985, 350). The notion of resemblance mentioned here raises questions. These texts attest to the fact that Greek sculptors sought to make their portraits lifelike. But to what degree did they succeed? All the Greek art that has come down to us is highly idealized. And yet, can we really say that Rodin's portrait of Balzac is more true to its model? To our eyes, perhaps. The artist took a different, more expressionist approach. The definition of the principle of resemblance is completely relative, corresponding to certain requirements of the age and the history of representation within each culture.

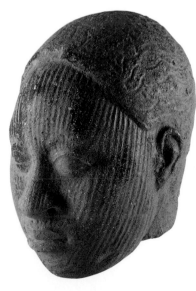

20. Head. Thirteenth to fifteenth century. Terra cotta. Nigeria, Ile-Ife. Height: 17 cm. Paris, Musée National des Arts d'Afrique et d'Océanie (formerly collection of the Musée Barbier-Mueller), A 96-1-4. The head is hollow and was made without a potter's wheel, following the procedure habitually used in Africa for the fabrication of pottery.

Art Center College of Design
Library
1700 Lida Street
Pasadena, Calif. 91103

African sculptors left behind a few portraits whose degree of realism allows us to say they were conceived in a manner meant to produce an effect of resemblance with a very real, if not unique, person. The workmanship of these portraits can be linked without difficulty to that of Egyptian or Roman portraits. That experiment, unique in Africa, was conducted by court artists of the kings of the city-state of Ile-Ife in present-day Nigeria, between the eleventh and fourteenth centuries. There were no real heirs to that art, until twentieth-century African artisans fell more deeply under the influence of Western images. Opinions differ, however, on the possible influence of the works of Ile-Ife on the art of old Benin. We now understand the error in evaluation and judgment made by Leo Frobenius: in the beginning of this century, he considered the art works of the civilization of Ile-Ife to be the result of a foreign artistic tradition, that of the Greeks or the ancient inhabitants of the mythical Atlantis.[1] Such a European influence, if it in fact existed, remains impossible to demonstrate, since the art of Ile-Ife predated by far the arrival of the first Europeans.

Portraits from Ile-Ife, in terra cotta, copper, or brass, depict men and women, most of them kings and queens (figs. 16–32).[2] Nothing allows us to assert, however, that these portraits were made during the lifetime of their models. They are for the most part heads; only a single intact full-length portrait and one bust have come down to us. Another portrait, representing a seated man, was found outside Ile-Ife, some two hundred kilometers north of the city, in the village of Tadda (fig. 22). That sculpture too was probably made by a founder from Ile-Ife. Some of these portraits have been attributed to particular persons by the traditions of the kingdom: one is said to depict a usurper, Lajuwa, who seized the throne of the *oni* Aworokolokin upon the latter's death (fig. 32). Another, in the form of a mask, is believed to represent the *oni* Obalufon, who introduced the art of lost-wax casting in Ile-Ife. But the traditions of that city do not tell us the identity of the other individuals represented: kings, queens, dignitaries, or men condemned to be sacrificed, who wear gags over their mouths.

Sculptors paid particular attention to the treatment of the contours of the face. In certain cases, the headdress is elaborated with great concern for detail. Hair and hats are treated methodically, even schematically. Certain brass heads have no head-dresses, only holes following the root line of the hair, above the forehead and to the base of the ears, and along the upper and lower lines of the mouth (fig. 17). It would seem that these holes were used to affix beaded veils, similar to those that Yoruba kings still wear, which are designed to hide their faces. That is one of the questions raised by a few of these portraits, whose fate seems to have been to remain invisible, like the face of their royal model.

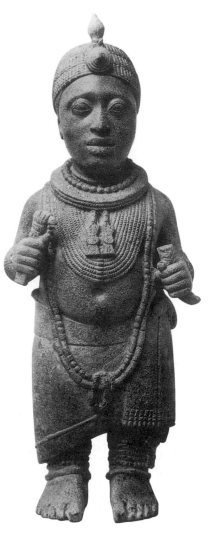

21. Male effigy. Fourteenth to fifteenth century. Brass with zinc content. Nigeria, Ile-Ife, Ita Yemoo. Height: 47.1 cm. Ife, Museum of Ife Antiquities, 79.R.12. *Oni* covered with his regalia.

22. Seated man. End of thirteenth century to fourteenth century. Copper. Nigeria, Tadda. Height: 53.7 cm. Lagos, National Museum, 79 R.18.

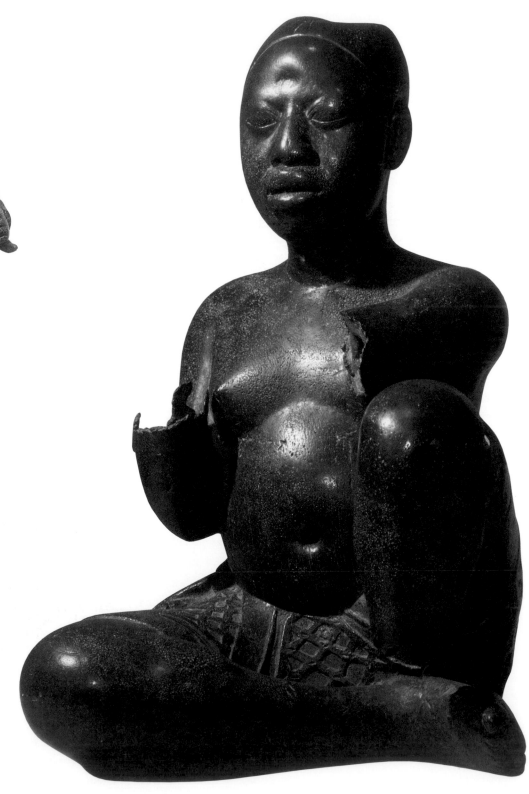

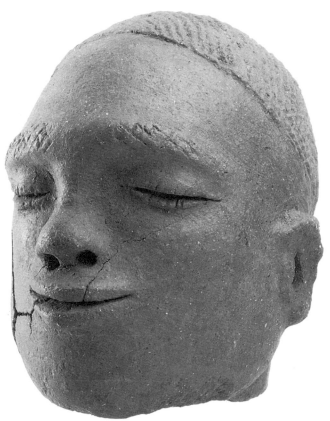

23. Head. 500 B.C. to A.D. 500. Terra cotta. Nigeria, region of Sokoto. Height: 13 cm. Paris, private collection.

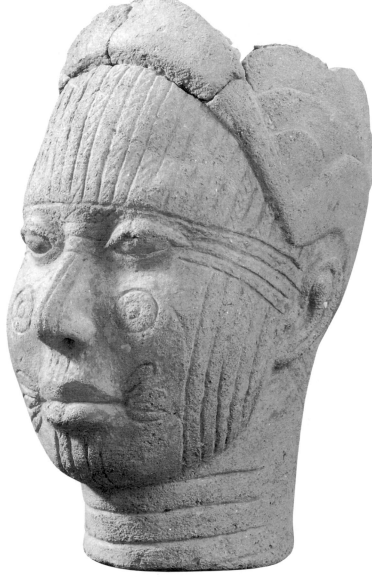

24. Head. Fourteenth to fifteenth century. Terra cotta. Nigeria, Ile-Ife. Height: 17.1 cm. Ife, Obafemi Awolowo University, Department of Archaeology.

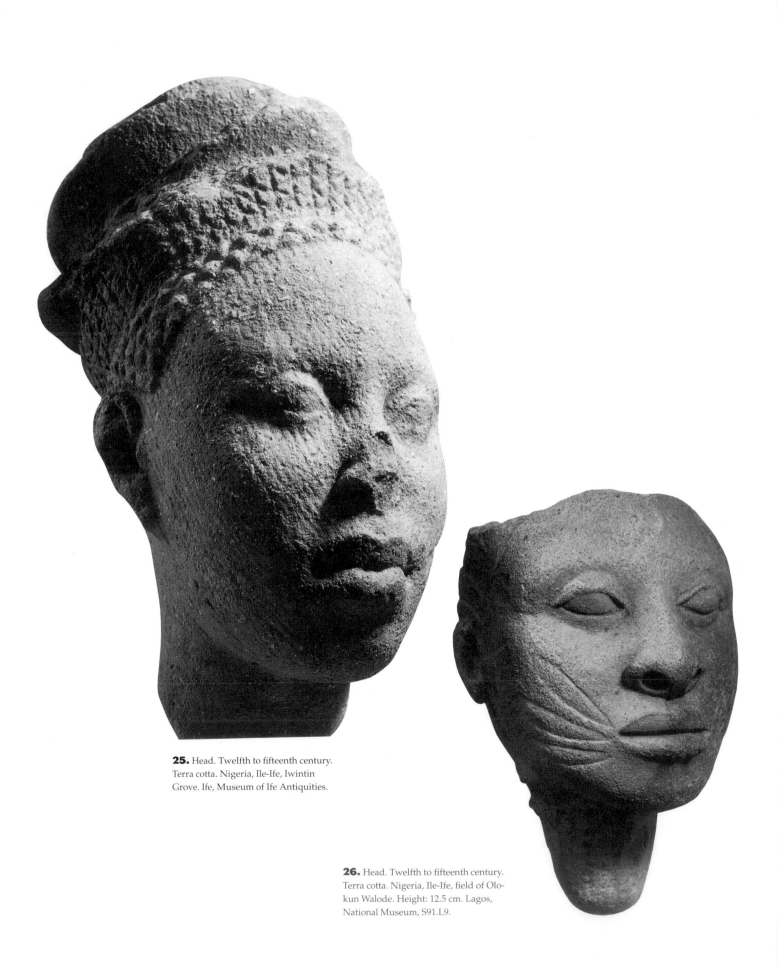

25. Head. Twelfth to fifteenth century. Terra cotta. Nigeria, Ile-Ife, Iwintin Grove. Ife, Museum of Ife Antiquities.

26. Head. Twelfth to fifteenth century. Terra cotta. Nigeria, Ile-Ife, field of Olo-kun Walode. Height: 12.5 cm. Lagos, National Museum, S91.L9.

Although some of the portraits of Ile-Ife are obviously the work of less trained sculptors, most attest to great skill in representing the contours of the flesh on a human face: curve of the cheeks, tension of the jawbone, positioning of the eyes in their sockets, markings of circles around the eyes, rims of ears. All these features seem to have been taken from life. These characteristics were confined to the art of Ile-Ife; artisans of other city-states, such as Owo, though they adopted the same tradition of the portrait, did not manage to equal the skill of their counterparts in this area. Such a knowledge of the muscular structure of the face can only be the product of meticulous and passionate observation, a long apprenticeship, and a desire to reproduce what is revealed when one looks objectively at reality. That attitude is altogether unique among African civilizations. The attention given to the positioning of the nose, the swelling of the nostrils, the bulge of the lips—sometimes slightly parted and with the trace of a smile vanishing at the corners—indicates the intense desire the sculptors of Ile-Ife had to capture the breath and quiver of life in the faces of their models. In addition, true to the demands of the portrait, the shape of the nose, and, to a lesser degree, of the lips, the proportion of the face, and the positioning of different muscles and organs within the face varied from one portrait to the next, so that no head was identical to any other, not because of the ornaments (headdress and scarification) superimposed on it, but because of the physiognomy itself.

Nonetheless, these portraits are still idealized, in the manner of Egyptian and many Roman portraits: they depict young people and, apart from the scarifications, no facial feature is more prominent than any other, to such a degree that it is not always easy to differentiate the men from the women. The flesh stretches over the bone structure and envelops it in a firm, plump oval; the expression is fixed in the same calm impassivity found in numerous heads of kings, queens, and dignitaries of Egypt. The depiction of the eyes is almost identical on each of the faces: two mandorlas stretching toward the temples house sculpted sockets just under the skin, without any marking for the pupil.

The upper eyelid, made with a double incision, covers the eyeball with a curved arch, giving some of these faces a slightly lowered, almost Oriental, gaze. The same schematic treatment is used to depict the headdress, the woven tresses of hair, and head coverings, as if the concern for verisimilitude that allows a spark of life to animate these faces no longer had anything to do with the elements that surround them, which are reduced to soberly sketched signs with a purely descriptive function. The folds or rolls, similar to furrows, that form rings around some of the necks are part of the same interpretation. They are conventional elements recalling the status of the persons represented: noble, powerful, and magnificent women and

27. Head. Twelfth to thirteenth century. Terra cotta. Nigeria, Ile-Ife, Ita Yemoo. Height: 25 cm. Ife, Museum of Ife Antiquities, 79.R.7. Profile view of head in fig. 16.

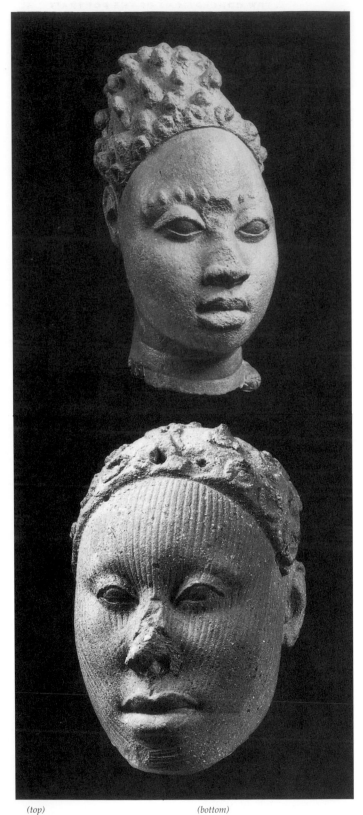

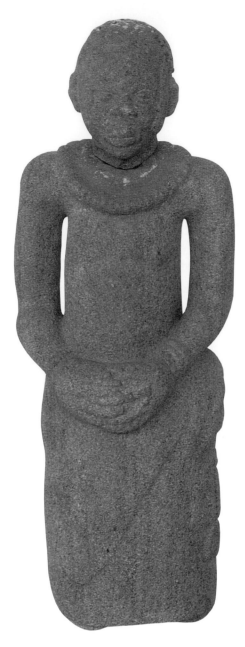

(top)
28. Head. Twelfth to fifteenth century. Terra cotta. Nigeria, Ile-Ife, Olokun Grove. Height: 17.2 cm. Berlin, Museum für Völkerkunde, III C 27530. Head found by Frobenius in 1910.

(bottom)
29. Head. Probably twelfth to fifteenth century. Terra cotta. Nigeria, Ile-Ife, Olokun Grove. Height: 15.6 cm. Berlin, Museum für Völkerkunde, III C 27526. Head found by Frobenius in 1910.

30. Male effigy. Twelfth to fifteenth century (?). Stone and iron nails. Nigeria, Ile-Ife, Ore Grove. Height: 101.3 cm. Ife, Museum of Ife Antiquities. The art of sculpture in stone is rare in Africa, and this work of art is all the more remarkable for that. Note the concern for realist expression in the gesture of the hands folded over the belly. The pagne is depicted knotted on the left hip, according to the custom, as it would later be in the art of the kingdom of Benin. Iron nails were inserted into the stone to represent the hair.

men. These folds of fat, which are also found in west Africa in heads sculpted by the Akan, express the beauty and prosperity of those who sport them. As if to underscore their emblematic role, these rolls shape necks that are sometimes exaggerated in length, in comparison to the volume of the head: The necks are in that case similar to pedestals on which the head proper rests, thus accentuating the effect of idealization. The individualized realism found in the contours of the face thus seems to disappear as soon as one moves to the periphery of the face.

At first glance, a few rare examples escape that conformism. Such is the case for the portrait in terra cotta of a man with bloated features, a prominent arch to the eyebrows, and open mouth, similar to a garden gargoyle (fig. 31); and for the metal heads of two men—forming the handle of a cane—one of whom is wearing a gag made of rope, which signals his fate as a sacrificial victim, while the other has a face furrowed with deep wrinkles (Willett 1967b, plates 4 and 5). Both examples might be called expressionistic, and, in our tradition, almost caricatural. In the first case, however, the effect of idealization persists: the face is perfectly symmetrical, the flabby cheeks equal in size on the left and right; the bump on the forehead forms a protuberance triangular in shape, which is equivalent to the hole forming the mouth; the curved ridge formed by the arch of the eyebrows corresponds to the arch formed by the bloated pockets around the eyes. Unlike the other heads, which all depict harmonious youth, this one presents us with a swollen face creased by deep wrinkles. The ideal of harmony that prevails in the other heads seems to have disappeared, yet we are still dealing with an idealization, as suggested by the symmetry and regularity of the contours of the face. This time, however, it is an idealization of ugliness. The figure is wearing a large bead on his forehead, thus revealing that he occupied an important ritual position in the society of Ile-Ife.[3]

Full-length works and busts display similar characteristics: although the treatment of the face always stems from the same mode of creation, relying on a principle of idealized resemblance to a model, the same is not true for the rest of the body. Like the headdress, it is depicted in a more schematic and conventional manner: hands and feet conform to a stereotypical model, and the body is reduced to a monolithic parallelepiped partly covered with always identical ornaments, representing the attributes of the monarchy (fig. 21). The sole exception is the Tadda man, who is devoid of ornament. Although the faces are always conceived as a function of a desire to transcribe realistic details in a relatively faithful manner, the bodies appear to be interchangeable. That rule seems to have been sidestepped in the case of the seated Tadda figure, in which the conception of the body is a reflection of that prevailing for the face: its accurate proportions and stoutness, the contours of

31. Head. Thirteenth to fourteenth century. Terra cotta. Nigeria, Ile-Ife, Obalara. Height: 15.2 cm. Ife, University Art Museum, Obafemi Awolowo University.

muscles in the legs, and even the shape of the foot, which is more detailed than in other sculptures, are consistent with the treatment of the face (fig. 22). The sculpture of the seated Tadda man constitutes a work of art that is formally and stylistically homogeneous in the treatment of its parts, though the head is larger than it would have been in reality.

In the full-length art works, the head is disproportionately large. I do not accept the hypothesis advanced by several authors, that the disproportionate size of the head corresponds to a canon of African sculpture. There are numerous counterexamples that suffice to prove the contrary. In contrast, the role and significance attributed to the head in the Yoruba world, and, as we shall see, in the Edo world, offer a possible explanation, both of the fact that the head is larger than life and of the realist treatment given it—or at least the most important part of it, the face. Apart from the Tadda bronze, in which the attention the sculptor gives to a naturalist rendering concerns the body as a whole, only the faces of Ile-Ife heads show such experimentation. The bodies partly escape it, and other figurations, such as those of animals, which are numerous in the art of Ile-Ife, also seem to privilege a creation subject to the same laws of decorative and conventional detail.

The almost naturalist conception of the faces of Ile-Ife appears even more unusual when we consider the art of the Edo in the kingdom of Benin, which followed in the wake of the Ile-Ife kingdom. Oranyan, a prince of Ile-Ife, is said to have founded the second dynasty of Benin: custom has it that, on one occasion, the head of the deceased king of the Edo was sent to Ile-Ife to be buried in the place Oranyan had come from. In return, the *oni* of Ile-Ife was to send the Edo the head of their *oba*, but in the form of a brass effigy. In the late fourteenth century, the *oba* Oguola then asked the *oni* of Ile-Ife to send him an artisan who was expert in the casting of metals, so that he could teach the Edo that new art (Willett 1967b, 131). In addition to granting the same importance to the heads, the art of the former Benin shared certain motifs with the art works of Ile-Ife, such as the grotesque mask whose mouth opened to reveal sharp teeth and whose nostrils spewed serpent or fish bodies that climbed toward the temples of the mask (Willett 1967b, 168 and 170). Nonetheless, the art of Benin does not include works that attain the degree of realism found in Ile-Ife. The difference is not negligible: it stems from an entirely different intellectual attitude, all the more worthy of notice in that the Edo were familiar with the naturalistic art of Ile-Ife. Consider the two full-length brass sculptures depicting dwarves, whom the king of Benin liked to have around him as "entertainment," according to Olfert Dapper (fig. 33) (see below, p. 148).

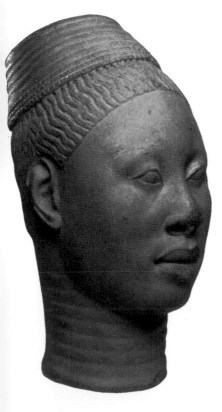

32. Head. Twelfth to fifteenth century. Terra cotta. Nigeria, Ile-Ife. Height: 32.8 cm. Ife, palace of the *oni*, Museum of Ife Antiquities, 20 (79.R.10).

The effigies of sovereigns, kings, and queen mothers, of dignitaries and officers of the court, which the art of the kingdom of Benin has bequeathed to us in abundance, are also portraits. But, whereas in Ile-Ife the sculptors manifested an interest in physiognomic resemblance, in Benin no particular attention was given to the expression of such a resemblance. And, contrary to the case of the statuary of Ile-Ife, full-length portraits abound in Benin. The portraits of the kingdom of Benin all correspond to a canonical model, in which the rendering of facial features is fixed in a single schematic mold. In Edo art as in Egyptian statuary, all human beings have the same face as the king. That stylization also applies to the figurations of animals: silurids, leopards, lions, and roosters. Each of these species was always formed in a similar manner. The oval face, the structure of the nose, and the disposition of the mouth and eyes are identical from one sculpture to the next. The eyes are wide open, disproportionately large, and surrounded by two eyelids with prominent edges, the lashes sometimes marked with grooves, brought to life with a recessed circle to serve as the pupil. Also unlike the art works of Ile-Ife, those of Benin are packed with details describing headdresses, ornaments, clothing, emblems, and attributes, which allow the beholder to define the social and symbolic identity of the individual represented. Physiognomic portraits never appeared in Benin, with the exception of the effigies of dwarves previously cited; the portrait is merely emblematic and based on a multiplication of faces identical to that of the *oba*.

In the court art of Benin, the entire effort of sculptors appears to have been directed toward the detailed transcription of the attributes of the different individuals represented. That quest for refinement in decoration seems to have occurred at the expense of a more faithful rendering of the morphological reality of the effigies: the proliferation of ornament invades the entire surface of the image and even the carved backgrounds of brass plaques in bas-relief and high relief. The general schematism of the figures contrasts with the meticulous description of costumes and insignia. Here again, that conception may be linked to Near Eastern expressions, where man disappears behind his function. Closer to our own context, Louis XIV, absolute monarch by divine right, liked to have himself depicted in allegories, at the expense of the principle of resemblance. He was represented dressed in the attributes of historical or mythological characters, such as Alexander the Great or Apollo, whose greatness he believed was comparable to his own (see Laude 1965, 416). Thus, even though the portrait, as a mode of representing an individualized personality, was broadly practiced in the seventeenth century, the "official" portrait continued to privilege decoration and pomp, at the expense of physiognomic and

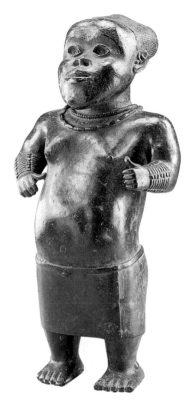

33. Sculpture representing a court dwarf. End of fourteenth to beginning of fifteenth century. Brass, lost-wax casting. Nigeria, kingdom of Benin, Edo. Height: 59.3 cm. Vienna, Museum für Völkerkunde. Inv. 64.745. Copyright Archives Musée Dapper, Paris.

psychological resemblance. Emblematic figuration celebrated the sacralization of power. The portraits of sovereigns and dignitaries of Africa did not break that rule. Although the oral tradition has preserved very little of the meaning of these art works, the abundance of motifs and decorations that adorn the royal portrait and court art generally allows anyone able to read them to discover the meaning of the whole and to reconstitute a few pieces of history and rites. In that case, the ornament almost comes to resemble writing, since the profusion of detail cannot be the result merely of a decorative intention: it also attests to a desire to take note of everything. That profusion thus had both a mnemonic and a commemorative function, as an inscription in time of information having to do with each reign and of elements designed to be committed to memory by future generations. In fact, the art of Ile-Ife, unlike that of Benin, gives us very little information about what the monarchy of the eleventh, twelfth, thirteenth, and fourteenth centuries was like. The fact that the Edo turned their interest to the detailed description of attributes rather than the expression of an individuality bestowed by nature—the individuality of the face—shows the importance of the political and informative vocation of their court art.

In Benin, the *oba* heads wear a kind of high necklace around their necks, composed of several rows of coral beads and, on top of their heads, a cap in the form of a hairnet, also of coral beads (fig. 35). The heads created in the nineteenth century sport a more complex headdress, still used by the kings of today, in which two winglike appendages stick up from either side of the head (fig. 34). These wings represent either the barbels of a mudfish, a symbol of royalty, or the ceremonial sword with slightly curved blade, called an *ada*, also reserved for the king and the most important chiefs.

Depicted at the base of certain of these heads are symbols of the sovereign's power: leopards, elephant trunks, silurids, crocodiles, etc. The king's mother wore a headdress, likewise made of a hairnet of coral beads, but in the shape of a peak, which historians of Benin art have called a "chicken's beak" (fig. 36); that headdress is still worn by high-ranking Edo women. Red coral beads were, and still are, reserved for the *oba*, his mother, his wives, and the high dignitaries of the kingdom. Like all royal attributes, they have a mythical meaning, since they were supposed to have been stolen from Olokun, the god of seas and waters, source of all earthly riches, one of the most popular gods in the kingdom of Benin. Olokun is the son of Osanobua, the god of creation. On village altars, Olokun is depicted in the form of a Benin *oba*, wearing the crown and the costume of coral beads, of which he remains the divine owner (Ben-Amos 1995, 64–69). It was in the sacred grove dedicated to Olokun, located in Ile-Ife, that Leo Frobenius discovered several heads in terra cotta

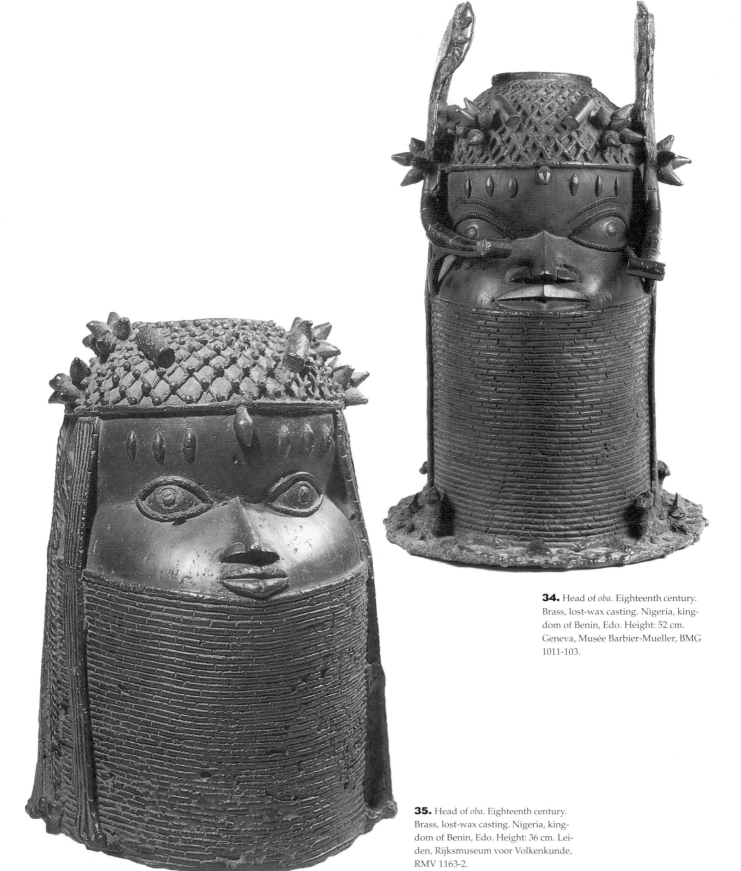

34. Head of *oba*. Eighteenth century. Brass, lost-wax casting. Nigeria, kingdom of Benin, Edo. Height: 52 cm. Geneva, Musée Barbier-Mueller, BMG 1011-103.

35. Head of *oba*. Eighteenth century. Brass, lost-wax casting. Nigeria, kingdom of Benin, Edo. Height: 36 cm. Leiden, Rijksmuseum voor Volkenkunde, RMV 1163-2.

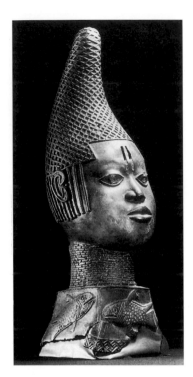

36. Head of queen mother. Sixteenth century. Brass, lost-wax casting. Nigeria, kingdom of Benin, Edo. Height: 50.8 cm. Berlin, Museum für Völkerkunde, III C 12507. Presumed to be a head of Queen Idia.

(figs. 28 and 29) and numerous beads, this time of glass. One of the hymns sung during the feast of Olokun in Ile-Ife invokes the god Olokun in these terms: "God of beads rise out of the earth . . . Rise up out of the earth, children of water" (Willett 1967b, 25). As the seat of a vital force inherited from the god and transmitted to the king, every year these beads receive the blood of sacrificial victims, which in past times were human. These beads are the receptacle of a power, *ase*, that dictates that everything said by the king in their presence will become reality. "When the king is wearing this heavy beaded costume," says Ihaza, a chief of Benin, "he does not shake or blink but stays still and unmoving. As soon as he sits down on the throne he is not a human being but a god" (Ben-Amos 1995, 96).

The Benin heads display variants depending on the era; these, however, do not compromise the general configuration of the sculptures. For example, in the older heads (sixteenth century), the necklace leaves the chin free (fig. 37), while more recent examples (eighteenth century) imprison it up to the mouth (figs. 34 and 35). Whether heads, full-length portraits in the form of figurines, brass plaques in high relief, or drawings carved in ivory, portraits of the sovereigns of Benin always depict them dressed in their beaded costume. Convention dictates that the frontal view be privileged, in full-length sculptures as in high relief plaques. The form of the costume and the headdress, like the objects worn by the king and those around him and the gestures of figures, always relate to a specific ceremony, each requiring the wearing of particular ornaments, the handling of objects, and an immediately identifiable body language.

The social and ritual identity of the figures is recognizable by the costume and objects represented. The most common representations of the *oba* show him dressed in all his royal insignia, holding in his right hand the *eben*, the ceremonial sword with which he dances to honor his ancestors (fig. 103), and grasping in his left hand another object, a small ivory bell or a proclamation staff, *isevbere igho*, designed to send evil away and to make effective the words he utters. Elsewhere, the sovereign brandishes in his left hand a rattle staff, *ukhurhe*, a sign of the authority inherited from his father and of his union with ancestral spirits, which are invoked when he strikes the staff against the ground. In his right hand he holds a rough-hewn neolithic ax, symbol of his supernatural authority.[4] Another frequently found image depicts him flanked by two individuals supporting his forearms and hands while he travels on foot or horseback (fig. 68). According to certain versions, the first courier is the successor to the throne, the *edayken*, and the second is the supreme chief of the army, the *ezomo* (Duchâteau 1990, 69); in that case, the triad would depict power in its future fulfillment and the bellicose element that allows it to be main-

tained. In certain scenes, servants seem to be sheltering him from the sun with their shields held over his head (fig. 67). That same scene of the upright *oba* supported on the left and right can still be observed during his enthronement and at most of the great palace ceremonies. As a reminder of his status as divine king, the *oba* may also be depicted with two silurids in place of his legs; the silurid, a privileged sacrificial victim offered to Olokun, god of the sea and waters, alludes to the close relation linking the *oba* to that god, which is recalled in the capacity of the fish to live both on earth and in the water. The *oba*'s domain is dry land, while the god's is water (fig. 69).

The king's mother may also be depicted standing, hands and forearms supported by servants, some of whom protect her with two lifted shields, in a manner similar to that used for the *oba* (fig. 70). In these representations, the queen mother sports the same regalia as the *oba* himself: the crossed bandolier, the crown, and the shirt of coral beads, for example. In addition to the *oba*, only the *oba*'s mother, the crown prince, or *edayken*, and the chief of armies, *ezomo*, have the right to such a costume (Ben-Amos 1983, 82). The *ezomo*, commander and war chief, and city chiefs wear the necklace and coral beads adorned with leopard's teeth, which mark their status as warriors (fig. 73). Important individuals camouflage the knot of their pagne, resting on their left hip, with a mask of brass or sculpted ivory depicting the face of a leopard or a crocodile head (fig. 126). Portraits of the Portuguese are also part of the representations found in the art of Benin from the sixteenth and seventeenth centuries: men with bushy hair and long beards, dressed in doublets buttoned and gathered at the waist to form a skirt, baggy trousers, and hats with plumes are meticulously portrayed. Others wear small buckles, ruffs, and morions with a central crest (fig. 77). Over the course of these two centuries, the faces of the Portuguese become a particularly common motif. A few distinctive elements drawn from the headdress and costume are sufficient to transcribe not the specificity of a particular individual, but the visitor's singularity as a foreigner. The catalog of attitudes and attributes determining costumes of kings or officials in the iconography of Benin would be lengthy, and I shall not attempt to compose it here. It includes numerous other effigies: ceremonial chiefs, horsemen, warriors, Portuguese soldiers, members of guilds, musicians, dignitaries, young boys (probably pages), servants, and priests.

Within that vast nomenclature, there are a few images that have been interpreted as the figuration of a particular *oba*, recognizable by the insignia that accompany him, and a reference to a specific event in the history of the kingdom, commemorated by tradition. One portrait of a king's mother also meets these requirements. History tells that the *oba* Esigie, the Benin sovereign who witnessed the arrival of

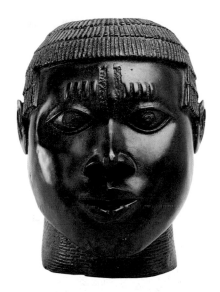

37. Man's head. Fifteenth to sixteenth century. Brass, lost-wax casting. Nigeria, kingdom of Benin, Edo. Height: 21 cm. Geneva, Musée Barbier-Mueller, BMG 1011-121. Trophy head of a foreigner: the headdress and scarifications above the eye sockets indicate this is not an Edo.

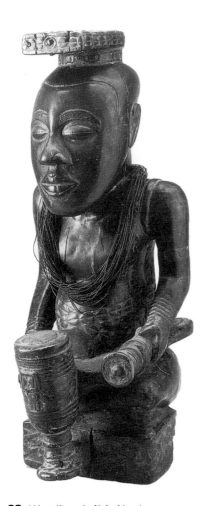

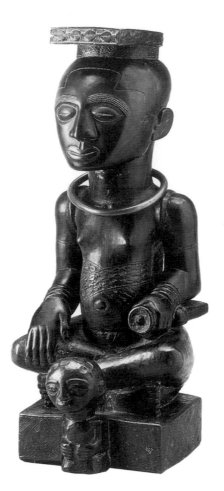

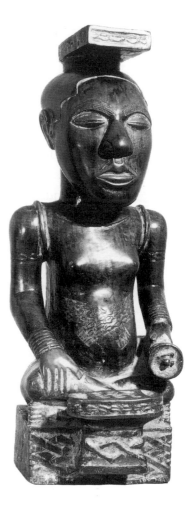

38. *Ndop* effigy of a Kuba king (or *nyim*). End of eighteenth century. Wood and vegetable fibers. Zaire, western Kasai, Nshyeeng, Bushoong (Kuba). Height: 51 cm. Tervueren, Musée Royal de l'Afrique Centrale, R.G. 15256. Brought back by Emil Torday in 1908. According to Torday, the effigy depicts the *nyim* Kot a-Mbul (late eighteenth century).

39. *Ndop* effigy of a Kuba king (or *nyim*). Eighteenth century. Wood and metal. Zaire, western Kasai, Nshyeeng, Bushoong (Kuba). Height: 55 cm. Tervueren, Musée Royal de l'Afrique Centrale, R.G. 27655. Portrait of King Miko mi-Mbul (eighteenth century).

40. *Ndop* effigy of a Kuba king (or *nyim*). Eighteenth century. Wood. Zaire, western Kasai, Nshyeeng, Bushoong (Kuba). Height: 54.6 cm. London, Museum of Mankind, 1909.12-10.1. Posthumous portrait of the *nyim* Shyaam-a-Mbul a-Ngoong, founder of the Kuba kingdom (seventeenth century).

the Portuguese in the late fifteenth century, inaugurated the tradition of portraits by creating the title of queen mother, *iye oba*, and by having a head made of his mother, Idia. A portrait dating from that era exists; according to tradition, it depicts Queen Idia (fig. 36). The first in a long series, the portrait of Idia seems similar to all the queen's portraits that followed. What differentiates it are the fish adorning the pyramid base that supports the head: according to certain Edo artisans, they are an allusion to the efforts of Idia's warriors, who pushed enemy soldiers back beyond the River Niger during a battle (Ben-Amos 1995, 35). Another image, this time on a sixteenth-century plaque, shows the *oba* Esigie on horseback, his arms supported in the classic ceremonial position by two men, one of whom bears the effigy of a bird, its wings outspread. This picture refers to the war previously mentioned, when the *oba* is supposed to have put to death a bird that had predicted the defeat of his armies, and then to have gone on to win the battle, demonstrating the superiority of his force (fig. 68) (Ben-Amos 1995, 35). The picture does not represent the *oba* so much as the principal elements allowing the beholder to reconstitute an event. It is a portrait, however, and the *oba* appears as the principal actor of the scene: looking at it, the Edo recognize the monarch and can thus remember the story of the prophetic bird.[5] These portraits, in which the emblems have a commemorative vocation, came back into fashion in the twentieth century; in the 1940s, the *oba* Akenzua II, who reigned from 1930 to 1978, asked that the eroded bas-reliefs of unbaked clay in the palace be replaced with new royal portraits, which, however, were just as conventional as the previous ones (Blackmun 1990, 61). These portraits represent Akenzua II himself, his father Eweka II, his grandfather Ovoranwen, who was sent into exile by the English, and two famous *oba* of the sixteenth century, Ozolua and his son Esigie (mentioned above). Each is recognizable by certain elements. Thus, Akenzua II is represented holding a leopard with one hand and an elephant with the other. He sacrificed these two animals at his enthronement, thus reproducing the gesture of his eighteenth-century ancestor Akenzua I, and in this way appropriating his emblems. Ozolua the war king is depicted dressed in a long metal suit of armor forged by his artisans; one of his arms is protected by a shield reputed to make him invincible. This shield alludes to an event in which Ozolua was killed after he set aside his shield to go bathing, thus becoming vulnerable. With the hand of the arm protected by the magic shield, he is lifting an enemy, whose body is being split in two by the scimitar he holds in the opposite hand (Blackmun 1990, 62–65). More surprising, but a confirmation of a similar conception of the portrait, is the image that depicts the *oba* Ovoranwen relieved of his command. The artist was inspired by a photo taken by the English, and familiar to the Edo, in which the king

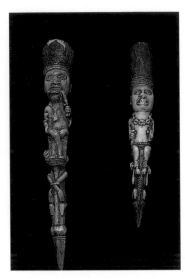

41. Handles of flyswatters (?). Ivory. Zaire, Kongo. Height: 26 cm (left) and 23 cm (right). Tervueren, Musée Royal de l'Afrique Centrale, R.G. 38571 and R.G. 43708. The chief is depicted seated on a circular throne. At right the hands of a prisoner holding his ankles are visible. The body of the prisoner is sculpted on the other side of the object; he is on his knees and his neck is caught in a rope. The same theme of the prisoner is found at left: this time, his hands are tied around the column. The royal stool is placed at the top of this column.

42. Chief's cane handle, or *mwala*. Ivory, Zaire, Kongo. Height: 34 cm. Tervueren, Musée Royal de l'Afrique Centrale, R.G. 50.29.1.

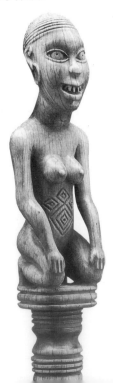

appears on the deck of the ship carrying him off to exile, dressed in a simple toga, without his regalia, and seated in a chair. The sculptor has kept the chief elements, which allow beholders to identify the scene: the toga, rolled up under his armpits, and the chair.

The statues of the Kuba sovereigns of Zaire also belong to that set of portraits with a commemorative vocation, in which the emblem is enough to identify the individual represented and thus to individualize the portrait. The Kuba call them *ndop* and reserve their use for their kings (figs. 38–40). Whichever sovereign is represented, these statues show him sitting cross-legged on a pedestal symbolizing the royal platform; the king wears a sort of headdress with visor, called a *shody*, and sports a particular hairstyle produced by a coat of black cosmetics, which is applied to his head on certain occasions. Curved ornaments encircle his shoulders, and bracelets adorn his forearms and wrists. A wide cowrie shell belt is crossed over his abdomen. Another belt holds up a sort of pagne in the back. His right hand rests on the corresponding knee, while his left grips the pommel of a ceremonial sword, an *ilwoon*, its blade facing backwards (Cornet 1982, 58–59).[6] The workmanship is the same for all the statues, with a few stylistic variations due to the hand of the sculptor. The monarch's eyes are half-closed in a full and oval face, the two eyelids drawn in the manner of the two shells of an almond joined together; the bust, often marked by some slight stoutness, a sign of health and prosperity comparable to the ringed necks of the Ile-Ife heads, stands vertically on minuscule legs. The tradition of these portraits is supposed to have begun toward the middle of the eighteenth century and disappeared toward the end of the nineteenth.[7] What differentiates these portraits is the object, called *ibol*, represented on the front face of the pedestal.

One of the words the Kuba use to name their king, or *nyim*, is *ngesh*, which also designates the spirits of nature. After his death, the king becomes a *ngesh* and remains at his gravesite. The *ndop* statue is fabricated at the time of his enthronement, along with the royal drum; it is then regularly rubbed with red wood powder, *tukula*, and with palm oil. During his reign, any incident concerning the royal person was liable to manifest itself on the *ndop* as well. Tradition tells us that the mortal wound received by a certain *nyim* appeared simultaneously on the body of the statue, in the form of a nick. The *ndop* was kept by the king's wives, and when one of them gave birth, the statue was placed beside her to assure a happy outcome to the birthing process. The *ndop* was thus conceived as the bearer of a part of the *nyim*'s soul.

At his death, the *ndop* was placed near the nyim's deathbed, so that it could collect the sovereign's vital force. Then, during the period of seclusion that preceded his

accession to the throne, the king's successor was required to remain beside the statue, so that the captured force would come to inhabit his own body.

Custom has it that during his enthronement, the future *nyim* reveals his new name, his official name, and the corresponding symbol. For each symbol and each name, a proverb is composed to signify it. The Kuba, like the Edo of Benin, seek to preserve the traditions of the kingdom; just as the interpretation of certain objects associated with the sovereign allows the Edo to recognize the *oba* represented, so that of the *ibol* makes it possible for the Kuba to reconstitute certain events in the history of the reign and to identify the *nyim* depicted. The different *mabol* [8] to be found depict a game of *lyeel*,[9] a drum, an anvil, a human figure, a flyswatter, a parrot, a bunch of walnuts, a human head, a pirogue or leopard skin, a rooster, and an adze (Cornet 1982, 73–74). The portrait of the *nyim* Miko mi-Mbul, who is believed to have reigned during the first third of the nineteenth century, includes an *ibol* of a small human figure, signifying the king's omnipotence over his subjects. Another more romantic but disputed version is that this figure is a slave, whom the king married and then freed. King Kot a-Ntshey is seated in front of a drum. King Shyaam a-Mbul a-Ngoong holds in front of him a game of *lyeel*, which he is said to have invented. He was also the founder of the Bushoong dynasty. As we have seen, the emblematic character of the Kuba royal portrait rests on the figuration of an allegorical object.

Other examples come to us from the Kongo and Chokwe. Kongo court art offers numerous effigies of chiefs, wives, and mother and child. Most are found in the ornamentation on scepters, flyswatters, or canes. The chief is always depicted wearing a cap of woven and embroidered raffia fibers, *mpu*, insignia of his rank, and generally chewing on a bitter root, *munkwiza*, symbolizing the supernatural powers acquired during enthronement (figs. 41, 46).[10] A supplicant or prisoner—criminal or war captive—often accompanies these representations. Female figures are sculpted in the cane handles of chiefs, called *mvwala* (fig. 42). These canes are part of the regalia: Kongo tradition maintains that the nine canes with which the *manikongo* governed corresponded to the nine original clans of the kingdom. These canes were used during rites in which the king reasserted his control over his territories (*Trésors d'Afrique* 1995, 292). That female figure may represent the founding ancestor of the clan. The other female figures exhibit one or several attributes of the chieftaincy: *mpu* cap, bracelets, cowrie shell necklace adorned with leopard's teeth, a certain type of scarification, or a certain attitude. Figures of women meeting the same plastic criteria are found in the statuettes representing a mother and child, called *pfemba*, whose function remains obscure even today (figs. 43–45).

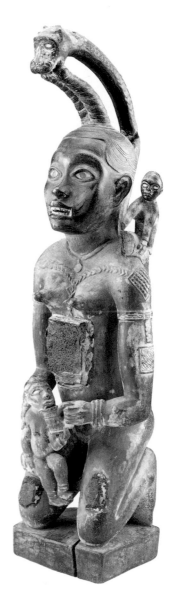

43. Female effigy. Eighteenth to nineteenth century (?). Wood and glass. Angola, Cabinda, Kongo (Vili). Height: 44 cm. Leiden, Rijksmuseum voor Volkenkunde, 1354.47 (1902). Figurine belonging to a category that includes various objects, some of which have an anthropomorphic appearance, incarnating the personalized powers from the world of the dead, called *minkisi* (*nkisi* in the singular) in Kikongo. Pieces of material with supernatural powers, used in magical practices in which the *minkisi* play a part, are introduced into the object. The treatment of the animal head holding parts of a headdress in its mouth is very clearly inspired by a European model, perhaps from the sixteenth century.

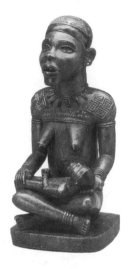

44. *Pfemba* effigy. Wood and glass. Zaire, Kongo (Yombe). Height: 29 cm. Tervueren, Musée Royal de l'Afrique Centrale, R.G. 24662.

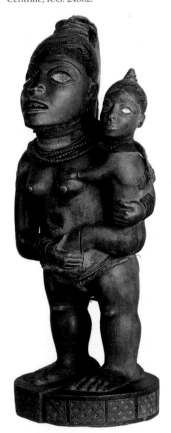

45. Female effigy. Eighteenth to nineteenth century (?). Wood, rope, beads, and glass. Angola, Cabinda, Kongo (Vili). Height: 44 cm. Leiden, Rijksmuseum voor Volkenkunde, 2668.2101 (1947). *Nkisi* statuette.

Kongo effigies are also marked by a realism that, in a manner similar to that observed in the statues of Kuba kings, seeks to transcribe certain traits proper to the human person as it appears in reality: a roundness and suppleness of the members, details of the hands, and contours of the face. As in Kuba statuary and even more in that of Ile-Ife, the contours of cheeks and lips and the shape of the nose reveal a very particular attention to notations of physiognomy. That intention also appears in the contours of certain masks and is further underscored in the figuration of eyes: in order to make them more true to life, the sculptors transcribe the shape of the eyeball as it is, imprisoned between the two eyelids, and bestow a gaze on the statue by making a hole to mark the place of the pupil. Other examples possess glass eyes, including a black pupil; the choice made by Kongo artists in their attempt to translate the brilliance of the eye by using a reflective material may bring to mind the practices of Egyptian sculptors, as shown in the statue of the *Seated Scribe* or in the famous polychromatic portrait of Nefertiti. However, the eyes of Kongo statuettes are disproportionately large, and, when made of glass, inscribed within a broad, oblong, and perfectly flat area that does not follow the curve of the face.

Chokwe sculptors have left behind numerous effigies of their chiefs, responding to the same taste for realism in the attitude and physique of the body that we find in Kongo art. Two types of royal effigies are found among the Chokwe: first, those of the mythic founder of the Lunda and then the Chokwe dynasty, Tshibinda Ilunga, venerated as the hero who introduced the art of hunting, and the inventor of powerful charms; and second, those of the great Chokwe chiefs.[11] Except for portraits of Tshibinda, recognizable by specific attributes—but then, he is a mythical figure—portraits of Chokwe chiefs do not allow the beholder to identify them, since they are all depicted in a limited number of conventional attitudes. Sculptures of Tshibinda show him wearing the headdress with two lateral wings curving backward characteristic of Chokwe sovereigns, and holding the insignia of the hunter: in his right hand he holds the staff from which protective charms are suspended during halts; in his left he holds the animal horn into which certain powders with magical characteristics are deposited (fig. 50). In other portraits, the horn is replaced by a stone gun (fig. 51) (Bastin 1988, 53–54). Certain sculptures of Tshibinda show him with his cartridge pouch, a calabash containing gunpowder, an ax, a knife, and a protective amulet—a tortoise shell—attached to his belt (Bastin 1982, 137). Chiefs are represented with the same kind of headdress as Tshibinda, though less elaborate. Like the hero hunter, they are depicted nude, and their headdress may be the only insignia recalling their rank. That headdress reproduces that of the *cikungu* mask, a sacred symbol of the dynasty evoking the chief's ancestors. This mask is

never represented as such, except as suggested by the silhouette of the chiefs' head-dresses. The physical attitudes depicted in that statuary vary, reproducing certain behaviors relating to court body language. The statues of chiefs show them standing, or seated on a throne, in the traditional round form, or in the form of a folding chair, inspired by Western chairs. When standing, the chief extends his hands toward his pubis or slightly in front of his belly. Hands in front of the chest may represent a gesture called *taci*, sign of force and power (figs. 47 and 48) (Bastin 1982, 112). When seated, the chief makes the gesture—called *mwoyo*—of clapping his hands; as dispenser of well-being and prosperity, he wishes these blessings on his subjects (fig. 52) (Bastin 1982, 112). A few portraits represent a chief preparing to take snuff—both a sign of welcome to a visitor and an invocation to the spirits made before his subjects (Bastin 1982, 133). Others are playing a lamellophone, called a *sanza* (fig. 93). Certain prestigious objects, such as scepters, also have representations of chiefs, either depicted full length, or portraying only the head (figs. 47, 93, 96).

For the Chokwe, this is above all a means of representing the chief as the one who performs essential symbolic functions, manifested by gestures, on which the balance and harmony of the community depend, or as a mythic hero and founder of social existence itself. The statuary expresses the sacred character of sovereignty by fixing in material form gestures essential to the kingdom. These are comparable to those depicted in the art of Benin, though more limited in their expression. Chokwe portraits are portraits of gestures. This does not prevent a certain naturalism from taking hold, however: in many cases, the treatment of the ears, the curve of the cheeks, and the shape of the nose reveal a meticulous observation of the physiognomic reality of the face. That attention is also directed to the shape of the hands and feet, which are generally large, a trait specific to Chokwe statuary, in which the fingers, phalanges, and nails are precisely shaped. The portraits of Tshibinda Ilunga show him with enormous hands and feet, disproportionately large in relation to the rest of the body. His musculature is also sculpted in such a way as to evoke the sovereign's power. Feet and hands are surprising for their very advanced naturalism. In confirmation of that particular tendency, sculptors adorned the chins of certain portraits with natural hair to serve as a beard. That organic and human matter introduced into the sculpture places it in a situation of near adequation with the reality of flesh and blood: If there is resemblance, it rests not only on an equivalence of appearance, but also on a sort of transfer of vitality, through the intermediary of these fragments of living matter, the hair. The exaggerated size of Tshibinda's hands may express the hero's exceptional agility; that of his feet, his endurance during hunting parties (Bastin 1988, 54).

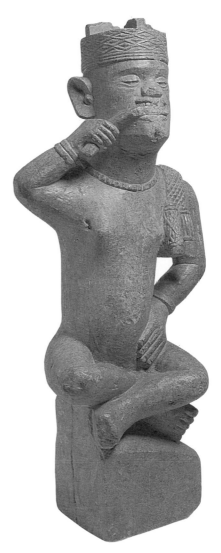

46. Funerary statuette. Nineteenth century (?). Soapstone. Zaire, Matadi, Kongo. Height: 49 cm. Geneva, Musée Barbier-Mueller, BMG 1021-17. The history and function of these funerary effigies are still unclear. They may have served as receptacles for the soul of the deceased chief. The headdress, *ndunga*, surmounted by four curved leopard's teeth, the stole folded over the shoulder, and the necklace are the insignia of authority in Kongo, mentioned since the seventeenth century. Identified with a *nkisi*, the chief chews on the bitter root *munkwiza* (as he is depicted doing on the handles of flyswatters previously shown), which grants him supernatural powers. The crossed position of the legs also indicates that this may be an effigy dedicated to a chief.

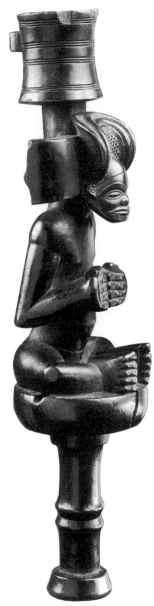

47. Chokwe scepter surmounted by a snuffbox. Nineteenth century. Wood and twisted iron rod. Angola, Chokwe, style of the country of origin. Height: 27.5 cm. Brussels, private collection. The chief, or *mwanangana*, seems to be seated on a seat with a circular top, a form in use before the arrival of chairs of European inspiration. He wears the headdress corresponding to his rank, called *cipenya mutwe*. The top to the snuffbox is missing.

Chokwe artisans gave no attention to the rendering of manufactured insignia or regalia that attest to the sovereignty of their chiefs, except for headdresses, a sign of recognition of royalty. This is very different from the art of Benin, where faces and bodies conform to a single stereotypical model, while costumes and attributes are depicted with an obsessive concern for detail. Chokwe sovereignty seems to manifest itself more in the physical particularities of chiefs, though they are standardized in their morphology, as if the portrait were as much a portrait of gestures as a portrait of feet and hands. The realistic treatment of the members is often replicated in that of the face where, in many instances, an inclination to resemble a real model sometimes surfaces: not only the head, as in Ile-Ife, but the hands and feet as well, which seem to be a physical and mental extension of the head. Among the Chokwe, the exceptional character of the monarch is vested in his physical body, whose vitality and power, we recall, are the guarantors of those of the kingdom.

The same desire for plastic transformation as a function of this corporal model of the extraordinary being of the king or queen is also found in Akan portraits in terra cotta. They are defined by the Akan as true portraits executed to celebrate the memory of important personages, including the king and queen mother, after their death; a few of these portraits retain traces of paint. That custom goes back at least to the seventeenth century, if we are to believe European testimony. During funeral ceremonies, these portraits may have been incorporated into a larger whole that included figurations of servants and courtiers, erected near the gravesite (fig. 54). This is an old custom, as attested in the testimony of Pieter de Marees, dating from 1620, regarding the Fanti royal funeral. He notes that painted clay portraits were set on the graves of all the "Gentlemen" who had served the king.[12] On such occasions, the common people had the right only to decorated pottery, which might also include heads, but whose shape differed radically from that reserved for courtiers. The prototypes of these heads of the common people, which are found among the Akan of Ghana in the wood statuettes of fecundity called *akuaba*, take the form of flat disks on which the bridge of the nose, the arch of the eyebrows, and sometimes the mouth are indicated schematically, by small furrows in relief. These clay heads can also be part of altars. Some were conceived as autonomous objects; others have been uncovered next to remains during excavations, suggesting they were attached to a body that was also modeled in terra cotta.[13]

There is no desire in Akan statuary to individualize the portrait in relation to a specific model. In terms of style, the oval of the face seems to be linked to schemata characteristic of a determinate region and artist: the form of the eyes generally reproduces that of a coffee bean and suggests a gaze from half-closed eyelids. The neck often displays a ringed conformation suggesting folds of fat. Beyond the vari-

ants, the only elements that allow one to individualize the portrait are the form and ornaments of the headdress and the scarifications (figs. 53–61). Other heads, of similar workmanship but cast in gold, serve as sword ornaments or masks among the Ashanti or the Baule (Ivory Coast). One of these gold masks was found in 1874 by the English, during the sack of Kumasi, in the treasury of the *asantehene* Kofi Kakari (fig. 61).

Akan portraits, though they do not demonstrate as marked a tendency toward naturalism as that suggested by the Chokwe or by the Yoruba faces of Ile-Ife, nonetheless attest to a clear desire to transcribe a particular model of the head and face; this model reproduces an aesthetic ideal realized in the very physical conformation of the royal heads. According to custom, in fact, for several weeks after birth, the Akan shaped the heads of young children of the royal house by massaging them, in order to enlarge the skull (Preston 1989–90, 71). Subsequently, certain cosmetics, reserved for princes, completed the modification of their physiognomy. The folds of fat furrowing the neck, already mentioned with reference to the statuary of Ile-Ife, constitute a mark of beauty and health. As such, they were reproduced in royal statuary. That parallelism extends even further: not only are the heads and faces of princes molded in such a way as to attain an ideal form reproduced in the statuary; the shine given to their skin through a mixture of gold dust and shea butter, which they use as a cosmetic, is also rendered through mica dust introduced into the clay. Thus, the terra cotta used for this royal portrait is able to reflect light, just as the face of the living sovereign did. Whether in the portrait or in its model, the same desire is manifested to express the luminosity and brilliance—similar to gold or the sun—of the monarchy, incarnated by the sovereign and his family (Preston 1989–90, 73). Like Chokwe statuary, Akan statuary in clay transcribes the exceptional character of royal morphology. The face and head of the king are molded twice as it were: once during his lifetime, in his body itself at his birth, and then again after his death, in clay. And we should emphasize that it may not be by chance that in both cases this is women's work: it was women who massaged the skulls of newborns, and it was they who then modeled the clay heads.[14]

Until recently—that is, until the use of photography became common—the African portrait was reserved for the king and a few great personages. The workmanship of these portraits, as the preceding examples have shown, always conforms to models in which convention takes precedence over the transcription of reality. It is more important to African sculptors that the formal elements they have extracted from their observation of nature adhere to a consecrated and preexisting model than that they create unique works. If the portrait exists in Africa, it exists within these limits:

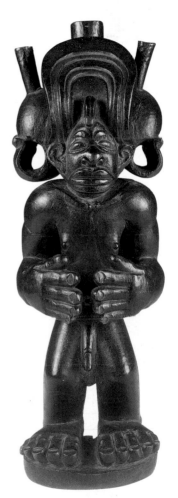

48. Chief's effigy. Nineteenth century. Wood. Angola, Chokwe, style of the country of origin. Height: 35 cm. Brussels, private collection.

it is less the king or chief as individual who is to be represented than certain traits expressing, in an easily recognizable and comprehensible manner, the principal characteristics of royalty inscribed in the king's body—stoutness, youth, muscular vigor—and those closely associated with it—insignia, emblems, regalia. The portraits of chiefs sculpted in wood by the court artists of the chieftaincies of the Cameroon Grasslands do not deviate from the rule, though the style in place in that region seems to allow the rendering of expressive physiognomies. Thus, there is a statue of a seated king from the chieftaincy of Bafoum, holding in his left hand an enemy head, probably cut off with the saber he is brandishing in his right (Paul and Ruth Tishman collection). The king's mouth seems to be open in a laugh celebrating his victory. When one looks at a number of the faces of royal statues from the Grasslands, however, it appears that the motif of lips visibly uncovering the teeth is very popular. Without proposing an extensive interpretation, I might advance the notion that this motif does not stem from an expressionistic transcription, but from the use of a conventional sign expressing royal power. That standardization, which, as we have seen, makes use of various degrees of realism, tends to ignore the individual features of the person. In the case of the naturalistic expressions previously noted, that of the statuary of Ile-Ife for example, the physical appearance of individuals, though imitating reality in certain details, does not necessarily reproduce that of a particular person. The representation of the king's face and body, as in ancient Egypt and many other civilizations, corresponds to forms that have been imposed. Recall that, for these African kings, physical imperfection and infirmity were prohibited; the king's body, as a metonym for the kingdom, was not to be confined by the constraints its human nature imposed on it: eating, drinking, sneezing, harming itself, getting old, dying. As a result, the king's body and face, and, by logical implication, their representation, seem obliged to glorify an ideal vision of man, as an adult in full possession of his physical and spiritual faculties. In his body, the sovereign concentrates the aesthetic aspirations of his people, and in this case, aesthetics closely associates beauty with vigor, force, the harmony of morphology, brilliance, and luminosity. Stoutness, youth, muscular vigor, and peace, qualities present in an object, the king's body—that is, in his portrait—reflect the state of the kingdom. That is what the effigies of these monarchs seem to tell us: the dignified and serene faces of the kings and queens of Ile-Ife, untouched by even the shadow of a wrinkle; the tense musculature of Chokwe chiefs, manifesting an excess of bodily vitality; the calm impassivity of the Kuba *nyim*, residing in a noble plumpness; the sparkle of metal in the heads from Ile-Ife and Benin; and the mica flakes encrusted in the clay of Akan portraits. When an accident injures the person who

represents the kingdom, his portrait is likely to feel the brunt of the blow in turn, if we are to believe Kuba conceptions. The qualities of certain materials such as gold, brass, or copper, and also, to a lesser extent, terra cotta and very hard woods (of which the *ndop*, for example, are made), predisposed them to serve as royal materials. These metals do not rust, thus expressing the incorruptibility of the monarchy, and they shine. In Benin objects of brass and bronze were polished with that aim in view (Ben-Amos 1995, 88).

The perfect symmetry of these faces and bodies also confirms the need for royal perfection; a real or figural dissymmetry in the sovereign's morphology is impossible. Verticality serves the cause of hieratism. The frontal position, in the case of the court portrait, bears a very particular meaning: it underscores the equilibrium and harmony of the parts and imposes on the beholder of the king's effigy a privileged position for viewing, a single point of view, that of the face-to-face encounter, similar to that confronting the visitor during an audience at the palace, even though, as often happens, the sovereign remains hidden. The history of Western sculpture shows that the law of frontality was for a long time the only one known, as if human representation could be inscribed only within a relationship in which the beholder facing the statue was, as it were, in a reflexive position. Note that portraits of African kings and queens depict them without a gaze: the eye sockets are generally empty, and when they are not, as in the case of certain heads from Benin or in Kongo art, the pupil is more a graphic motif than the expression of reality. The representation of the iris and pupil is not a matter of course. In the realm of perception, the iris and pupil "are essentially related to color" (Wittkower 1995); more perhaps than any other part of the face, the pupil and iris are unstable in their form. In the history of Western sculpture, the plastic means to represent the eye appeared during the Hellenic period, when the iris was depicted by a hollow circle in the eyeball, marked by one or two small holes made in the pupil. During the Renaissance, Italian sculptors, perpetuating the medieval tradition, preferred to leave the eyeball empty and unpainted, since they judged it "better lent itself to the expression of general ideas such as sensitivity and compassion, which require that the gaze be directed into space rather than toward a point" (Wittkower 1995, 196–201). The reasons that compelled African sculptors to leave the eyeballs empty in most cases certainly had different sources, linked to, among other things, interpretations on the symbolic order having to do with that part of the eye.[15] Meeting another's gaze is not always without consequence, a view expressed in attitudes of avoidance. Hence, in certain African societies, a great-grandfather cannot look his great-grandson in the eye without the risk of taking his life. Within such a context, the absence of a gaze observed in a

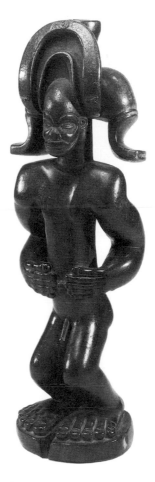

49. Chief's effigy. Nineteenth century. Wood with traces of verdigris in one of the eye sockets, indicating that the eyes were encrusted with brass. Angola, Kilenge, Chokwe, style of the country of origin. Height: 35.5 cm. Lisbon, Museu de Etnologia.

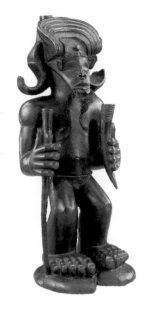

50. Effigy of Tshibinda Ilunga. Nineteenth century. Wood and fibers. Angola, Chokwe, style of the country of origin. Height: 40 cm. Fort Worth (Texas), Kimbell Art Museum.

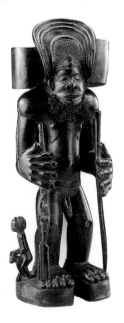

51. Effigy of Tshibinda Ilunga. Nineteenth century. Wood and fibers. Angola, Moxico, Chokwe, style of the country of origin. Height: 40 cm. Porto, Universidade do Porto, Museu do instituto de Antropologia "Dr. Mendes Corrêa," inv. 86.04.03. Copyright Archives Musée Dapper, Paris.

statuary that, in other respects, gives some indications of an attention to the transcription of characteristics of the living man is not insignificant. In fact, the absence of a gaze introduces a feeling of distance and irreducible difference.

Every king is identical in his body to the one who preceded him and to the one who will follow. To commit a particular event to memory, within a context that claims that all reigns succeed one another and resemble one another in their implementation of the same values—prosperity, power, balance—seems to introduce difference where there should be only repetition. Mention of the unique, even through the intermediary of specific details introduced into representation, occurs in Kuba and Edo portraits. Among the Kuba, the *ibol* that adorns the statue's base does not seem adequate to differentiate every king, since several *nyim* chose the same *ibol*. It would seem it was primarily the oral tradition that attributed specific identities to portraits, whose workmanship was invariably linked to the same model. A few distinctive features have sometimes been introduced as if by larceny: the *ndop* of King Mbomboosh stands out because of the inscription of three folds of fat around his neck and a slight stoutness of the torso, reminiscent of his obesity. The case of royal effigies in Benin, where certain *oba* can be identified by the attributes they hold in their hands, again seems peculiar to that kingdom: early contact with the Europeans allowed different *oba*, particularly in the sixteenth century, to acquire a personal power greater than that granted them by tradition. It is within that framework, no doubt, that one must consider a number of these portraits, in which *oba* sought to inscribe their singularity by introducing particular symbols within a representation that remained conventional. If the idea of resemblance is present in some of these kings' portraits, it is to be understood as a resemblance sought with an ideal type, which one also attempts to produce in nature, as the Akan do, for example, by molding the heads of children of royal birth. The desire that an image reproduce the physiognomy and physical characteristics of a real person is in some sense the desire to circumscribe and arrest in a single object the traits and properties of a unique living being. That approach seems foreign to an African conception of representation. To seek to fix in material form the parts of the person that are fleeting and subject to change, such as the manifestation of internal states through the gaze or the muscles of the face, is not at the heart of African preoccupations. One must remember that, even in the recent Western tradition, the portrait is only an approach, an attempt—destined to be ever begun anew—to grasp the physical and psychological qualities of a living person in accordance with plastic and aesthetic criteria, which are in turn very variable. The area where sculptors accurately expressed a desire for resemblance was in the figuration of insignia and

emblems, signs produced, conceived, and mastered by men. These portraits thus remind us that, in the African conception, the human person was not understood primarily as a psychological individual, but was rather defined in the first place in terms of his status in the social and symbolic order. The roles of insignia (demonstrated extensively by the images of the old kingdom of Benin), of headdresses (as all the portraits of African monarchs underscore), and of scarifications (present in the statuary of Ile-Ife and Benin and among the Akan and Kongo), appear more important in defining the individuality of the person. The faces and bodies of kings and queens observed in Akan or Chokwe statuary, and in that of Ile-Ife and Benin, are both different from one another and strangely similar, as if the different versions of a single idea were being articulated in them, the idea of an irreducible totality, the monarchy. Men of flesh and blood, however, are called upon to signify that monarchy, even while the effort is made to reduce their diversity; through these portraits, the singular person of these kings is transfigured, transcended by the consecrated person. The effigy of the king is overdetermined by these signs, these emblems; the logical outcome is that, in certain cases, the effigy disappears in favor of the signs alone. That possibility is found in the art of Benin, in what Blackmun defines as the "emblematic portrait" (see above, note 5), and in Chokwe works of art: the headdress represents the chief. In the art of Benin or of the Chokwe, there is an ostentatious representation of the signs of power, either through the size given them (as in the Chokwe headdress, for example) or in the profusion of details included in the representation. In such cases, the portrait becomes an enumeration.

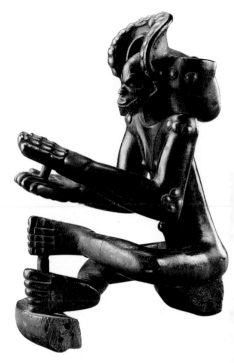

52. Effigy of seated chief. Eighteenth to nineteenth century. Wood, hair, and brass nails. Angola, Chokwe. Height: 25 cm. Brussels, private collection.

Although it is difficult, even impossible, to attribute a singular identity to these portraits, by their very existence they constitute the material traces of a physical continuation of the person for whom they were made. In ancient Egypt, the diorite statue of the Egyptian pharaoh was considered his living double. A comparable idea is invoked in the function of African portraits. The Kuba *ndop*, completed during the king's lifetime, is conceived as a double of the king, and the effigy is the site where the spirit of the king becomes fixed at his death. Among the Akan, the placement of his terra cotta portrait, surrounded by figurines representing the people of his court, in the vicinity of the monarch's tomb attests to a desire to reconstitute the king's environment as it appeared in reality. It is as if, through the intermediary of his effigy, the deceased had to perpetuate after death what he was during his lifetime. In that case as well, it would seem that certain spiritual principles belonging to the king remain present in the earthen figurine erected after his death. Every image is a reality in itself, an indestructible presence; by definition, the reproduction of human morphology as an image (or object) establishes a relation of duplicity

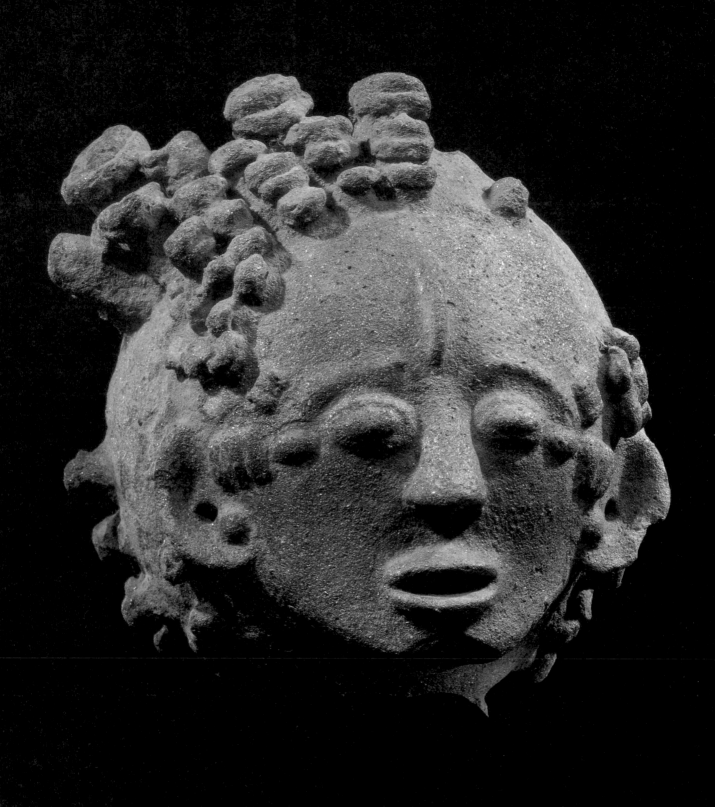

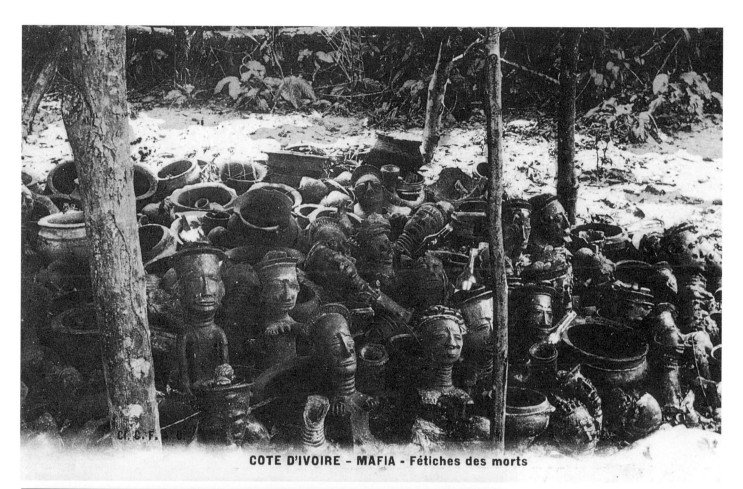

COTE D'IVOIRE – MAFIA - Fétiches des morts

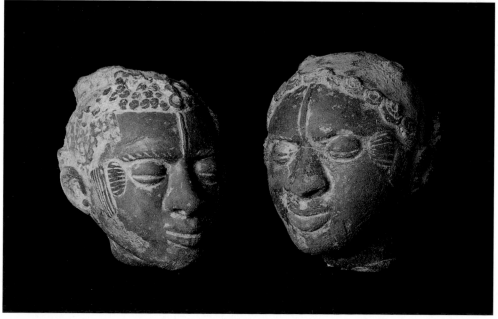

(facing page)
53. Head. Eighteenth century. Terra cotta. Ghana, Akan (probably Adansi). Height: approx. 20 cm. Brussels, private collection (formerly Rasmussen collection).

(above)
54. Depository of funerary effigies in terra cotta. Old postcard. Ivory Coast. Paris, Karen Petrossian collection.

(left)
55. Heads. Seventeenth to eighteenth century. Terra cotta. Ghana, Akan. Height: 18 cm (left) and 16 cm (right). Paris, private collection.

between it and its model. The idea of the double is thus inscribed within every anthropomorphic image or object, and may be even more present in the part of the body that combines the largest number of human traits: the head and face.

The reader may have noted that a number of these royal portraits confine themselves to the head; in addition, as we have underscored, in the case of full-length portraits, the heads are sometimes of disproportionate size. That very particular attention given to the head stems from a certain intellectual projection invested in that part of the human body. We possess some information about Yoruba, Edo, and Akan heads. The Yoruba maintained that a man's head, *ori*, like his body, had both an external reality, *ode*, and an internal reality, *inu*. That internal head, *ori inu*, may be represented in the form of a cone (Drewal 1993, 42). In addition to royal portraits with a tendency toward naturalism, the artists of Ile-Ife left behind representations of these conical heads. That internal head is the seat of thought, character, and patience, the reflective qualities of the person (Drewal 1993, 42). These qualities were likely to dwell in the "external" head, and thus to rise to the surface of the face. The physiognomies of portraits from Ile-Ife reveal these same qualities, inherent in the royal person. Various interpretations have been advanced regarding the function of these heads from Ile-Ife, in particular those made of metal. According to Frank Willett, during royal funerals these heads served to symbolize the continuity of the monarchy during the interregnum (Drewal 1993, 46). The elements of interpretation provided by Henry J. Drewal seem more convincing. He recalls that, in their funerary practices, the Yoruba did not traditionally use the representation of deceased sovereigns, at least not before the twentieth century (in modern times in Owo, for example, funeral mannequins have been used). Upon their death, kings and queens became gods, *orisha*, and their remains were dispersed in certain places that were in no wise tombs. The heads of Ile-Ife, in particular those made of metal, were instead put to use during certain royal ceremonies, when they wore the king's regalia, such as the crown with beaded fringe (Drewal 1993, 48). In that case, the head became a sort of double for that of the sovereign, the seat of all the qualities, already cited, that an adult man ought to possess, and moreover, was explicitly invested with such a function. During the enthronement ceremony of the new *oba* in the kingdom of Benin, a head in terra cotta, bearing the crown of coral beads, was set before the crown prince; this crown was to definitively make him an *oba* (Nevadomsky 1984b, 52). That head was destined subsequently to be cast in metal.

In fact, for the Edo as well, the role of the head, *uhumwu*, was essential. Tradition tells us that the custom of fabricating heads cast in metal comes from Ile-Ife. Among

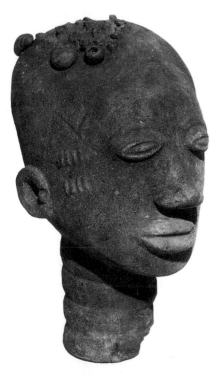

56. Head. Probably nineteenth century. Terra cotta. Ghana, Fomena, Adansi (Akan). Height: 27 cm. London, Museum of Mankind, 1933.12.2.1.

the Edo, the head was the seat of thought, of judgment, of will, of character, of listening, of the gaze, and of speech. In it, the capacity of each person was formed to organize actions in such a way that they brought prosperity to the person governing them. The well-being of a man and of his family depended on his Head (understood here in the sense of a spiritual principle). Among the Edo, there is thus a cult of the Head, in which the latter receives sacrificial offerings in gratitude for the health and prosperity its owner acquires because of it. The head of the family also worships his Head on behalf of the other members of the group; and he takes care of their Heads to assure that they maintain good relations with one another. It is said of a person on whom fortune has not smiled that he has a "bad Head." Every man must concern himself with the cult of his Head; in addition, the *oba* must pay homage to his Head, on which the well-being of everyone depends, at an annual ceremony. During the same rite, the *oba* sends his priest to celebrate the Heads of chiefs through whom he governs. Although every Edo worships his own Head, only the great chiefs, the queen mother, and the *oba* possess altars of the Head (Bradbury 1973, 263–64 and 270–82).[16] Chiefs used heads of terra cotta or wood on their altars. The use of metal heads was reserved for the *oba* and his mother. As seat of judgment and thought, the heads of conquered chiefs were brought back as trophies to the *oba*, who had brass replicas made of them (fig. 37). These heads may have been kept

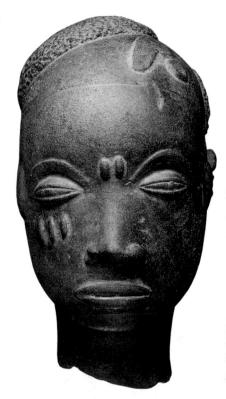

57. Head. Seventeenth to eighteenth century. Terra cotta. Ghana, Twifo or Wassa, Akan. Height: 24 cm. Geneva, Musée Barbier-Mueller, BMG 1009-6.

58. Heads. Seventeenth to eighteenth century. Terra cotta. Ghana or Ivory Coast, Akan. Height: 20.1 cm; Width: 21.1 cm (left). Height: 18.7 cm (right). Tervueren, Musée Royal de l'Afrique Centrale, R.G. 77.18.1 and R.G. 88.17.1.

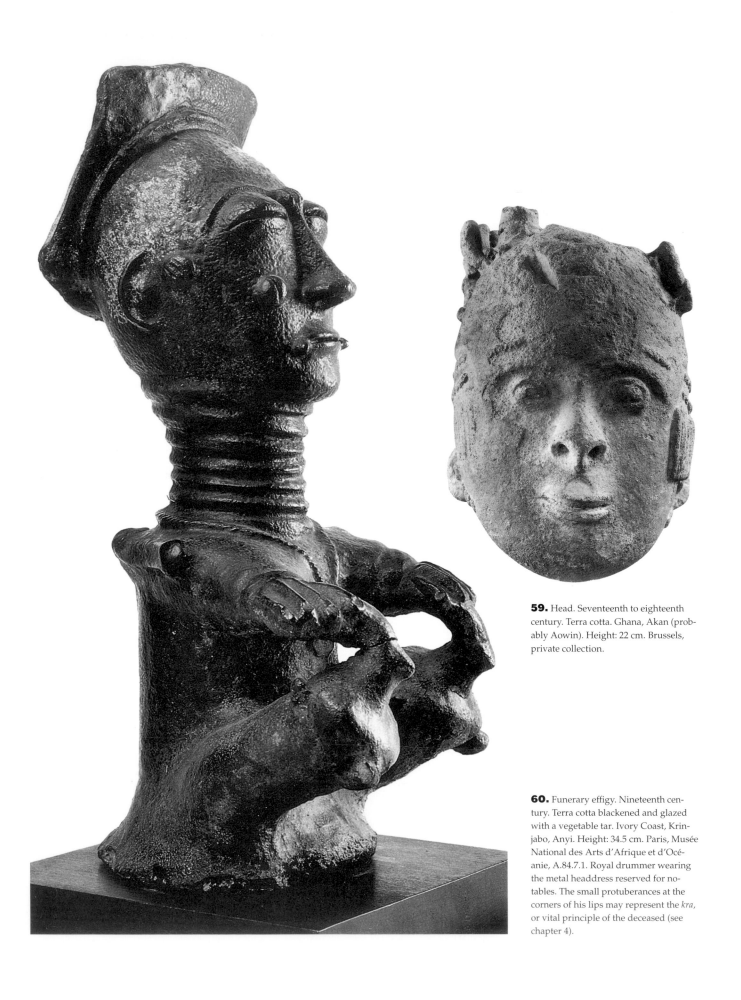

59. Head. Seventeenth to eighteenth century. Terra cotta. Ghana, Akan (probably Aowin). Height: 22 cm. Brussels, private collection.

60. Funerary effigy. Nineteenth century. Terra cotta blackened and glazed with a vegetable tar. Ivory Coast, Krinjabo, Anyi. Height: 34.5 cm. Paris, Musée National des Arts d'Afrique et d'Océanie, A.84.7.1. Royal drummer wearing the metal headdress reserved for notables. The small protuberances at the corners of his lips may represent the *kra*, or vital principle of the deceased (see chapter 4).

on the altar of the ancestors of the kingdom of Benin (Ben-Amos 1995, 22), and the proliferation of commemorative metal heads increased the *oba*'s prestige and power (fig. 80).[17]

The brass heads of *oba* or queen mothers resemble one another to such a degree that they all seem to have come from the same mold. The model barely changes at all over the five centuries of fabrication. Only the number of rows of necklace beads and a few elements of the headdress undergo transformation, allowing us to identify them chronologically. Since the "internal heads" of the *oba* are filled with the skills and qualities required of royalty, the "external heads"—the portraits—give material form to the existence and nature of these qualities, through their regular, harmonious, and unchanging human features. The same observation is valid for the portraits of Ile-Ife or the Akan portraits in ceramic. The serenity that marks them, the symmetrical regularity of their features, reflect the necessary peace of mind of their royal models; in this sense, the king ought to resemble his portrait. The royal children of the Akan learn from their earliest years to master their facial expressions and gestures, and to suppress the singularities of their character in order to adhere to this model of impassivity (Preston 1989–90, 76). For similar reasons having to do with the importance granted the "internal head," the heads, cast in brass, of enemy chiefs killed at war were shown the same deference. An eighteenth-century observer in Dahomey described a similar custom there of keeping trophy heads. He relates the conversation he had on this matter with King Kpengla. The king, displaying the mummified head of an enemy king he had conquered, said: "This is a man who gave me so much trouble . . . I am myself a warrior, and if I had to fall into the hands of the enemy, I would wish to be treated with the same decency I exemplify" (Mercier 1962, 118). The trophy head is the portrait's most radical and perhaps most complete expression. The problem of resemblance or adequation to the model is no longer raised, nor is that of representation. The image and the reality it invokes are now the same.

61. Head. Eighteenth to nineteenth century. Gold, lost-wax casting. Ghana, Akan. Height: 18 cm. London, Wallace Collection. This head was part of the treasury of the *asantehene* Kofi Kakari (1867–74). It may have served as a sword ornament, since the Ashanti had the habit of adorning the blade with gold figurines; the heads may represent those of the enemy chiefs killed during the battle.

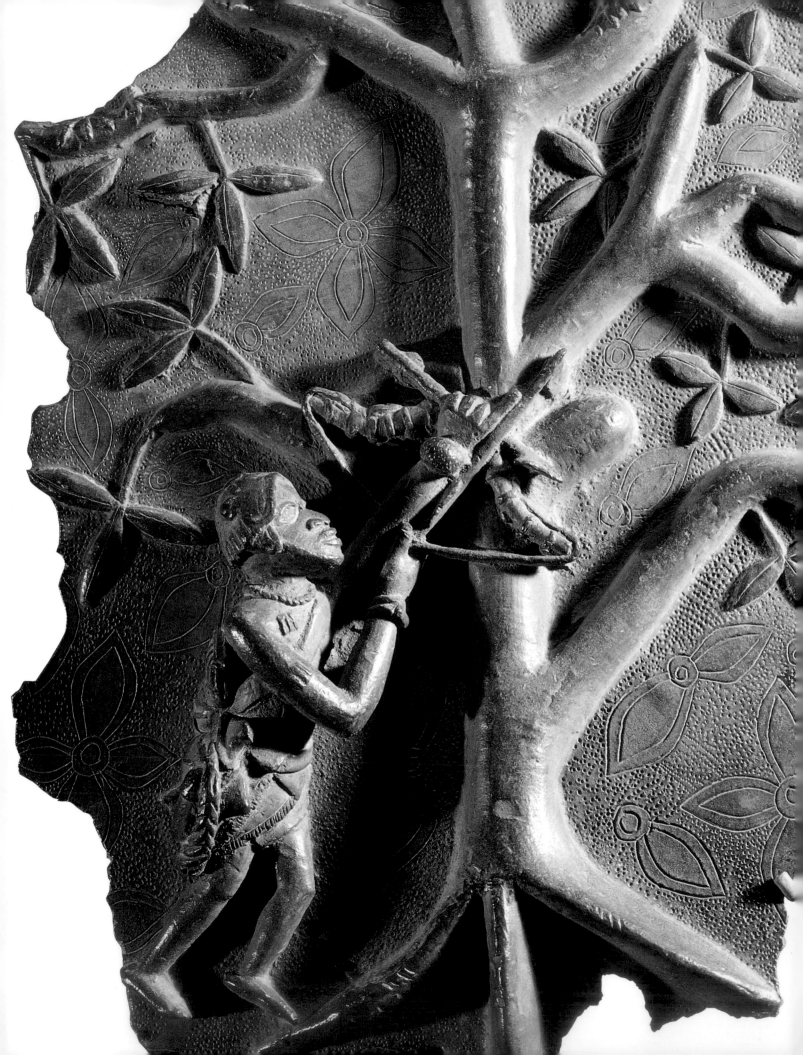

CHAPTER THREE
History Told in Images

African iconography includes few examples of images, whether on a plane surface or in the round, where one or several figures are depicted carrying out an action. In terms of this mode of expression, there is nothing in Africa comparable to Egyptian, Mesopotamian, or Roman creations. The scenes found on brass plaques from the kingdom of old Benin or in the hangings of the kingdom of Dahomey are not so different from these Western forms in the intention they reveal, however. For the most part, it is their composition that differs: less descriptive, and thus less realistic, they do not unfold across long frescoes where scenes are linked to one another, a layout that may be specific to peoples familiar with writing. In this area, tradition dictates that the figures, whether they belong to the animal or the human world (with all degrees of transition possible from one to the other), be represented in an irreducible singularity. When there is a group of effigies, in statuary for example, it is generally the result of a juxtaposition of particular units brought together in one place, a place of worship most often, in an order established by a series of ritual acts. The objects are arranged as a function of these acts. The form these effigies take is not conceived in terms of a relationship with other effigies, in order to produce a scene with a narrative aim. African representations privilege man and certain animals and they grant a very particular importance to the living, upright man. Like the sculptures of gods in ancient Egypt or those created by Giacometti, they are fixed in the most radical verticality, and in a frontal, face-to-face relation, whose essential role in the royal portrait has already been noted. The plant world and that of manufactured objects appear only rarely in iconography, except in the form of abstract symbols having only a remote resemblance to reality.

In the African context, "narrative" denotes a visual expression seeking to transmit information about particular persons and events.[1] What was banished from traditional iconography, described above, such as the world of plants and objects, finds its place here, not as mere ornamental decoration, but as a significant element within the scene depicted. It is interesting to note that, within the sphere of influence of these court arts, a popular art sometimes developed that used the same realist reference points. In addition to the Yoruba statuary of Nigeria and the banners of the Fanti military companies of Ghana, we might cite in this context an older art, such as that of Djenné, which offers numerous cases of a figuration of events involving one or several characters using a rich body language (see p. 152). There are scenes of childbirth, figures presenting offerings, and an astonishing representation in which a man, armed with a knife held in his right hand, stands pressed against the neck of a large animal of indeterminate species, while another man kneels under the beast's belly, both hands over its mouth.

(previous pages)
Detail of figure 75.

(facing page)
62. House porticos sculpted in wood in high relief. Cameroon Grasslands, 1930. Paris, photo library of the Musée de l'Homme. The scenes depicted tell of a victorious chief's return from battle.

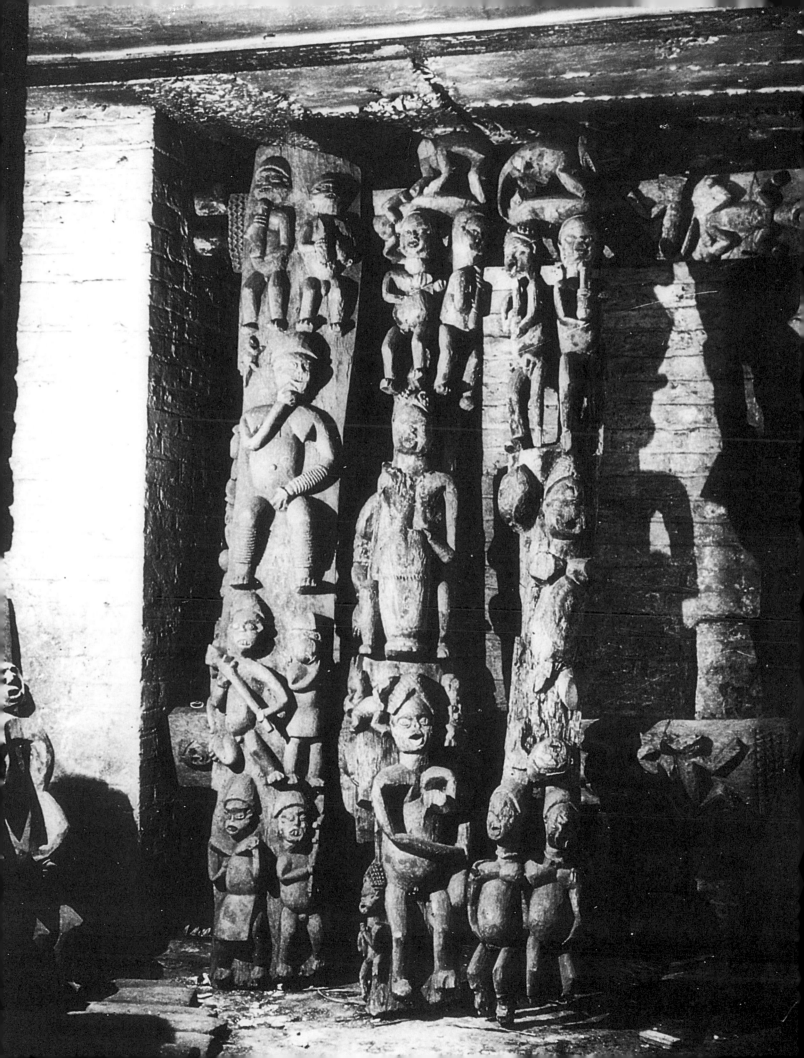

63. Bas-relief in painted clay from the palace of Abomey. Benin, Abomey, Musée Historique. Photo by Giovanna Antongini and Tito Spini. Throne of King Guezo resting on the severed heads of his enemies. Right, the royal *recado*.

64. Bas-relief in painted clay from the palace of Abomey. Benin, Abomey, Musée Historique. Photo by Giovanna Antongini and Tito Spini. A Fon warrior cuts off the head of a "Nago" enemy.

I shall consider two types of narrative figuration, each of which follows a slightly different path, though both have the primary function of celebrating the king's or chief's power. The art of the kingdoms of Benin and Dahomey in particular, and one aspect of the art created for the Ashanti aristocracy, reveal a desire for commemoration, the desire to translate into images the monarchy itself and certain important moments of court life, through figurations of the sovereign and members of his entourage. In contrast, Chokwe court art, in alluding to scenes inspired for the most part by everyday or ritual life, proposes a different interpretation of the royal function.

The kings' palace of old Benin, before its destruction in 1897, was probably comparable to a veritable monument raised to the sovereigns' glory. The copper and brass plaques that covered its walls celebrated in a repetitive manner—numerous motifs and scenes are reproduced in identical form on different plaques—ceremonies and wars, victory, power, and the divine nature of its royal occupants. Bas-reliefs in painted clay and hangings with appliquéd motifs in the palaces of Abomey (present-day Benin) had a comparable function, and there the military exploits of the Fon are described in more detail than they are among the Edo. The message remains the same, however: we are given to understand that the king's power is commensurate with his valor in war. One recurrent motif is that of the warrior cut in two by the victor's saber. That iconographic depiction has some relation to certain of the arts named above—Egyptian, Assyrian, or Roman (Trajan's Column and Arch in Rome)—in which a transcription of the idea of royalty is associated with the figuration of war activity.

A monument is a work of art "constructed with the precise aim of keeping the memory" of a particular action and destiny "in the consciousness of future generations" (Riegl 1984, 35). The palaces of the capital of old Benin and those of Abomey are monuments with a value of remembrance and perpetuation of the monarchy, which, on principle and in its very essence, is renewed in a cyclical and continuous manner. When we consider the art of the kingdom of Benin over the five centuries of its history (from the fifteenth to the nineteenth century), we find the style varies very little, given the time elapsed. The image of royalty appears unified and indivisible. "Remembrance" is a constant preoccupation among these monarchies of western Africa—the Fon, the Edo, and the Akan—and, in that sense, narrative representation seems to be the system of expression best adapted to that aim. Even today, on certain occasions, Fon custom dictates that court chroniclers, *kpaliga*, sing praises of the kings and the great events of the kingdom, five times each day; the *kpaliga* recites his text while moving around the walls of the palace, along a path fixed by tradition,

stopping at certain places. These sites have now been transformed into vacant lots. With his litanies, he reincarnates both them and the walls that once stood there and that are no longer recognizable (Antongini and Spini 1989, 24–25). Echoing the words of the *kpaliga*, bas-reliefs emerge from the earthen walls of the palaces of Kings Guezo and Glele, evoking the great deeds of the Fon monarchy. The image remains to reflect the words. In the same way, the Edo and the Ashanti manifest a desire to celebrate that historical past. Not only are the walls of the palace historiated, but objects are as well: pectorals, pendants, rings, bracelets, hip ornaments, seats, boxes, and lamps. Courtiers lived in remembrance of royal power and in the commemoration of history. This concern with celebration nonetheless transcended the walls of the palace and the proximity of great men, moving into language, in the form of proverbs, popular narratives, and songs.

"The blade does not pierce the elephant, / Fire does not consume the king's home," claims a Fon war chant, reminding us that the elephant was the emblematic animal of King Glele (Mercier 1962, 211). Another chant, this one a court chant, declares: "All animals have ears, / But the ears of the elephant are larger than all other ears." The image of the elephant recurs in other contexts, such as the ornamentation on calabashes, related to proverbs that express affection or love toward a person. In that situation too, invincibility is requisite—namely, the invincibility of the lover. The animal motif might then evoke the following proverb: "When elephant passes, all the animals hear the noise of its steps. / I fear no one and all the world will hear me" (Preston Blier 1991, 101 n. 13).

The scenes that adorned the walls of the palace of the kingdom of Benin, and those still visible in Abomey, were, or still are in the second case, organized into juxtaposed compositions of between fifty and seventy centimeters per side. It is impossible today to know whether the layout of the plaques in the Edo kingdom followed a precise order, a reading sequence comparable to that found in the art of religious buildings during the European Middle Ages. Nor do the depictions found on the bas-reliefs from Abomey seem to follow a particular order. Everything leads us to believe that, although the series of images refers to the universal history of the kingdom as a whole, that whole is understood as a sum of events added together, which always hark back to the figure of a sovereign or the emblem that signifies him, two recurring motifs in iconography.

The realist and narrative style, the composition, and the format of the Edo plaques led certain authors to infer a European influence. The oldest plaques, in fact, date from the fifteenth century;[2] as it happens, the Portuguese reached the capital of the kingdom in 1472, and, during their later visits, attempted to spread the

65. Bas-relief in painted clay from the palace of Abomey. Benin, Abomey, Musée Historique. Photo by Giovanna Antongini and Tito Spini. An "Amazon" transports the enemy she has just killed.

Catholic faith. Very quickly, a hybrid art developed, called Bini-Portuguese, when new arrivals used the talents of Edo ivory carvers to produce objects destined for the houses of European princes. The Edo became familiar with the pictures illustrating the books brought by missionaries and merchants, and may have reproduced certain of their features. Nothing can be proved in this matter regarding the brass plaques.[3] All we can say is that, in the course of the sixteenth century, Edo artists used modes of expression with a perspectivist tendency, and that it is possible to imagine that their model was European images. In addition, the ivory carvers were fully capable of copying scenes, in particular hunting scenes, from pictures brought by the Europeans onto objects destined for export. Numerous examples of animal horns demonstrate this. But although Edo artists may have been inspired by these images, they did not replicate their composition or style in court art works. Artists in the service of the Kongo sovereign also had prolonged contact with Europeans and their images, beginning in the fifteenth century, but they did not produce art works displaying related rules of expression. In that case, only sculpture was adapted from European canons, in the relative realism of facial expressions and bodies and in certain motifs very clearly inspired by European iconography (fig. 43).

Several types of representation are found on Edo plaques. Some depict individuals from the court or animals: big cats, fish, or birds. Each plaque contains only a single effigy of man or animal, so that the juxtaposition of these plaques is reminiscent of pictures in a catalog. A second mode of representation depicts the *oba*, great chiefs, and individuals acting in the service of the sovereign. A third, more complex mode evokes particular moments in the political or ceremonial life of Edo royalty. The background of these plaques is always adorned with carved motifs, the most frequent being a form of "flower" with three or four "petals" (figs. 67–69).[4]

The position of human figures within the space of the plaque varies as a function of the individual's status in Edo society. All figures are depicted full length, standing, and almost always frontally; this is very different from the Egyptian rule dictating that man be depicted with his head in profile and his torso facing the beholder. In African iconography, a reclining man is a dead man; representations the Fon made of their enemies depict them on the ground, in the position of the vanquished. In contrast, on Edo plaques, men stand to their full height, as a large and motionless crowd facing the beholder; on certain plaques, these figures of every size invade the surface to the point of saturating the space. It is as if, through that effect of dense juxtaposition, Edo artists sought to express the power and vitality of the kingdom by depicting their great number (figs. 72 and 73). Sometimes the artist has carved them kneeling, a sign of deference toward the king. Only the *oba* has the right

to the seated position, on a throne or horse (fig. 68). The depiction of these individuals is conceived symmetrically, even when the median axis of the composition implied by that type of division is slightly off center, as in the representation of an action. Every image has a principal figure, either isolated in the center of the plaque or surrounded by other figures smaller in size. Numerous plaques have two identical figures.

The central figure in the image is the main protagonist of the scene, in general the *oba* or a great Edo chief, such as the *ezomo*, one of the two supreme commanders of the kingdom. That principle of placing one figure, often of great height, in the center of the image along a symmetrical axis appears to be a fundamental model of composition, since it is found in other, three-dimensional media, such as the altars to the Hand, called *ikebogo*, as well as altars dedicated to the queen mother (fig. 70), bells, pendants, and so forth. There is one example of a plaque, however, that appears to propose a different solution. This is a representation of the palace entryway. In the center, three steps lead to a door topped by a pyramid roof on which the body of a python slithers (fig. 71). On each side of the door stand two guards and two pages equipped with fans. The center of the image seems to be occupied by a void. The figure of the python, however, provides the key to the interpretation: the python represents Olokun, the god of waters, the counterpart in the aquatic world of the *oba* on earth. The Edo sometimes call the python *omwansomwan*, "one man surpasses another" (Ben-Amos 1995). The downward orientation given to the head of the reptile suggests that this empty central space, in the center of the palace door frame, is that occupied by the *oba*, the man who surpasses all others. This model of an image organized around a center is found again in the Fon hangings of Dahomey. Among the Edo, it is closely associated with the principle of symmetrical organization, used to express the idea of a sovereignty resting on a strongly hierarchical society, at the summit and center of which sits the *oba*, the true axis of the earthly world. The consequence of that logic of representation is that every figure located in the center of the image refers to the *oba*, even if it does not represent him directly.

The *oba* is only rarely depicted by himself. Certain images show him with legs curved in the form of silurids. On one of them, the shape of the silurids' bodies replicates that of the sovereign's arms, which hold two leopards by the tail, as if he were preparing to spin them in the air (fig. 69). The arrangement of the arms and legs on either side of the king's body and their positioning in the space of the plaque are perfectly symmetrical. This is a symbolic and emblematic representation of the sovereign's divine powers: a sort of double of Olokun, god of waters, he bears the sign of that god in his fish-shaped legs.[5] As an earthly sovereign, he brandishes two

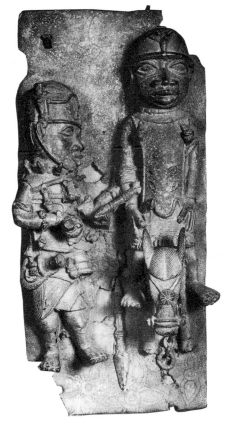

66. Plaque from the *oba*'s palace. Sixteenth to seventeenth century. Brass, lost-wax casting. Nigeria, kingdom of Benin, Edo. Height: 40 cm. London, British Museum, 1898-1-15-47.

leopards, symbols of his power in this world. The leopard motif is very often de-
picted in the court arts of these regions. The Ashanti have a tendency to represent it
as well, as an attribute of royal power; the lids of certain objects, boxes called *kuduo*,
are frequently adorned with a scene depicting a feline in the process of killing an
herbivore (fig. 85).

More often, figurations of the *oba* depict him attended by two individuals, on his
left and right. These figures, as we have seen, are sometimes kneeling beside him
and supporting his forearms, a gesture still in use today in certain ceremonies
(fig. 68); at other times, they shelter him from the sun with their shields held above
his head (fig. 67). That scene is also found on altars dedicated to queen mothers, but
rendered in three dimensions (fig. 70). This type of triad composition is used with
other individuals, such as a war chief flanked by his two musicians or a king's envoy
accompanied by his associates. In the case of representations of the *oba*, the triad
produces a visual effect with great descriptive power. In the center stands the king.
On either side, slightly smaller—as a function of the codification that dictates that
the size of the figures be proportionate to the rank they hold in society—two other
figures, by dint of the place they occupy in the image, manage to give weight to that
triangular composition, whose summit is the king's head (fig. 68). Could there be a
more pertinent expression of royalty *in majesty*? The artists of the Romanesque era
used the same technique when they sought to celebrate the glory of Christ in the
tympana of churches.[6]

Among the images conceived by Edo artists, some depict scenes with figures
other than the *oba*, scenes in which they are, as it were, captured in mid-action. Note
in this regard that the *oba* is never depicted in that manner; seated or standing sur-
rounded by chiefs, pages, or warriors, his forearms supported, or with regalia in his
hands, he seems destined never to depart from the hieratic attitude proper to him,
immobilized in a codified gesture that makes him immediately recognizable. To de-
pict action, the Edo used other individuals from the royal entourage and other
scenes besides those in which the king appears in majesty. Thus, there are numerous
representations of musicians playing or of merchants sent by the *oba*, preparing to
exchange their merchandise with the Europeans. A few rare scenes depict moments
of ritual life, reminding us that the palace was at its center; others depict the Edo in
battle, while still others show hunting expeditions. The figuration of movement also
exists in statuary, in particular that dedicated to portraits of Portuguese soldiers
handling their guns.

Of the battle scenes, one is repeated numerous times: it depicts a war chief, iden-
tifiable by his necklace composed of leopard's fangs pointed toward the sky, a bell

hanging from his neck, and the head of a leopard adorning his costume. These three attributes were designed to protect him during battles. This war chief is accompanied, as is only right and proper, by his retinue, including horn players; his sword is unsheathed, and with his free left hand he is seizing the arm or neck of an enemy on horseback (fig. 73). The enemy is easily recognizable by the scarifications cut across his cheeks, which contrast with the smooth face of the Edo.[7] The fact that he is seated on a horse indicates he is probably a chief. The enemy chief is portrayed in three-quarters profile, since, quite logically, frontality is reserved for the Edo chief. Another plaque shows an identical scene, but with the roles reversed as it were: the enemy chief and his horse are figured frontally and the Edo warrior is shown with his body in three-quarters profile and his head in profile. Since the enemy warrior is on horseback, the Edo is lower than his enemy (fig. 66). In this last example, the image gives preeminence to the enemy chief. In both cases, theatrical techniques are employed, especially in the second image, which uses the artifice of a play of gazes: the Edo warrior has his face turned toward the captured enemy chief, who is depicted frontally, a position that in Edo art signifies strength. Two other scenes depict rites: in the first, a cow is being sacrificed (fig. 72); in the second, two figures cling to ropes hanging from the branch of a tree (fig. 76). In the first image, all the figures are facing the beholder, except an assistant on the right, depicted in three-quarters profile; he seems to be holding the mouth and nose of the animal shut. The cow is seen from above, its four hooves spread apart and held by four assistants. In the second image, acrobatic dancers move around ropes attached to the branches of a tree, at the top of which are perched two birds, their wings spread as if preparing to take flight.[8] The symmetrical organization of the image is respected in this case: the two dancers are on either side of the central tree trunk, whose upper branch serves as a perch for the three birds placed at the top (note the use once more of the number 3). The gestures of the two figures and the movements made by the ropes, however, break the regularity of the composition. Although we may deduce that the mode of gripping and manipulating the ropes was strictly codified, the impression produced by the spectacle is of a fanciful and disorderly portrayal of the details of reality, which seem to irrupt suddenly in a space frozen by the symmetrical order.

Hunting is also a recurring theme within the Edo iconographic corpus. One image shows us a European wearing a morion on his head, his bow pulled back and pointed toward the sky, the arrow ready to sail toward a group of birds perched at the top of a tree (fig. 75). The tree trunk divides the space of the image vertically into two equal parts; its roots, three in number, are also drawn in perfect detail. The hunter is seen in profile.[9]

Among the representations on the plaques just discussed, a few manifest a real effort to express certain details as they are grasped by the experience of perception. I have described the figuration of movement; there is also an effort to transcribe depth, through a perspectivist rendering in space of the objects that inhabit it. The plaque depicting members of the court standing on either side of the palace entryway attests perfectly to the intellectual approach followed by Edo artisans, in their effort to express the presence of man in a measurable, masterable, and hence representable world. Man appears framed by the elements of real space, the architecture of the palace (fig. 71). Jean Laude has pointed out that desire to transcribe details linked to the experience of depth, "in which the elements located in a three-dimensional space are staggered along a vertical axis" (Laude 1988, 146). Even though, in accordance with this principle, the figures are all in the foreground, the approach is clearly perceptible. Thus, the scene of putting the cow to death, also described by Laude, is shown frontally, at least for the four lower figures, from above for the cow, and in accordance with vertical staggering (the superposition of different heights) for the figures that, in the real scene, would have been located behind the animal (fig. 72). The conjunction of these three systems transcribes the third dimension in a manner obviously very different from classical perspective, which is illusionist in its principles; it does not so much transcribe the view an onlooker might have of the real scene as the particular view of each of the actors in the ritual. Hence, the animal is shown from above so as to bring out the strange position it has been put in to be killed, its legs spread apart, a position that anticipates the form its hide will take once it is tanned.

Although we lack information about the ceremony shown on that plaque, it is possible that the original position of the victim had a meaning that was sufficiently important to the artist to have led him to spread its body over that large surface. Another example obeying the same rules is a plaque depicting a drummer (fig. 78); all his instruments, writes Laude, "are depicted from bird's eye view, arranged in a semicircle around the musician" (1988, 146). Another plaque shows two members of the guild of leopard hunters, their arms laden with arrows. Between them, two captured leopards are represented lying on the ground, their mouths gagged and their legs bound (fig. 74).[10] Certain small details manifest a great concern for accuracy on the part of the sculptor: the leopards' tails are not identical, nor is the movement of the ropes that hold them prisoner. Once more, the disordered or unexpected aspect of reality finds its place. Although the animals are seen from above, like the cow in the ritual previously described, the hunters are presented frontally, not motionless but captured in a movement that suggests running. The hunter on the left, slightly larger than the other, seems to be coming toward us.

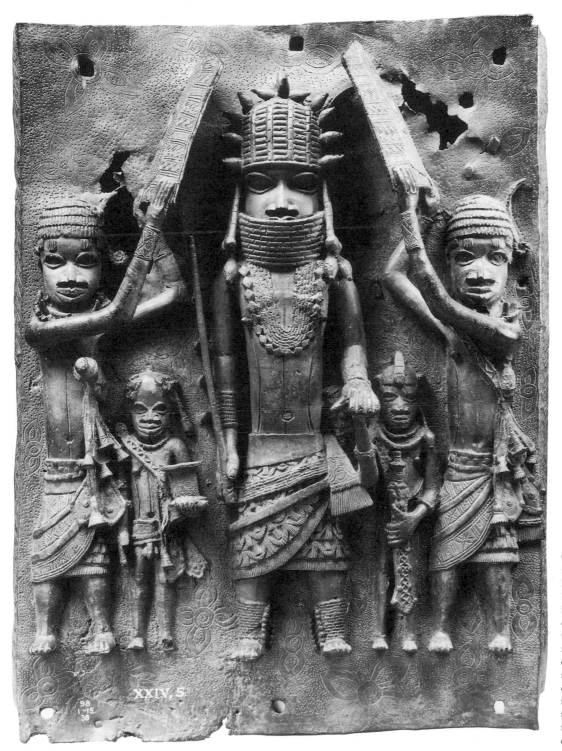

67. Plaque from the *oba*'s palace. Sixteenth to seventeenth century. Brass, lost-wax casting. Nigeria, kingdom of Benin, Edo. Height: 42 cm. London, British Museum, 1898-1-15-38. The *oba*, accompanied by two warriors holding up their shields. One of his assistants carries a box, *ekpokin*, serving to transport certain ceremonial gifts. This may be a representation of the ritual called *igue*, during which the *oba* receives presents from the *oni* of Ile-Ife, which are brought to him in a box of this type. The essential function of *igue* is to reinforce the powers of the sovereign.

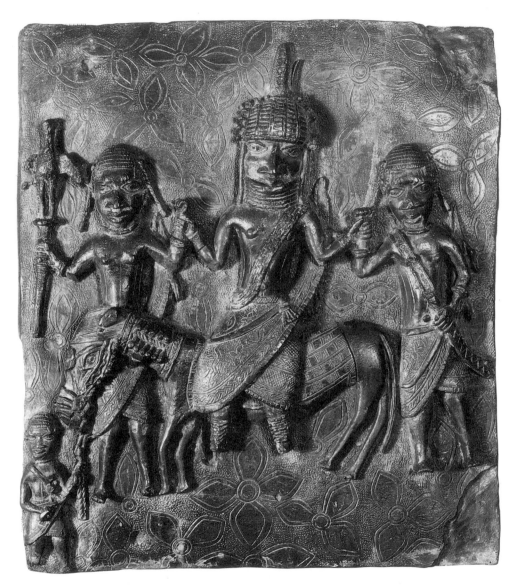

69. Plaque from the *oba*'s palace. Sixteenth century. Brass, lost-wax casting. Nigeria, kingdom of Benin, Edo. Height: 39.5 cm. London, British Museum, 1898-1-15-30.

68. Plaque from the *oba*'s palace. Sixteenth century. Brass, lost-wax casting. Nigeria, kingdom of Benin, Edo. Height: 43 cm. London, British Museum, 1898-1-15-44. Return of the *oba* Esigie from war against the Igala.

70. Altar dedicated to a queen mother. Seventeenth to eighteenth century. Brass, lost-wax casting. Nigeria, kingdom of Benin, Edo. Height: 34.3 cm. New York, Metropolitan Museum of Art, Gift of Mr. and Mrs. Klaus G. Perls, 1991.17.111.

The Edo image, in integrating an expression of depth, manifests the awareness artists have had of the existence of that quality of space, of its structuring role, and of the possibility of expressing it as an autonomous fact. The image, however, is still conceived in terms of the dimensions of the object represented and not from the point of view of an observer outside it. Each figure—generally human—displayed on the plaque forms a singular totality whose integrity is respected. There are only rare instances where a figure is not seen in its entirety. Such is the case for a plaque on which the artist chose to represent frontally the horse on which the enemy chief sits, so that only the head and forelegs are visible (fig. 66). The figures overlap as little as possible, since the artist is seeking above all to grasp the reality of the being or object; and, in reality, every thing exists for itself, as a totality. Within such a system of thought, to hide part of that totality in favor of an overall representation would be to call into question the very integrity of the object or creature represented. Finally, as we have seen, the dimensions of figures are calculated on the basis of particular symbolic investments: the *oba* always has to be slightly larger than those around him, and there is no diminution of the size of figures as a function of their distance. Another factor is no doubt determining, however. It is revealed in the desire of Edo artists to show human figures in their integrity, independent of the place they occupy in real space. In a rite such as that depicted in the scene of the cow sacrifice, each participant occupies a particular place as a function of his position in society and the role he has to play in that particular rite. Holding the back left hoof is not the same as holding the animal's head. When we examine the image, we see that the actors in the scene are not portrayed identically, but are differentiated by their headdresses or the ornaments they are wearing. The representation of a space in which the figures are staggered along vertical axes not only corresponds to the Edo's desire to respect the symbolic integrity of persons by making them perfectly visible, but also expresses a desire to represent the hierarchical principles governing the relations among the participants and to recall the rules of that division of roles. The Edo of old Benin attached so much importance to the expression of these values that, in other images, where groups of figures are combined, the same intention to assign each the exact place falling to him is manifest (figs. 68, 70, and 71).

The representation of movement, which, in the Edo image, breaks the rule of frontality, also creates distortions, by introducing body parts seen in profile or in three-quarters profile. The face-to-face relation imposed on the observer of these images in most cases, with the *oba* standing in the center, symbolically encloses that observer within the field of vision of the effigies represented. Conversely, when the

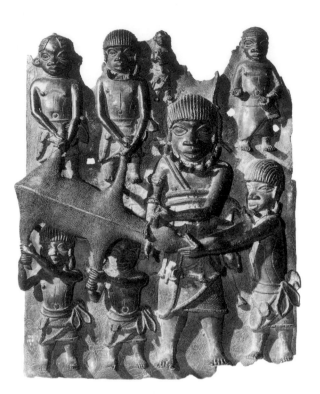

71. Plaque from the *oba*'s palace. Sixteenth to seventeenth century. Brass, lost-wax casting. Nigeria, kingdom of Benin, Edo. Height: 52 cm. London, British Museum, 1898-1-15-46.

72. Plaque from the *oba*'s palace. Sixteenth to seventeenth century. Brass, lost-wax casting. Nigeria, kingdom of Benin, Edo. Height: 51 cm. London, British Museum, 1961. AF 18.1.

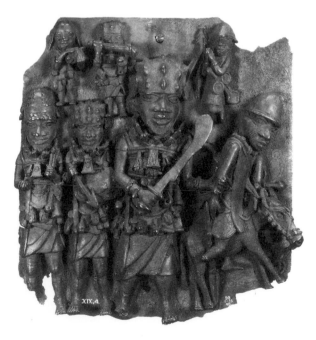

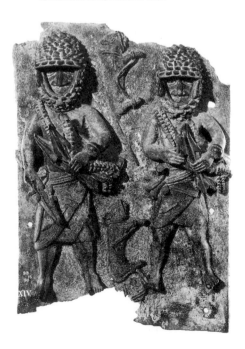

73. Plaque from the *oba*'s palace. Sixteenth to seventeenth century. Brass, lost-wax casting. Nigeria, kingdom of Benin, Edo. Height: 47 cm. London, British Museum, 1898-1-15-48.

74. Plaque from the *oba*'s palace. Sixteenth century. Brass, lost-wax casting. Nigeria, kingdom of Benin, Edo. Height: 43 cm. London, British Museum, 1898-1-15-80.

gaze and body make the gesture of turning away, a distance is introduced between the beholder and what is represented in the image. Traces of that distance can be found in the effort manifested by Edo artists to transcribe the third dimension. But the distance imposed by any objectification of the relation to the world is still relative. The carved backgrounds of the plaques, which form a single plane to which the third dimension is definitively relegated, are sown with "river leaves," the leaves of the universe of the god Olokun, which allude to the symbolic and mystical space of the god encompassing the earthly domain in which the *oba* reigns. The Edo attempted to reduce the diversity of the things of the world by depicting only those that were part of the royal person. The function of the king's body or of the bodies of those who represent him—priests, emissaries, and warriors—is to contain the plurality of matter and of the universe. It is a symbolic place, a metonym for the kingdom, and hence for the world. The kingdom's existence, however, is part of a greater totality, an infinite and immeasurable continuum, the symbolic and mystical universe of the god. The figures on the plaques of old Benin are not supported by anything: their feet float in the void, and they seem to emerge or rise up from the depth of the relief, out of that background of "river leaves" that holds them. Sometimes, as if to underscore further their rightful place within that universe of the god, the figures wear the same "river leaf" motif on their pagne. It is difficult today to know how the ancient Edo viewed these images. The artistic choices they made, however, suggest a few paths of interpretation and reveal a part of the intellectual conception at work behind these figurations. The mode they adopted for transcribing space was shared by peoples of antiquity and by Egyptians, who have already been discussed at length. Some of the figurative traits used are also shared with Byzantine art of the Middle Ages, which nonetheless stems from a very particular tradition. Byzantine artists sought first to offer the person contemplating the form represented on the image an intellectual vision of the supersensible world—that is, of the divine. However, the function of the gold background in Byzantine mosaics is not unrelated to that of the "river leaves" background of Edo plaques. In each case, space has a homogenizing function: gold manifests the light of the Christian god, and river leaves symbolize the waters of another god, born on the banks of the Gulf of Guinea.

The iconography of Benin provides only one scene referring to a precise historical event; I described it in part in the previous chapter. In it, an *oba* is seated sidesaddle on a horse, his arms supported, as etiquette dictates, by two assistants, one of whom holds a staff in his hand. A bird with wings spread is perched at the top of the staff, similar in every respect to those seen perched in the branches of the two plaques already described. One small figure at lower left leads the horse by a bridle (fig. 68).

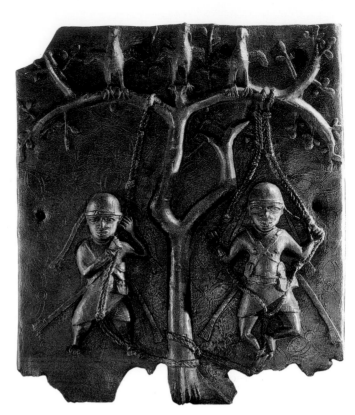

75. Plaque from the *oba*'s palace. Sixteenth to seventeenth century. Brass, lost-wax casting. Nigeria, kingdom of Benin, Edo. Height: 45.7 cm. Berlin, Museum für Völkerkunde.

76. Plaque from the *oba*'s palace. Sixteenth century. Brass, lost-wax casting. Nigeria, kingdom of Benin, Edo. Height: 43 cm. Nigeria, Lagos, National Museum, 48.36.40.

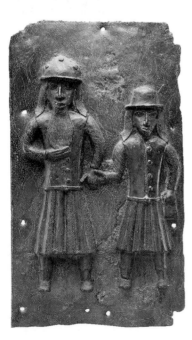

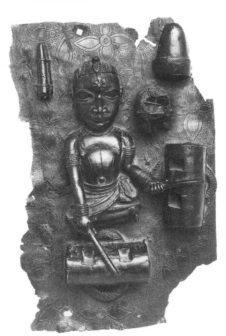

77. Plaque from the *oba*'s palace. Sixteenth to seventeenth century. Brass, lost-wax casting. Nigeria, kingdom of Benin, Edo. Height: 52.1 cm. New York, Metropolitan Museum of Art, Gift of Mr. and Mrs. Klaus G. Perls, 1991.17.18. Two Portuguese against a "river leaf" background.

78. Plaque from the *oba*'s palace. Sixteenth to seventeenth century. Brass, lost-wax casting. Nigeria, kingdom of Benin, Edo. Height: 51 cm. London, British Museum, 1913.12.11.1.

That *oba*, we recall, has been identified as Esigie, fifteenth king of Benin, who reigned from the early sixteenth century. Aided by his mother, Idia, Esigie waged a merciless war against the Igala people, whose territory extended to the northeast of the kingdom, on the opposite bank of the Niger. The *ata* of Idah was reduced to a state of vassalage, and Benin was able to secure control of that navigable waterway, necessary for its commercial activities (Ben-Amos 1995, 35–37). The scene represents a victorious Esigie returning from the battlefield. The presence of the bird alludes to one episode of the event, from the legend already mentioned, in which Esigie, on the way to war, came across a bird, "the bird of prophecy," who predicted his defeat. The *oba* had the bird killed on the spot, and won the battle. In that way, the sovereign dared to defy destiny itself. Upon his return, he ordered the royal smiths to create an object—an idiophone—depicting the bird, and required that each of his chiefs strike the bird-shaped instrument during the ceremonies commemorating that victory (Ezra 1992, 197–201). It is that idiophone, in fact, that is depicted on the image. Ever since then, the memory of that victory over the Igala has remained in the royal chronicles and in Edo oral tradition.

For the most part, Edo plaques display representations that seemingly have to do with a history without precise chronology, depicting instead events in the cycles organizing the ritual life of the court. However, even images that do not include particular details allowing one to anchor them in chronological time—such as the bird in the previous case—are effective means used by the Edo to preserve the memory of the kingdom's history. It matters little whether the event really took place when and how the Edo of today describe it; the important thing is to organize and master the past with the aid of images composed by artisans and with the help of court historians. It is important to underscore at this point that the role of royal artists in this memory work is no less important than that of court chroniclers. The guild of *igbesanmwan*, sculptors in ivory and wood, and that of *iguneronmwon*, copper founders, still possess an iconographic knowledge indispensable for the preservation of the kingdom's traditions. Note that, in reality, two events are represented on the plaque celebrating the return of the victorious *oba* Esigie: first, the happy outcome of the battle, in the figuration of the *oba* seated facing the beholder, in majesty, on his horse as if on a throne; and second, the commemorative decision that followed, the creation of a new object and a new rite.

Robert E. Bradbury recalls in this regard that the brass art works of Benin constitute "potential sources of certain kinds of historical information" but that "dating and interpretation present many difficulties" (Bradbury 1973, 251). He takes the example of a brass object called an *ikebogo*, cylindrical in shape, with human figures

79. Historiated tusk from an altar to royal ancestors. Probably eighteenth century. Ivory. Nigeria, kingdom of Benin, Edo. Height: 156 cm. Diameter at base: 13 cm. Paris, Musée National des Arts d'Afrique et d'Océanie, MNAN 62.7.1. From bottom to top, on the median axes and the convex face: an interlacing motif (emblem of the guild of ivory carvers); a palace officer wearing a cross (object of European origin); to his left, a Portuguese grasps a copper shackle; an *oba* with legs in the form of silurids holds his rattle staff, *ukhurhe*, with one hand and his sword, *eben*, with the other; to the *oba*'s left, a figure on horseback; then an *oba* in a costume of coral beads, supported on each side by two nobles, and with two leopards facing each other at his feet. Symbols evoking royalty or a particular *oba* are present: the leopard, silurids—positioned head to tail and tail to head—a python, an elephant trunk with a hand at the end (emblem of the *oba* Akenzua I, early eighteenth century). References to the aquatic world of the god Olokun are depicted with motifs of the python and silurid. The tusks were washed and bleached with lemon juice to give them the whiteness of chalk.

and animals depicted in relief along its entire circumference; this type of object was reserved for the *oba*, his mother, or *iye oba*, and the *ezomo*, one of the two war chiefs. At the time of his inquiry, the *ikebogo* described by Bradbury belonged to the *ezomo* Omoruyi, who had inherited the office. It measures forty centimeters in height and depicts the great deeds of another *ezomo*, Ehenua, whom Omoruyi considered the ancestor of the family. The surface is very different from that of the plaques because it is a cylindrical object, but it obeys the same rules of figuration—dimensions of the figures, symmetrical composition, vertical staggering. At the top of this imposing brass cylinder and in the center of the circle, seated facing the beholder and sculpted in three dimensions, is an *oba*, identified by the *ezomo* Omoruyi as Akenzua I, who reigned in the eighteenth century. He is surrounded by assistants—a horn player, a bearer of offerings, a "healer"—and by European soldiers, bodyguards. He holds the end of a rope, to which animals are attached—a cow, a she-goat, and a ram. Facing him stands a leopard, an emblem of royalty. The sovereign wears no ceremonial costume, in what seems to be a representation of a rite, during which the aforementioned animals are to be sacrificed. Note that the same iconography depicting the king on his seat and surrounded by members of his guard and by musicians is found among the Ashanti, in objects with a comparable cylindrical shape, called *kuduo* (fig. 84). Along the circumference of the cylinder, similar to the figures in high relief on the plaques, stand various figures, including the *ezomo* Ehenua, located just below the king and of much greater size: the *ikebogo* was in fact cast in his honor. The *ezomo*, surrounded by bearers of emblems, by warriors, and by musicians, is in war garb: in his left hand, he holds a rope to which five human heads are attached, while the warriors following him each hold a severed head bearing various scarifications and headdresses, thus revealing the heads' different geographical origins. On his costume and attached to his arms, different attributes demonstrate that the *ezomo* is acting under the protection of spirits and powerful charms, which make him immune to the enemy's arrows. The base of the cylinder is adorned with the heads of animals sacrificed by the *oba*.[11] The iconographic elements present on this *ikebogo* show at a glance the power of a war chief in the service of the sovereign and the extent of that power, through the diversity of enemy trophy heads. By the position he occupies—he is represented under the *oba*, or more exactly, under the royal leopard and above the frieze of animal heads—we are told he represents the military power of the *oba* and that this power is linked to the necessity of making sacrificial offerings. As Bradbury notes, nothing allows us a priori to attribute a meaning much more extensive than this to these two juxtaposed scenes, that in which the sovereign prepares a sacrifice and that depicting the victorious

military chief. All in all, these scenes are fairly conventional in their expression. The interpretation proposed by the owner of the object is necessary if we are to understand more about it. The object is said to have been conceived for Ehenua by the *oba* himself, in gratitude for his aid in the conflict between him and the other supreme military chief, the *iyase*. Ehenua was victorious over that chief. The *ikebogo*, then, commemorates a military victory. The *ezomo* Omoruyi questioned by Bradbury confirms that meaning for the scenes, relying, as in the case of the episode of the "bird of prophecy," on a detail present on the *ikebogo*. It has to do with the battle against the rebel military chief and was commemorated in the family's oral tradition. The battle was so terrible that Ehenua had to intervene five times, cutting off one head each time. When he cut off the fifth head, his sword slashed the victim's face; one of the five heads depicted on the object does in fact bear a gash. As a function of that sign, which authenticates the nature of the victory celebrated on the *ikebogo*, the scene depicted at the top can also be interpreted: it represents the *oba* preparing to make a sacrifice to his ancestors, to ask them to secure Ehenua's victory.

Like the episode of the bird of prophecy, the episode of the gash on the enemy's severed head is not based solely on anecdote. In the first case, the bird became the very attribute of the *oba* Esigie, and took on the value of a symbol of his victory and the challenge he issued against destiny. These two motifs, the gash and the bird, are the metonymic signs of past deeds. Even though their chronological value remains ambiguous, these signs provide Edo memory with a series of reference points for a history essentially grounded in military victories.

Other Edo objects possess the same value of historiography: there are sculpted elephant tusks arranged on the altars of royal ancestors within the palace, and altars to the ancestors of important chiefs such as the *ezomo*. These tusks are generally inserted into containers, which are nothing other than the brass heads of kings or queen mothers discussed above (fig. 80). Each *oba* must have a set of tusks sculpted in memory of his father when the altar dedicated to the father is set up. The altars of deceased queen mothers may also include sculpted tusks. The iconography carved in the ivory of these tusks represents the same figures as those found on the plaques:[12] an *oba* with legs in the form of mudfish; an *oba* with arms supported by the *ezomo* and the *edayken*; an *oba* brandishing insignia of power, such as the *eben*, in each hand; the *iye oba*, or queen mother; animals symbolizing royalty—leopards, silurids, or pythons; priests and dignitaries and the emblems of their duties and powers; captives with their heads severed; and Europeans. As on the plaques, the composition of the figures is organized around a median axis, with figures superposed along it and important figures standing out by their greater size. Each tusk

80. Altar to royal ancestors, dedicated to the *oba* Ovoranwen (1888–97). Nigeria, kingdom of Benin, Edo. Photo by Eliot Elisofon, 1970. Washington, National Museum of African Art, Eliot Elisofon Archives. Four heads of *oba* support historiated tusks. In the center of the altar, on the earthen platform, stands another small brass altar, where an *oba* sits on his throne, holding the ceremonial sword, *eben*, in one hand. Two assistants lift shields toward him. Behind the brass altar, idiophones called *ukhurhe* are lined up against the wall. They are equipped with a slit through which a small stick is introduced, emitting a sort of rattling sound when shaken. These rattle staffs were used to call the spirits. The brass bells arranged along the periphery of the earthen platform have the same function.

replicates representations fixed by tradition, such as that of the warrior *oba* Ozolua, recognizable by his long coat of mail; each also celebrates the glorious past of the kingdom, its institutions, and the sovereign's occult powers. One of these tusks, which belongs to the family of the current *ezomo*, repeats the theme of the victory of Ehenua over the rebel war chief. It is believed to have been sculpted at the request of the son of Ehenua to honor the memory of his father (Blackmun 1991, 58). Even though the motifs used, their style, and the manner in which the different figures are arranged allow one to date the tusks,[13] it does not seem that they depict precise deeds. At most, dynastic insignia are inscribed on them, designating particular *oba* and sometimes making it possible to identify the recipient of the tusk. The history of the kingdom is evoked through conventional portraits of a few sovereigns, such as the great kings of the sixteenth century—Ozolua or his son Esigie—and their emblems. Many *oba* adopted the attributes of these great kings of legendary exploits.

Another art also favored the expression of the military activities of its sovereigns: that of the court of the Fon kings from old Dahomey. Like those of Benin, the monarchies of Dahomey were warlike, and the sovereign was the supreme master of the armies. For the most part, the memory of his exploits is depicted in the few bas-reliefs from palaces that have resisted time, modeled in relief in unbaked clay, and in the cut-out motifs appliqued onto hangings, banners, cushions, hammocks, parasols, caps, and the canvas of tents erected for certain ceremonies. These are all polychromatic works. The production of fabrics adorned with appliqued motifs was controlled by the king, and its use was reserved for him and the kingdom's elites. During royal ceremonies, the visitor witnessed a large-scale display of these textiles. Fon iconography also employs a wealth of elements to depict very different objects of the world, more varied than in the case of old Benin: diverse animals, plants, fruits, domestic or royal objects, and battle scenes. Although these elements are particularly represented in the two modes of expression just cited—bas-reliefs and fabrics—they can also be found in other media, such as *recados* (court staffs),[14] jewels, statuettes, or portable altars called *asen*.

The very detailed figurative character of Fon art allowed its inventors to express, in a more precise manner than in the Edo case, the complexity of the different great events that marked the history of the kingdom, which began in the seventeenth century. Even though it too is limited by the plastic conventions all court art imposes, the art of Dahomey, by the very variety of the representations observable in it, seems to take more liberty and to give more place to objects of the world that do not belong to the king's immediate environment. Unlike the art of old Benin, in which only the Europeans, the Portuguese in particular, have their place in im-

ages—and even then, it is a highly symbolic place, since it is always associated with the realm of the god of waters, Olokun—Fon figuration integrates objects that do not belong to the culture of its creators. An analysis of the iconographic repertoire reveals that the contributions of foreign artisans (new tools, for example) captured during wars find their place in it. Similarly, objects brought by Europeans—the wheel, the gun, the cannon, the wineskin, the boat, the sedan chair—became common motifs (Antongini and Spini 1989, 20). As among the Edo, that integration into court art of motifs describing the foreign world of Europeans is an expression of the new temporal powers kings acquired through contact with European merchants, by becoming masters of commercial transactions with them. The Dahomey dynasty included a poet king, King Behanzin (1889–94), the last great king, whom the French sent into exile, and whose works are still known among his people (Mercier 1962, 212). Fon representations use two main figurative systems, often concomitantly. The first embraces allegory and in certain cases the rebus, while the second is related to a narrative mode of expression, more developed than among the Edo, since the different stages of a single event can be depicted.

The first system is essentially used to represent royal names. Each royal name transcribes a maxim uttered by the sovereign. At his accession to the throne, the crown prince presents himself before a gathering of all his people and must pronounce a maxim expressing his ambitions, evoking the battles he has led, the force he unleashed to accede to the throne, or any other remarkable deed in his life. A few words or syllables of that maxim are selected to compose his first royal name or "strong name," thereafter used as his usual name (Mercier and Lombard 1959, 20–23; Mercier 1962, 110–11). Each king possesses several strong names, and acquires additional ones as his reign continues and important events come to mark it. The visual expression of these strong names, whether graphic or sculpted, is one of the reasons for the variety in the Fon iconographic repertoire: objects, animals, and plants cited in the motto form the basis for the symbolic representation of the king as both emblem and allegory, since each motto articulates a thought, a watchword, or a moral duty. Objects such as stones, thunder, the rainbow, a tinderbox, and an enemy can all compose a part of the name. As both maxim and image, the strong names of Fon kings can be compared to the noble mottoes used during the Middle Ages in Europe. Certain bas-reliefs, taken from the palaces of King Guezo (1818–58) and his son Glele (1858–89) and now displayed in Abomey, depict the strong names of these kings.

Let us take the example of the strong names of Guezo and Glele and the origin of their principal emblems. The strong name "Guezo" was formed from the following

81. Ring. Eighteenth to nineteenth century (?). Brass. Ijebu-Ode (?) (Nigeria), Yoruba. Diameter: 18 cm. Geneva, Musée Barbier-Mueller, BMG 1011-106. A dozen rings of this type are known to us today, but their function remains unknown. They all depict macabre scenes in which vultures devour tortured and decapitated bodies. Some of these rings were fabricated by Edo artists and found in the *oba*'s palace. This one is not of Edo workmanship and the reclining figure is dressed in the manner of Yoruba chiefs. At his feet rests a sphere, and on each side of his head are sculpted motifs in the shape of leaves or shell valves.

motto written in Fon: *ge de zo ma si gbe*, which means "No cardinal (whose tail feathers are the color of fire) can set the brush ablaze," or, in other words, "my enemies are powerless against me." One of his emblems, constructed from the adage "It is with a very resistant stick that the potter pulls out his jar cooked over the fire," depicts a jar over a fire, being pulled out with a stick. This motto refers to the fact that, in taking power, Guezo brought the country out of anarchy and violence.

The most common emblem of that king, however, is the buffalo, which is invoked in another proverb: "When the buffalo has become strong, he crosses the country, and nothing can approach him or stop him as he passes." The motto in this case refers to the force and combativeness of the animal, which is compared to that of the king and his warriors, who cross and conquer enemy territories. As for the strong name "Glele," it comes from the following proverb: *gle le ma yon ze*, or "no one could carry off a cultivated field." Another says: "I am the lion cub who sows terror as soon as its teeth have come in." One of his emblems was the lion, and a number of mottoes articulated by Glele and songs composed to the glory of his reign use metaphors with the central theme of that animal's strength and the terror he instills (Mercier 1962, 22 and 28–31; Antongini and Spini 1989, 23–24). The Musée de l'Homme in Paris possesses a wood sculpture the size of a man depicting Glele as a lion cub: the head of the effigy is that of a lion, its mouth open and teeth bared. The rest of the body takes human form, with the torso and a part of the arms covered with a finely sculpted mane. The same museum holds a similar effigy representing King Behanzin: this time, the head is that of a shark, emblem of that king, and the torso is equipped with fins. Let me emphasize the properly emblematic, and even allegorical, conception of the royal portrait, which excludes all other forms of representation.

The king's strong names make the king. In the image, the king is totally identified with the objects and ideas put forth by the maxims he produces. If the kings of old Benin were hardly personalized in their representations, those of Dahomey are presented only in the form of allegories illustrating their strong names, and in the objects reserved for their use, such as the regalia. In becoming visible through the play of metaphor, each king of Dahomey composed an entire repertoire of words and motifs for himself, thus individualizing himself: the poetic creations of Behanzin, already mentioned, also seem to be part of that logic. The kings themselves forged the images and phrases they wished to transmit to their descendants and to their people, though within constraints proper to the Fon figurative system. Other parameters also come into play in the articulation of royal maxims and in the creation of the corresponding iconography, having to do with the revelations obtained after

divinatory consultations made at the new king's accession to the throne. For the Fon, the destiny of every human being is written in the 256 signs of the Fa cult. Each of these signs is associated with the maxims, in which the destiny of the consulting king is read. Hence Glele's motto, "No one could carry off a cultivated field," and the maxim evoking the lion have to be linked to his Fa sign (Preston Blier 1990 and 1991). Part of these emblematic representations of kings can thus be interpreted as a translation into images of predictions made by Fa. The predictions represented are those that have come true: Glele, for example, turned out to be a powerful and re-spected sovereign. It seems, however, that the king was free to create his strong names based on other maxims besides those associated with his divinatory sign. On the other hand, a large number of the objects celebrating Glele and his reign were conceived in plastic terms as a function of these divinatory maxims.

The motifs on the door of Glele's tomb, ordered during his lifetime, obey that rule. On the door of his father Guezo's tomb, which Glele had sculpted at the same time as his own, and in a very similar composition and style, one finds the figuration of different strong names and references both to his father's reign and to his own (fig. 82). The door is divided into two rectangles. The upper one has a frog adorning each of the four corners, then three other animals—an elephant, a horse, and a hornbill—and two weapons, a saber with rounded blade and a knife.[15] In the lower rectangle, the four frogs appear in the same position, along with an antelope, a seated dog with a set of eyes on each side of its nose, a gun, a *recado*, and a smith's hammer. The elephant and the horse both represent King Guezo. The king, who, as we have seen, had the buffalo as part of his coat of arms, chose the emblem of the elephant after a war against a "Nago" chief,[16] whose size was compared to that of the elephant. Given the legendary force of his adversary, the king of Porto-Novo advised Guezo not to undertake that war. Guezo replied with this line: "We have killed more than one elephant with our guns, and the one we are hunting is no more terrible than the others." After that event and the creation of this new strong name, Guezo attributed the motif of the elephant to himself as an emblem. The horse rep-resents another strong name: "The horse's bit cannot go to the buffalo" (Waterlot 1926, plate 12). The hornbill refers to a mythical being, *alantan gbobo*, a fabled bird called "king of birds," whose very powerful beak can grasp any weight whatever, and all other birds (Waterlot 1926, plate 17). Glele compared himself to that animal, representations of which abound in the art of his reign. The figure of the hornbill also belongs to the bestiary of the divinatory Fa cult, as do frogs. The horny casque the hornbill sports on its head, at the base of its beak, is described in the cult as a burden it was given to bear.[17] The hornbill, like the lion, belongs to the sovereign's

82. Palace door. Nineteenth century. Wood, iron, paint. Benin, kingdom of Dahomey. Abomey, Fon. 174 × 95 cm. Paris, Musée de l'Homme, M.H. 93.45.4.

Fa sign. Thus, Glele compared himself to the bird: "I am called the hornbill. The baggage of life does not stay on the head of just anyone. The baggage of the whole country is on my head" (Preston Blier 1991, 45). As for the frogs, they bring to mind another property of Glele's Fa sign and of his reign, which was calm and serene: "It is there in a cool [calm] place that the frog rests" (Preston Blier 1991, 46). The saber, the knife, and the gun refer to the kingdom's military power. The dog (emblematic of another king, Kpengla) and the antelope may also represent one of the strong names of an ancestor of Glele, Agbanlicoce. The eyes and nose may express the sovereign's clearsightedness and perspicacity. The smith's hammer is an emblem of Guezo. The *recado* sports the head of a lion, Glele's animal (fig. 83).

The example of this door leaf is indicative of the way Fon artisans composed their images, with the help of these visual metaphors. They are juxtaposed with one another on a uniform background and are easily recognizable by the beholder, who can immediately identify each emblem and remember one or another of the corresponding mottoes. Recall that these motifs of strong names can correspond to different mottoes, though all are complementary in terms of their meaning. Thus the elephant, emblem of Guezo, fits other mottoes besides that articulated previously, such as: "The hunter who killed the elephant could never lift him alone," an adage signifying that Guezo did not believe there was anyone in the world powerful enough to take on his army (Mercier and Lombard 1959, 28). If we look closely at the way the decoration on that door was conceived, we also perceive that Glele must have taken an active role in its realization: his emblems appear in great number and the general composition is exactly circumscribed twice, by the four frogs above and below.

The uniform and neutral character of the background on which these emblematic motifs are inscribed—whether on fabrics, doors, or bas-reliefs—manifests a different conception from that of the Edo regarding the way figures from the world which they choose to represent become images and come to occupy space. Recall that in Edo plaques the background is carved with abstract designs evoking the god Olokun and his ascendancy over the universe. There is nothing like that among the Fon. In addition, in Edo plaques the sculptures in high relief are part of the background—which consists of a single wax relief destined to disappear when liquid copper or brass takes its place—while in Fon art works the motifs are always transferred. In the case of fabrics, they are cut out, then sewn onto another surface; on the wooden door just described, they are fastened on. The modeling of the bas-reliefs is achieved by adding clay. These few indications about the techniques used are of consequence in interpreting the images. The figures in high relief on Edo

83. *Recados.* Eighteenth and nineteenth century. Wood, copper, and forged iron. Benin, kingdom of Dahomey, Abomey, Fon. Height (left to right): 45.5 cm, 45.5 cm, 52 cm. Paris, Musée de l'Homme, M.H. 31.36.5, M.H. 31.36.11, M.H. 31.36.10. Left to right: *recados* of Behanzin, Glele, and Agadja.

plaques are indissociable from the background, both from the material point of view—as a result of the technique used—and from the symbolic perspective: they are conceived and shaped as if they were emerging from the aquatic universe—that is, from the world of Olokun, which is fluid and limitless by definition. Conversely, the allegorical figures of Fon iconography, a transcription of lapidary phrases proposed by the king on certain occasions, are indissociable from spoken language.

As words translated into images, whose only referent is the sovereign himself, they refer to those instances of royal enunciation when the monarch posits himself, in his singular person, as the center of space and time. By "singular person" I do not mean the sovereign's personality, but rather his role as the founding authority of the monarchy, based on visual as well as linguistic signs. Iconic signs are found affixed to every surface possible: palace walls, doors, fabrics, and so on. Similar to seals, they stamp objects in the king's immediate surroundings; and, like the *recados*, they are also charged with representing him in other places. It is clear that the technique that consists of fixing cut-out motifs onto another surface is grounded in a certain notion. If we are to believe the Fon conception of the image, each design refers to the king's words, which are then fixed in different places of a world that, unlike the Edo world, is a virgin land awaiting the imprint of its lawmaker and creator.

Each emblem expresses not only the singularity of a particular king, but also mottoes glorifying the power and force of the sovereign and his army, and certain moral values. Take the example of the motif of a jar with a hole in it, carried by two arms, with hands attempting to keep the water from pouring out. This is a symbol of union created by King Glele, calling upon his people to come together. "The kingdom is like a jar with a hole in it, it is surrounded by enemy kingdoms; the people must watch the borders and plug up the 'holes in the kingdom' " (Mercier and Lombard 1959, 30).[18] A number of these emblems also evoke the deeds, necessarily military in nature, that were the occasion for their creation.

In addition to the emblematic representations just discussed, the Fon used another figurative and narrative system, in which different war episodes in the history of the kingdom were described. Royal emblems were generally associated with these images, either because they were integrated into them, or because they were juxtaposed onto them. In the case of bas-reliefs, these images depict small, isolated scenes. On the hangings, a series of scenes reproduce certain moments in a narrative. Commenting on the profusion of motifs found on these fabrics, Paul Mercier defines them as "true royal memoirs." He reminds us in this context that, with the help of the same technique of cut-out and appliqued motifs, the Fon constructed "maps on which the information Dahomey spies had obtained is reported before a

war expedition" (Mercier 1962, 206). The bas-reliefs in the palaces of Guezo and Glele provide a few examples of this type of representation, depicting the wars conducted by the Fon against the "Nago" (Yoruba) in the eighteenth century, in an effort to shake off the yoke of the king's rule of the city-state of Oyo on Dahomey. Heads and members severed from enemy bodies abound in that iconography: a Fon warrior cutting off the leg of a "Nago" enemy; a Fon warrior decapitating a "Nago," whose body seems to be falling from a sort of pedestal (fig. 64); a Fon warrior, or "Amazon," carrying on her shoulder the body of a "Nago" who had shot an arrow at her in a surprise attack (she is taking the body back to her king) (fig. 65; Waterlot 1926, plate 13). Another bas-relief alludes to the same theme, though no scene is depicted on it. It is the figuration of Guezo's throne, resting on the four severed heads of Mahi enemies (the Mahi occupied a territory located to the north of Dahomey) (fig. 63). As in old Benin, the severed head of the adversary was an important war trophy. Recall the words uttered by King Kpengla before the mummified head of one of his adversaries. Fon art made great use of skulls, which served as drum ornaments, parasol ornaments, cane handles, drinking cups, and so on. The real throne of King Guezo, moreover, rests on four skulls (fig. 114).

These same scenes, but arranged into more complex compositions, are found on certain hangings. One of them, currently at the Musée Historique in Abomey, relates the taking of Savi in 1727 by King Agadja (1708–32). Savi was the capital of the small coastal kingdom of Ouidah; after that expedition, the kingdom of Dahomey controlled the cities along the coastline and could trade directly with the Europeans. The account of that event in images (fig. 87) is organized around a central motif depicting a European ship, whose stylized form reproduces the appearance of an eighteenth-century ship, with, on the deck, the threatening silhouette of a cannon.[19] The boat is the second emblem of King Agadja and celebrates his victory over Ouidah and his conquest of coastal territories. This same emblem was found in clay bas-reliefs in the palace of Agadja, which has been destroyed; in the place of the cannon stands a chair, with a Portuguese missionary brandishing a cross (Waterlot 1926, plate 5). Above the ship the sun, moon, and stars are aligned; their presence may recall the need for God's help in any human enterprise, in particular when it involves war. On the right side of the hanging certain deeds are evoked, having to do with the taking of Ouidah. Depicted in profile, the severed head of the conquered king of Ouidah is exhibited erect, in a pot or calabash, while the rest of his body lies on the ground. That macabre scene corresponds to another, portrayed in a very expressive manner at lower left, in which a Fon warrior is extirpating what seem to be guts from the abdomen of a dead enemy. Above the remains of the conquered

84. Ritual receptacle, or *kuduo*. Nineteenth century (?). Brass, lost-wax casting. Ghana, Ashanti. Height: 29 cm. Paris, Musée de l'Homme, M.H. 65.17.1. The chief is represented sitting on his seat and smoking a pipe, his body adorned with jewels. Seven transverse horn players and one double bell player surround him. Behind him stands a woman holding some kind of scepter. Facing him, another figure is seated, displaying an insignia ending in two spirals. At his left, the bearer of a saber with curved blade, *afenatene*, presents a severed head.

85. Ritual receptacle, or *kuduo*. Nineteenth century (?). Brass, lost-wax casting. Ghana, Ashanti. Height: 25 cm. Kilchberg, R. David and D. David. The motif of the big cat bringing down an herbivore alludes to a recurrent theme in the iconography of the ancient cultures of the eastern Mediterranean, which then spread to Europe.

86. Figurine (weight for weighing gold?). Brass, lost-wax casting. Ghana, Ashanti. Height: 5 cm. Length: 9 cm. Paris, Musée National des Arts d'Afrique et d'Océanie, MNAN 63.4.45. Funerary scene. Two men on all fours, perhaps slaves, carry on their backs a cadaver placed on a mat and enveloped in a shroud. Each of the bearers holds a piece of pottery on his neck, one round, the other flat. The meaning of this scene is not known to us. However, the position of the two bearers and the shroud wrapping the body suggest this is the funeral of a chief. The fabric represented, typical of western Africa, is composed of strips sewn together and adorned with motifs in a checkerboard pattern. It may be either a *kente* fabric, of Ashanti fabrication, or a Fulani blanket. The Ashanti imported textiles from northern regions, and their use was reserved for the *asantehene* and great dignitaries. Among other things, they were used to cover the drums of the chieftaincy and palanquins.

king, two Fon warriors, recognizable by their double-crossed bandoliers, are probably preparing to execute an enemy soldier they have just captured. Above them, a Fon warrior armed with a saber confronts an enemy equipped with a spear. Between the severed head of the king of Ouidah and his body, a female figure, smaller in size, is represented bending over a package she holds in her hands. The operation this little figure is performing represents the essential point of the story being told. This is a servant of Princess Nagueze, daughter of Agadja, whom the king gave in marriage to the king of Ouidah, as a ruse. Unlike the Fon army, the Ouidah troops were equipped with guns, through trade with the Europeans. Owing to that marriage, Agadja conquered the kingdom of Ouidah by inventing a stratagem, which is represented here: the servant, by wetting the gunpowder and cannon powder of the enemy troops, ensured victory for Agadja's warriors. On the opposite side of the hanging, on the left, a few scenes form a symmetrical counterpoint, vis-à-vis their meaning, to the scene just described. A hunter, representing Agadja, uses an ax to break up a termite nest, from which snakes are emerging; a monkey is preparing to cut off and eat a stalk of sorghum; and a crocodile is devouring a fish. The meanings of these three scenes complement one another: the king, though possessing no firearms, succeeded in conquering the enemy kingdom, which was better armed and better defended than his own. In fact, as lord of the kingdom, like the monkey or crocodile, he was obliged to seize and destroy the property of others in order to survive. In the lower part of the hanging, the regalia and a few strong names of Agadja appear: his saber, one of his *recados* adorned with Christian crosses, his throne, a buffalo and a leopard—emblematic animals of Fon royalty—and a hyena hunting antelopes, an allegorical image associated with the sovereign's Fa sign.

In the representation of that scene relating a historic deed—the taking of Ouidah and the circumstances of its success thanks to Agadja's ruse—the royal emblems play exactly the role of seal mentioned above.[20] They attest to the fact that the scene illustrates the history of the reign of one particular king, a scene expressed with the help of the graphic means proper to Fon art, such as the figures depicted "Egyptian style," their faces in profile, their torsos frontally, and their legs in three-quarters profile. One detail of that scene, the servant wetting the packet of powder, in itself allows us to reconstitute the individual moments in that episode of Agadja's rule, which unfolds before our eyes. The presence of the boat motif also serves to confirm the interpretation. Without the figure of the servant, the composition as a whole could represent a more general defense of the war power of the Fon monarchy, such as that found in Edo iconography. The precision provided by the Fon artists in the figuration of that particular event reveals a desire on their part, and on the part of their royal patron: they wish not only to express the history of each reign through a

conventional evocation of battles, which nothing in the image would allow us to understand in historically specific terms, but also to prove in some way a certain effective character of the deeds by authenticating them through representation. In so doing, the creators of that hanging add a surplus of reality, giving us a story to be read, that of a series of reigns that follow one another, in which the singularity of the event is identifiable in the particular facts that marked or produced it. A similar attempt can be found in Edo art, through the figuration of the bird or of the gash marking the severed enemy head; but this mode of expression seems to have been more advanced among the Fon. Fon art grants a greater place to men, not only the king but all those in his service, in that, in its aim and its acts, it produces and constructs history. The Fon sovereign seems to have had the right to express his individuality more assertively than his Edo counterpart. Among the Fon, history is presented as indissociable from the monarch's acts: the king makes history. Or, to borrow the words of Paul Mercier, "he transforms the world of men, by inscribing his name in history" (Mercier 1962, 109).

Fon artisans have recently produced a new version of that same composition, from which the figuration of motifs expressing the circumstances of the taking of Ouidah has been eliminated (Adams 1980, 38). Only the depiction of the strong names of King Agadja now appear: the ship, the hyena pursuing antelopes, the monkey eating millet, and the hunter destroying the termite nest inhabited by snakes. The reference to the taking of Ouidah is entirely contained within the emblem of the ship. There is no longer any narrative told in images. And, along with the account of the event, a certain rootedness in lived reality as constitutive of the history of the kingdom also disappears. There is a return to the abstraction of metaphor.

The concern on the part of Fon artisans for explicit narratives reveals another preoccupation at work in their figurative systems. The composition of that hanging is organized around a center, the motif of a ship of large dimensions, occupying half the space. The other figures surround that motif along the periphery. As we have seen, the choice of centralization as an expression of the hierarchical system implied within any monarchy was also made by Edo artists. In other hangings, however, the emblem of the king is not in the center of the image, but is simply larger, so that the effect is the same (Adams 1980, 37). This principle of composition leads the beholder to a reading overdetermined by the interpretation of that motif, which allows relations linking all the other scenes to become significant. There is no reading sequence: an overall meaning is given to the image by the royal emblem, which constitutes the referential element needed to construct its meaning. Not only does the king make history through his acts, he also gives history its meaning.

To fix the tradition of that history, the Fon used a mode of expression similar to the pictogram, understood not as a series of animated figures (there is no linearity in Fon compositions of figures) but as a group of figures reproducing an action.[21] The hanging just described has several pictograms understood in this sense. The most important for the meaning of the narrative is composed of two figures, the servant and the body of the enemy king cut in two, the head erect in a receptacle and the rest of the body lying on the ground. Fon artists closely intertwined the two motifs, the two major themes of the narrative: betrayal and the death that follows. The use of pictographic expression also shows that, in the very form of its expression, Fon art is linked to the structure of spoken language. This no doubt partly explains why Dahomey artists did not choose to use many figurations of humans or animals on the surface of their art works, whether canvas or clay. Thus, they did not produce the large frescoes combining beasts and people familiar to us from classical art. In terms of Edo art, the reasons for this might be different, since it is an art that seeks above all to signify the symbolic and hierarchical relations structuring society, with great concern for exactitude.

As in the art of Benin, but much more obviously, in Fon and Edo art movement is reserved for men. Animals stand rigid on their feet; but men move, since their arms and legs in motion, running after the enemy to kill him, are the instruments of royal power. Contrary to what occurs in other types of iconography, such as Egyptian or Assyrian art, the sovereign is never shown performing violent acts, at war or in the hunt; recall that he was prudently kept away from such activities. Fon and Edo artists do not use the king's physical strength as a metaphor for his power.

The very fact that they are captured in motion inscribes the characters of Fon and Edo iconography in the unfolding of time, and hence in history. Every representation of action, in effect, supposes that the instant fixed by the image entails a "before" and implies an "after." The figure of the king, whether appearing in the form of an emblem or in a hieratic portrait, is in some sense part of eternity. When we look at old Fon hangings, we see they all tell autonomous narratives relating to a particular king. A king would never have deeds that were not part of his reign reproduced on a hanging; thus, if we are to believe the images, the universal history of the kingdom seems to be understood more as a sum of historical blocks independent from one another, with art works differentiated and personalized by the sovereigns of Dahomey.

As we have already seen, that figuration of the history of Fon royalty is built solely on the depiction of war feats. In the art of Benin as in that of Dahomey, nothing is said about works and days, again unlike other arts, such as Egyptian. Edo images attest to trade with the Europeans, the Portuguese in particular, but only by

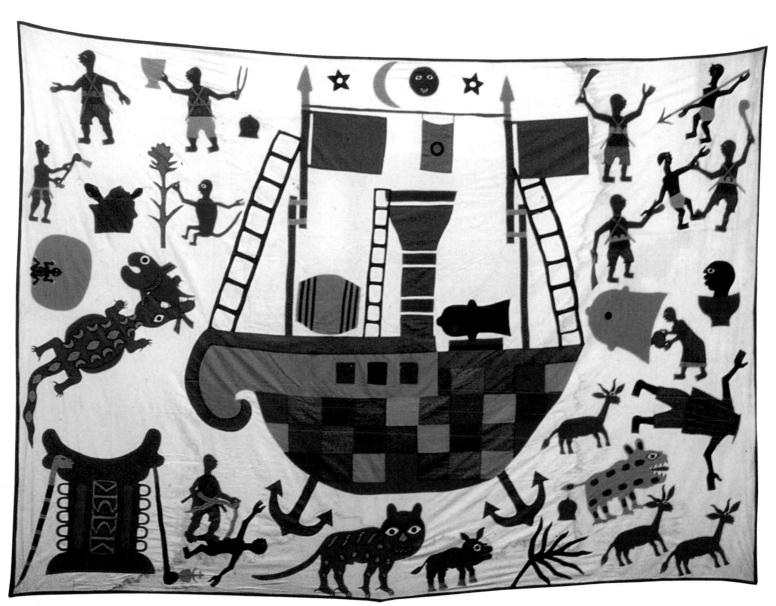

87. Fabric hanging with appliqued motifs, dedicated to King Agadja. Benin, kingdom of Dahomey, Abomey, Fon. Benin, Abomey, Musée Historique. Photo by Giovanna Antongini and Tito Spini.

allusion. Wars represent the key temporal reference points, engaging all the forces of the kingdom and producing legendary transformations in its economy, its institutions, or its territory. The conquest of coastal cities by Dahomey and its victory over the Yoruba suzerain of Oyo; the control of new expanses by the Edo, such as the banks of the River Niger during their campaign against the peoples of the north; and the encounter with Europeans are so many deeds that allowed the Edo and the Fon to contain the past of their kingdom within a diachronic perspective. In the absence of a writing system, which might have relieved minds of the burden of remembering, these deeds, especially among the Fon, were the foundation of iconography. Hence the Fon manifested an advanced awareness of a past made up of events, which they sought to depict in a logical and chronological manner.

The little scenes adorning the chairs of Chokwe great chiefs also borrow from the realist register and depict not only bloody battles and macabre subjects, but, unlike the arts just discussed, moments of daily and ritual life as well. This is less a morphological realism, however, such as that observed in the effigies of Tshibinda Ilunga and his successors, than a realism of attitude and situation: a chief transported in his hammock, a man feeding his ox, a man and woman coupling, an adulterous couple sniffed out by the husband's dog, a pipe smoker, the ceremony of circumcision, dances of initiation, a husband waiting for his meal while his wives grind. At no point do the decorations of these chairs, which can be extensive, allude to the history of the chieftaincy and the wars it conducted against its neighbors. The events depicted on them concern all Chokwe, both as particular individuals in domestic scenes and as integral parts of a collectivity founded on specific rites and beliefs. Thus, the sculpted motifs of the chair, called a *ngunja*, belonging to a *mwanangana*, a Chokwe chief or lord of the earth, do not simply evoke the small events of a theater of daily life (figs. 88 and 89).

The original model for these objects has to be sought in seventeenth-century Portuguese chairs, whose seats and backs were lined with leather. The back was sometimes even adorned with figurative scenes. This is not the only case of borrowing: the Ashanti did the same with their chiefs' seats (fig. 107). The principle of the seat—and more generally, of any art work made of wood—composed of pieces brought together and assembled with a mortise-and-tenon construction was foreign to the African conception, which privileged objects in one piece. The old throne of the Chokwe chiefs took the form of a small wooden stool with an hourglass shape, called a "chair in the shape of an anvil." This suggests that the chair's seat was originally a smith's anvil, a highly symbolic object in Africa, where metallurgy played an important role in the economic and spiritual development of numerous societies.

Each chair of the *ngunja* type formed a particular iconographic whole, though the sculpted motifs found on them all belong to the same repertoire and all describe the same kind of scenes. A slightly less common motif seems to be that referring to the Chokwe myth of origin. It depicts a female character representing Lweji, the Lunda princess, who, against the advice of her two brothers, married the Luba hunter Tshibinda Ilunga. Following that marriage, her two brothers left to found the Chokwe chieftaincy. The two brothers are depicted on either side of Lweji, who appears to be fighting with them and pushing them away, with both hands and both legs extended. The place this motif occupies in the general composition of the chair allows us to interpret it in that manner; as we shall see, that scene, which in this particular example is found sculpted in the center and top of the chair back, is found in other places of the object and encompasses a more general meaning. Sculpted in this crucial place at the top of the chair back, such a scene invites a certain reading of all the other scenes that compose the decoration on the bars of the chair; they are to be interpreted as a function of this central theme.[22] This is the same system of composition described previously in relation to Fon art. The morphology of the chair allows the scenes to be composed in space and to occupy different places as a function of the general orientation of the object and the meaning associated with it. In fact, the function of the Chokwe chiefs' chairs is not limited to the utilitarian role of receiving the body of their owner. The chair, and more particularly, all its histo-riated parts, must be *seen*. The chief does not move without his seat; if he goes to the market or passes through his village, someone in his entourage carries it for him: not the large *ngunja* chair, but a lighter piece of furniture, often a stool or small chair, which is also adorned with sculpted motifs. The chief does not necessarily sit on his large chair (its back is often made uncomfortable by the high reliefs), but may sit at its feet on an animal skin, sometimes resting his back against the chair. Other ex-amples confirm that particular use of the Chokwe chair; in the next chapter we will discover other royal seats put to the same use. There are thus reports of a chief, also the healer of his state, who was seen one day caring for a sick young woman in the presence of his large *ngunja* chair. The chair seemed to be presiding over the session and had been brought in to remind the patient of the deceased ancestor whose memory had been neglected, since that act of forgetting was the cause of the illness (Kauenhoven-Janzen 1981, 70). In the case of the *ngunja* chair, whose decorations are always suggestive, one might think it was as much the symbolism of an object per-ceived as the seat of redoubtable supernatural powers as the display and reading of the scenes sculpted on it that had a therapeutic effect on the ill woman.

The two *ngunja* chairs reproduced here (figs. 88 and 89) are large and abundantly historiated. Each of their backs contains five bars with figurines common to the two

chairs. One of them has sculpted uprights on the lower part shaped like caryatids, which represent four tutelary ancestors (fig. 88).[23] On the upper bar on the back of the other chair are three figures wearing cone-shaped masks, called *cikunza* (fig. 89).[24]

On top of each of the two uprights of this second chair back, an old woman holds a pot on her head. On the lower register, a woman is lamenting with a conventional gesture, her two hands placed together on her head; she is framed by two other masked figures of the *cihongo* type. Beneath them, two men are transporting a chief in a sort of hammock; then two women are rejecting the advances of two men wearing antelope horns, who are reaching their hands toward the women's pubic scarifications, called *mikonda*. Then, on the bottom bar, two women and two men, dressed in jackets of sorts, seem to be walking hand in hand. On the back bars, placed in the frontal position, are three bats, their heads facing down, flying over four women, each of whom holds her child in her arms. Beneath them, a woman is preparing to pour water from a calabash for her child; she is facing another woman who is grinding cassava. On the left side, a woman is rejecting the advances of two elderly men, recognizable by their beards, who have each grabbed one of her breasts; three figures advance on their hands and knees, one behind the other. This scene alludes to an episode in the initiation rite, called *mungonge*, performed on adult men. During a nocturnal episode, older men play the role of the spirits of the dead to frighten the novices. On the right side, two birds are quenching their thirst or seeking food and two dog-faced baboons are walking single file. Behind them, a European stands on an ox, followed by a man carrying a trunk; three musicians are seated across from them, one striking a slit drum, the two others playing a drum shaped like an hourglass.

The uprights of the back of the first chair (fig. 88) depict two characters, one of whom has his arms crossed over his chest, wearing the costume of another mask, the *kalelwa*.[25] At the top of the chair back stand three drummers; the gesture of the one in the middle is no doubt ritual in nature. Beneath them, two seated drummers are playing their instruments, shaped like hourglasses, while on the lower register two dancers are seated facing them, wearing the *cihongo* mask. Beneath them, two human figures, their arms raised, may represent stilt walkers, *mbongo*, who also play a role during the initiation of adult males. On the last bar a man, probably a chief, is being transported. On the upper bar of the lower part, we again find the scene in which a woman, both arms extended, pushes aside two men, one of whom is touching her pubic scarifications and the other her breast. One of the two men seems to be held back by another human figure. The bar that follows has three seated mothers holding their children in their arms and a fourth figure at one end. Beneath them, a

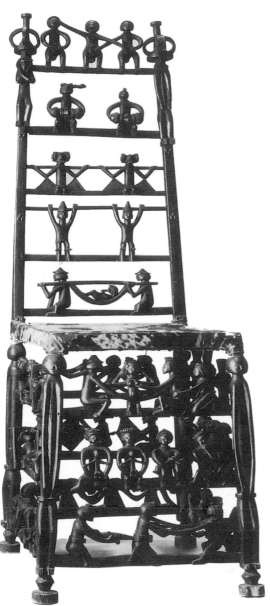

88. Chief's *ngunja* chair. Wood and ox skin. Angola, Chokwe and Badyok. Height: 129 cm. Göteborg, Ethnografiska Museet, GEM 35.2.1. Brought back in 1929.

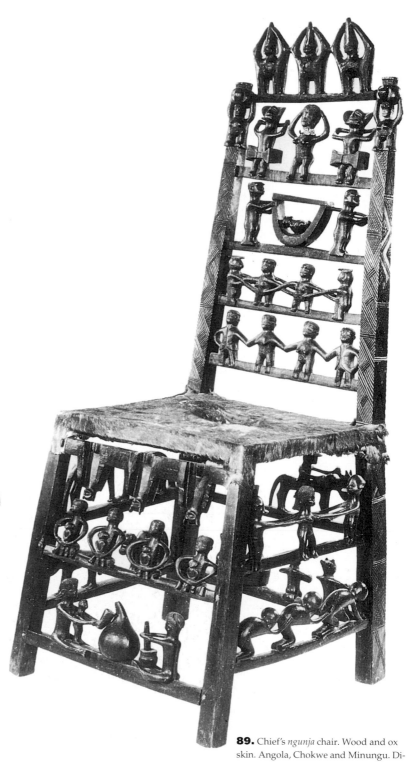

89. Chief's *ngunja* chair. Wood and ox skin. Angola, Chokwe and Minungu. Dimensions of a European chair. Angola, Museu do Dundo, B 170.

man is pointing his gun at the back of another. Behind them, on the middle register, are two slit drum players.

The iconography of the two chairs reproduced here repeats classical themes for this type of object, including the principal and determining theme of initiation. The *cikunza* masks standing at the top of one of the two chair backs (fig. 89), very recognizable by their head in the shape of antelope horns, represent the spirit of fecundity and of hunting, protector of young boys or novices who have gone into the bush for the first initiation, called *mukanda*, which includes the rite of circumcision. The two women carrying containers on their heads, at the top of the uprights of the chair back, may represent the old women responsible for cooking for the initiates. On the lower bar, the *cihongo* masks represent male spirits symbolizing power and wealth. The *cihongo* mask is a dance mask, the costume of which includes a basket belt from which a grass skirt hangs. The Chokwe sculptors perfectly transcribed the very particular shape of that skirt on the two chairs. This mask plays no role during initiation. On the other hand, it must be counted among the attributes of the lord of the land, *mwanangana*, for whose use it was reserved, since only the chief or one of his sons could wear it and dance. During dances he performed in the villages controlled by his father, the chief's son received gifts that represented a sort of tribute. The scene showing men and women touching each other's sexual parts may attest to the phase after initiation, when young people, introduced into the adult world, are authorized to marry. In the lower part of that chair, several scenes illustrate other stages of adult life, such as procreation and the moment of the second initiation, *mungonge*, reserved for adult men. The chief was necessarily an initiate at the *mungonge*, as an accomplished man who had gone through the two initiation rites: the *mukanda*, which allowed young boys to attain virility; and the *mungonge*, in which novices had to confront the aggressive spirits of the dead. Both rites play out a kind of cosmological drama in which the forces of darkness and death struggle against those of light and life (de Heusch 1982, chapter 5; de Heusch 1987, 450–57; de Heusch 1988, 19–44). The completion of the ritual cycle in its totality allowed the initiates to be part of the Council of Elders. On the second chair, the *kalelwa* masks sculpted at the top of the uprights are also part of the initiation rites designed for young boys: for example, the *cikunza* see that novices get food when it becomes scarce. The *cikunza* and the *kalelwa* are the benevolent spirits of the *mukanda*. The stilt walkers, depicted on the second bar from the bottom, allude to the second initiation, that of adult men, when, just before dawn, the *mbongo* enters the confines of the *mungonge*, carrying a lit torch announcing the end of the ordeal and the coming of dawn. The reference to the chief's powers is again expressed by the *cihongo* masks and by the hourglass drums, whose use was once reserved for him. Prominently

located on the two chairs is the motif of the chief carried in his hammock. The motif of the *cihongo* mask is frequently found on the backs of chiefs' chairs; as the emblem of the *mwanangana*, it recalls his responsibility for maintaining the kingdom's prosperity and the scope of his powers, since the *cihongo* mask can cause illness or sterility when it is irritated. The motif of the *cikunza* mask also appears very often, not only in reference to the role the spirit depicted by the mask plays in the rites of circumcision, but also in relation to a cult linked to it, in which it intervenes as protector of hunters and pregnant or sterile women.

As in the examples of Fon art described previously, the design invented by Chokwe artists for this royal piece of furniture seems to use motif compositions similar to pictograms. Moreover, the Chokwe created a vast repertoire of abstract motifs, called *yitoma*, which they used especially as decorations for their art works in wood, leather, or metal (Bastin 1961). When we look at the distribution of the figures on these chairs, we notice that the back, the part of the chair most exposed to view, seems to be reserved primarily for the evocation of the chief's temporal and spiritual power, while the lower part generally seems to be dedicated to the representation of scenes from daily life. But the arrangement of one in relation to the other is not without consequence for the interpretation of the whole, which portrays the chief as the guarantor of the well-being and fertility of his people, the person who can maintain in harmonious balance the spiritual forces invoked during initiation rites. To convey this idea, the Chokwe invented motifs that express, in a codified body language, moments that play a central role within the various stages of the unfolding rite. These moments are significant because they mark a shift from one state to the next: the appearance of the stilt walkers, the line of crawling elders representing the spirits of the dead, and the gestures of the *cikunza* or *cihongo* masks. The representation of such moments of transformation is similar to that observed in the picture narrative of the Fon servant's ruse during the taking of Ouidah. The chief manifests himself in these scenes, not in majesty, as in the art of old Benin, or through emblems, as in Dahomey, but as a figure integrated into this ordered and regulated world, the world represented by the iconography of the chair, through the *cihongo* mask and the motif of the hammock. The *ngunja* chair, emblem of the chief's power, contains in symbolic mode all the signs that ground Chokwe identity. Although there are no references to a historical past in the decorations on the *ngunja*, their hierarchical sequence of ideas does indicate how the Chokwe conceive the way every human being is constituted as a socialized individual participating in the symbolic administration of the world. For that reason, Chokwe chiefs' chairs ought also to be regarded as monuments.

CHAPTER FOUR
Insignia of Sovereignty and Court Objects

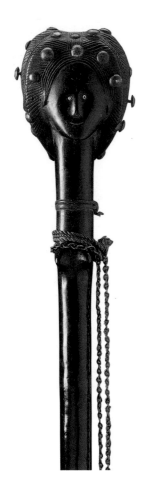

(previous pages)
Detail of figure 118.

(above)
90. Cane handle. Wood, upholsterer's nails, metal, fibers, beads. Angola, Benguela, Ovimbundu. Height: 61 cm. Tervueren, Musée Royal de l'Afrique Centrale, R.G. 79.1.144. Brought back in 1950.

(facing page)
91. Finials of linguist staffs. Wood covered in gold leaf. Ghana, Ashanti. Height (left to right): 150 cm, 168 cm, 153 cm. Kilchberg, R. David and D. David. The proverb expressed in the central staff is the following: "By itself, the forest can swallow the elephant."

A s a political and mystical symbol of the unity of his people, the body of the African sovereign may be covered with insignia during ceremonials; the effect is sometimes spectacular, as attested in the portraits of Kuba or Yoruba kings, to take only two examples (fig. 5). While ornaments and objects—such as the stool among the Akan (discussed below) or the coral bead necklace among the Edo—are always associated with noble titles, it is the king who seems to possess the greatest number of them. Their quantity might be commensurate with the desire to express the notion that *the monarchy possesses the king*. According to a statement by Jan Vansina, the king is simply "the man who occupies the monarchy" (Vansina 1964, 111), or perhaps, the man who "occupies" the insignia. That relation of equivalence between royalty and its insignia, for which the king's body provides only a provisional support (since other kings' bodies will come to replace it), reveals how the symbolic value of these emblems constitutes an end in itself. The insignia are the iconic manifestations of royal reality and refer only to themselves. The fact that royal insignia are often the only works allowed an anthropomorphic form may attest to this. Among the Kuba and the Chokwe, and in the chieftaincies of the Cameroon Grasslands, the only members of the community who can be represented are the chief and his first wife or mother, and then only on objects reserved for them. Insignia with the king's head or body on them reinforce the royal presence by reproducing it, and inscribe the sovereign in a relation of identity with his objects. Chokwe chief's-head scepters are an example of this (figs. 93 and 96).

As if to better demonstrate that condition of their existence and creation, the insignia of sovereignty are frequently diverted from the primary function their form might suggest. Hence, royal seats, despite their appearance, are not necessarily designed to let their owner rest, though they might accentuate his superiority over his subjects. The seats of the chieftaincy of Kom, located in the Grasslands region, receive the king's bodies, but only in the form of his bones: each seat is the place where the jawbone and certain other bones of deceased kings are collected in a calabash; it is then kept safe in a house designed for that purpose (*Sièges africains* 1994). These pieces of furniture nonetheless take the form of a seat, though the most striking part of their configuration consists in the sculpture of a standing human figure in the place of the chair back (fig. 109), whose silhouette is all the more imposing and remarkable in that it is covered with colored beads, consistent with the style of that region of Cameroon. In Kom, these sculpted figures represent the great chiefs and queen mothers of the dynasty. These representations resembling seats are kept in the shadows, in the mausoleums of deceased chiefs; they witness dynastic rituals, such as the washing of bones at the time of a chief's death, when members of the

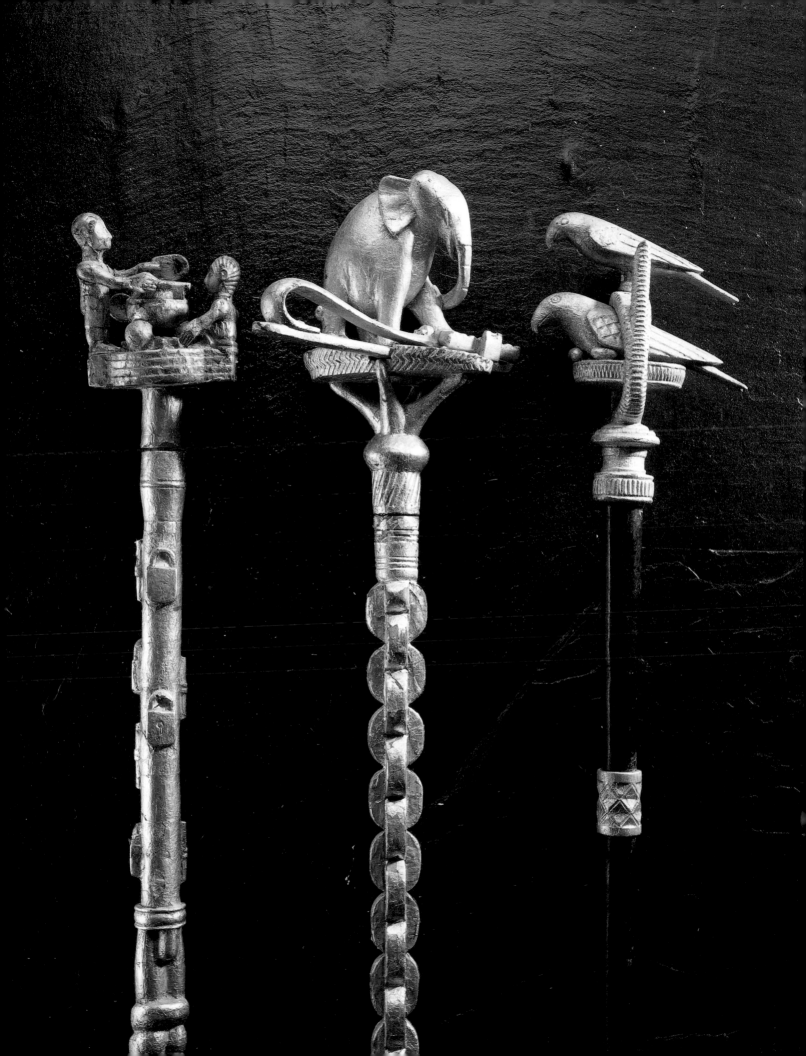

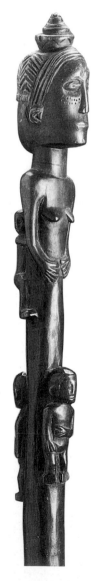

92. Cane handle. Wood. Angola, Benguela, Ovimbundu. Height: 132.6 cm. Tervueren, Musée Royal de l'Afrique Centrale, R.G. 67.63.1856.

royal cult rub the bones of his predecessors with oil. They also witness enthronements, at which time the regalia in which the new chief's body will be dressed are placed on the seat (Gebauer 1979, 90). That is also true for certain baskets, covered with cowrie shells and beads: they belong to the regalia of Kuba kings and can also be used by a few of their notables. These baskets are emblems in themselves and not because of any object they might contain, as their function might suggest (Cornet 1982, 305). The same fate is reserved for the stool that every Akan chief—or at least, every one whose memory the people want to perpetuate—receives posthumously. These stools, in the shape of the Golden Stool, emblem of the Ashanti confederacy, are above all receptacles of power, and no one sits on them. The Golden Stool, for example, never touches the bare ground; in public, it is always exhibited reclining on its own seat, in a chair reserved for it. I have already mentioned the various uses Chokwe chiefs make of their chairs.

As the symbol of the kingdom's unity, the person of the sovereign becomes the site where all the signs of that unity are brought together. Royal ceremonies, which for that reason must be spectacular, entail the exhibition of that body object covered with its emblems. Members of the court, wearing the insignia of their own offices, insignia that follow strict hierarchical rules of distribution, also participate in that theater production. As the emblems are deployed in these hours of royal festivities, whose pomp varies in level depending on the society, all spectators are invited to participate intellectually, affectively, and aesthetically in that shared art of celebration. In addition to their social and political role, the royal insignia and objects fabricated for the use of members of the noble lineage demonstrate a deeply aesthetic function, by their quantity, their brilliance, and their uniqueness. Beauty becomes in turn an emblem or value of power. When the *nyim* of the Kuba, Kot a-Mbeeky III, appeared dressed in his regalia (fig. 5), the magnificence of his costume, independent of the symbolic meaning attached to each of the pieces that compose it or to each of the motifs adorning those pieces, placed the beholder, confronted with that excess of splendor, in that zone of understanding where admiration can verge on fear. The same is true for the *asantehene*, when, on certain occasions such as the feast of the *odwira*, he moves about covered in gold and preceded by numerous servants bearing his emblems. The effect produced by that theatrical performance of royalty is no doubt attenuated today by the loss among African sovereigns of a large share of their political power and of their absolute power over life and death, which even recently they had over their subjects. The excessive weight of insignia covering the royal body attracts curiosity: the unique body language of the sovereign on those occasions is determined not only by etiquette, but also by the physical constraints—

the weight of the headdress and jewels, the ampleness of the cloth, and so on—imposed by certain costumes, which transform the man into a king, a being who, as we have seen, escapes normality.

The unity of the kingdom rests on everyone's recognition of royal authority, which is expressed, for example, in the proverbs and strong names invented by Fon sovereigns, and in the idea that the prosperity of the people depends on the king, the dispenser of material as well as spiritual benefits. The proliferation of regalia and other insignia of office observable in certain monarchies is maintained by the sovereign himself. Many kingdoms or chieftaincies possess treasuries, veritable accumulations of objects regularly exhibited before the public, recalling the sovereign's role as regulator and master of the flow of wealth. I have already noted the treasury of the Kuba *nyim*. The chiefs' residences in the societies of western Cameroon also house great quantities of objects, considered by the entire population to belong to the chief, but also to everyone. Treasuries of chieftaincies generally include regalia and other objects, obtained either through trade with neighboring chieftaincies, or through payments of tribute, or finally, through confiscation during wars. The composite character of these accumulations has been pointed out in the case of Cameroon, where the circulation of objects belonging to the treasuries of the chieftaincy demonstrates the close relations between these chieftaincies and the role of the treasuries in the assertion and display of their owners' power in relation to one another. Every chief promoted, sometimes in an authoritarian manner, the presence at his court of artisans or artists whose talents were likely to increase his prestige.[1] The annual feast of *odwira* in Kumasi, at which all the chiefs and vassals of the Ashanti were required to participate to show their allegiance, was also the occasion for a great display of wealth on the part of the *asantehene* (Rattray 1927). The feast of *odwira*, consisting of a ritual lasting several days—the word *odwira* means "purification"—in honor of the deceased Ashanti kings, concerned the whole of the Ashanti people; all the nation's altars dedicated to their gods and ancestors, as well as houses, regalia, and so on, were ritually cleansed of their impurities. This ritual corresponded to the coming of the first fruits and the harvest of the first yams, presented on altars and at the site where the remains of the deceased kings were stored. In short, the ceremony of *odwira* marked the end of one cycle and augured the success of the following one.

On that occasion, and to mark the change of cycle, all the royal gold ornaments were melted down, only to be recreated as new motifs and decorations (Rattray 1927, 126). The sovereign's role as multiplier of wealth was doubly marked at that time: first, by the exhibition of treasures and expenditures on luxuries called for by

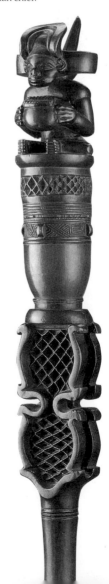

93. Scepter/snuffbox. Wood, twisted iron rod, and upholsterer's nails. Zaire, Shaba, Sandoa, Chokwe, Moxico style. Angola. Height: 47 cm. Tervueren, Musée Royal de l'Afrique Centrale, R.G. 41233. Collected between 1913 and 1915. This scepter belonged to a Chokwe chief of Sandoa. Wherever the chief made an official visit, a young boy preceded or followed him carrying the object and planted it in the ground where the chief stopped. The *mwanangana* is represented playing a lamellophone equipped with a calabash serving as soundbox. The net motif adorning the lower, "jigsaw" part, reproduces the grating on the cages in which the Chokwe used to keep birds, in order to enjoy their song (*Trésors d'Afrique* 1995, 325). It is possible that this motif alludes to the image of the musician chief.

such an event; and second, by the fact that part of that treasure in gold, once melted down, produced new objects, comparable at a symbolic level to the new fruits of the harvest. The creation of different forms required that artisans and artists of the court renovate their repertoire; each year was marked by the singularity of the gold regalia.

A king's accession to the throne seems to have been accompanied by signs indicating that a different era was beginning. We have seen that the Fon king, at the time of his enthronement, inaugurated his reign by creating mottoes, strong names, which were transcribed into iconography. The sovereign of the Kuba did the same: his installation led to the construction of a new capital. In passing through it, he gave each street a motto characteristic of his reign; to this motto, others would be added, concerning the capital itself, his reign, the new name he chose for himself, and the *ibol*, or emblem, designed to adorn his effigy, the *ndop* (Vansina 1964). Sometimes the king himself participated, and still participates, in the invention or introduction of new motifs, objects, and insignia. Certain Kuba kings, in addition to their particular *ibol*, left their descendants motifs that have since passed into iconography and bear their name. The very rich repertoire of motifs used by the Kuba includes a certain number invented by kings preoccupied with fame, such as an interlaced design called *mikomingom*, meaning "drum of Mikobi," created by the *nyim* Miko mi-Mbul to adorn one of his drums of office (Cornet 1982, 169). In the chants that celebrated these kings, an allusion was always made to the new element they contributed. That innovation, coming from this unique individual on whom the very existence of the kingdom rested, not only manifested a desire to add a decorative supplement to an art that, among the Kuba, was already rich in that respect; it also stemmed from the desire to contribute to the enrichment of everything representing the kingdom. The multiplication and proliferation of insignia and their decorations ought to be considered a process that reproduces on a smaller scale that prevailing for the kingdom as a whole, including the increase of wealth and power. The chief wished to leave the memory of his name to posterity. When they were enthroned, Ashanti chiefs invented a new decoration and design for their personal seat. The meaning of that design, formulated into a motto, was then committed to memory by the people. The chiefs of the Cameroon Grasslands did exactly the same thing, sometimes creating their works themselves, thus augmenting their reputation as monarchs and as artists. Tradition mentions the talent of some of them, such as Chief Garega, a great bead artist from the end of the nineteenth century, or the chief of Babanki-Tingo, whose works attained such prestige early in the twentieth century that Njoya, the sultan of the Bamum, at the time the most powerful person in the region, acquired one of them. History tells us that Njoya sent a delegation to

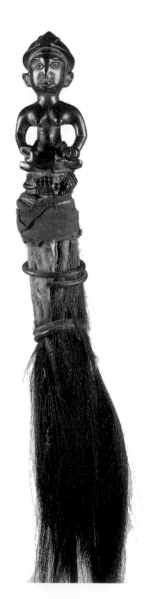

94. Flyswatter handle. Nineteenth century. Wood. Republic of Congo, Kongo (Kunyi). Height: 12 cm. Brussels, private collection.

Babanki, a four-day journey on foot from Fumban, the capital of the Bamum, to take possession of a ceremonial bed he had ordered. Upon its arrival, the delegation discovered that the creator of the work was none other than the chief himself (Perrois 1993a, 494; Perrois 1993b).

Crowns, headdresses, royal staffs, seats, ceremonial weapons, goblets, drinking horns, and ornaments composed a set of objects that adorned and surrounded the king; the right to use the forms, ornaments, and sometimes even the materials characteristic of them fell to him. The fact that certain distinctive elements of these models may be found in objects used by other people visually marks the royal hegemony. Hence, a number of objects possessed by the sovereign's entourage and members of the noble lineages are beholden to stylistic and aesthetic qualities proper to the royal insignia, and share part of their iconography. The monarchy establishes its ubiquity through the proliferation of court objects; in that way, it indirectly shapes society by organizing it into a strict hierarchical order. Jan Vansina has noted the complexity of this system of emblem distribution among the Kuba, whose rule extended to other African monarchies. Of course, supreme insignia—such as the kaolin with which he is anointed during his enthronement, the basket covered with cowrie shells on which he sits at the time, his drum of office, a scepter of a certain type, a particular sword, costume, or bow—are reserved for the king's use. The king shares certain emblems with all the chiefs included within the Kuba kingdom, and still others with the great dignitaries of his court. The logic organizing the differentiation of insignia and determining the social position of those who wear them may be a reflection of the logic that orders the objects of the world in general. Just as, among the Kuba, only the *nyim* and the chiefs of the chieftaincy wear the feather of an eagle, the most important bird in nature, other dignitaries, depending on their rank, sport feathers from different birds; the order prevailing among men reproduces the order supposedly organizing the animal world. Each of these insignia, Vansina recalls, bears a name—sometimes associated with a motto or particular narrative—alluding to certain deeds or certain aspects of the kingdom's history, so that "the whole ideology of the kingdom can be deduced from the meaning" of these insignia (Vansina 1964, 107–111). The distribution of the insignia and of the roles they designate reveals the composition of power, according to which an equilibrium between the supreme authority held by the king and that possessed by the chiefs and dignitaries, representatives of the community, has to be maintained. The circulation of these insignia does not end with members of the court and chiefs of the regions integrated into the kingdom; it extends to vassal or allied chieftaincies as well. Thus objects and styles travel far from their place of origin and are then liable to modify local creations. Out of gratitude for services rendered, the

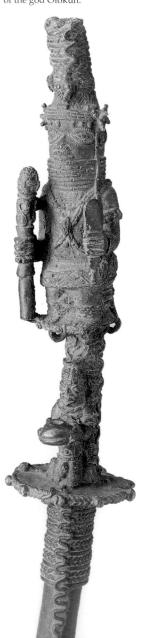

95. Scepter. End of eighteenth century. Brass. Nigeria, kingdom of Benin, Edo. Height: 68 cm. Vienna, Museum für Völkerkunde, Inv. 64724. The *oba* is depicted seated, holding a neolithic ax or "thunder stone" in his left hand, recalling his supernatural powers, and what might be a rattle staff in his right. Beneath him, a kneeling figure presents an offering of a box containing kola nuts. The shaft of the scepter is decorated with several motifs representing pythons, animals related to the world of the god Olokun.

asantehene, supreme chief of the Ashanti confederacy, had the habit of sending honorific rewards. It is because of this that numerous court objects and regalia from the Ashanti—chairs, parasols, and ceremonial swords—have been found in non-Akan regions, among the Nafana, whose territory extended to the north of Ashanti lands. René A. Bravmann, in his study of the relations between a small Nafana chieftaincy and the *asantehene*, demonstrates that the quantity of gifts distributed from Kumasi was proportionate to the political and military loans provided by the Nafana chieftaincy, and that the diffusion of these insignia among the Nafana led to the adoption of a certain number of rites and ceremonies from which these objects could not be dissociated. The objects also brought with them linguistic terms allowing them to be designated and used, and the rules regarding their circulation within society (Bravmann 1972). The diffusion of these prestigious objects among non-Akan communities was part of the policy of expansion and control of the territories practiced by the *asantehene*, and introduced traits of Ashanti culture into them. Perhaps more than other groups, the Ashanti knew how to use the power objects possess, wherever they happen to be found, to carry inscribed within them the function for which they were conceived. In addition to their function, the Ashanti imposed rules of the objects' use on the peoples they wished to dominate, rules that tended progressively to transform their social and political institutions.

Among the most widespread insignia of high position were royal staffs and ceremonial weapons—spears, swords, axes, and throwing knives (figs. 90–105). Note that the primary utilitarian role of these weapons or, to a certain degree, of these staffs—i.e., to be deadly—is diverted in favor of their symbolic function; such is also the fate of numerous insignia. The workmanship of the *eben* brandished by the *oba* of Benin (fig. 103), or of the *afenatene* exhibited by the *asantehene*'s messengers (fig. 105), does not allow its bearers to cut off heads or rend the enemy in two. However, their original vocation, both aggressive and defensive, hence protective, persists: the ceremonial swords the Ashanti keep in the residence housing the royal seats are supposed to protect the seats, and the altars that accompany them, and to hold the power they receive from the gods (Cole and Ross 1977, 147). The royal staff, which we are accustomed to call a scepter, must also be generally regarded as a transformation of the weapon any stick represents into a potentially dangerous instrument, as the manifestation of a power that is not directly physical but rather political and symbolic. In brandishing his royal staff, an "instrument to create distance," the king or chief exhibits his irreducible difference and the redoubtable authority he incarnates (Canetti 1966, 225). In that sense, the attention given to the ornamentation of these staffs or weapons seems to be proportionate to the extent

and sacredness of this power. In making the metal of his sword shine and in exhibiting its blade, the sovereign recalls the military function of that object and its capacity both to destroy all rivals and to create order. Let us recall that the use of metal weapons is closely associated in African societies, and certainly elsewhere in the world, with a symbolics of metallurgy, in which fire plays a role of foremost importance in the metaphors associated with them. The gold shining on the hilts of Akan ceremonial swords has the brilliance of the flame that allows the artisan to smelt and forge them into blades, and of the fire that comes from the sky, lightning, considered to be the manifestation of the gods when accompanied by the sound of thunder. Lightning is also often called "the knife of rain." Among the Ashanti, ceremonial swords are some of the most important regalia, after the royal stools. The great variety of forms and ornaments found on them alludes to the equally great variety of functions and meanings attributed to them.

The use of ceremonial weapons and of royal staffs is not reserved for the sovereign, since the monarchical system requires that the right to insignia be shared, in a strictly hierarchical manner that dictates the type of insignia used by each person. In becoming diffused throughout the kingdom, emblems, conceived as so many manifestations of the sovereign's royal presence, are part of the extension in space of royal power, as the Ashanti example cited above attests. It is also through them that the king's word circulates throughout the territory and reaches the most remote areas. The powers of the sword, shared with the royal staff, are not expressed solely through the different practical uses that can be made of it, but also through all the metaphorical meanings linked to these uses, meanings that all attest to the monarch's authority. As a result, the staff and sword, or any other weapon, appear as the instruments best able to express the sovereign's orders in material form, since in the very definition of what they are (that is, weapons) they include in virtuality the sentence that might be imposed should the order they express not be obeyed. Staffs and weapons are materialized orders, laden with menace. Just as the circulation of emblems, in signifying royal ubiquity, maintains the unity of the kingdom, their multiplication disperses the many orders and imperatives throughout the entire territory.

Different examples abound to shed light on this fundamental role of the insignia. When the *oba* delegated the power of life and death over his own subjects to a chief, he had one of his ceremonial swords, called an *ada*, taken to that chief. The sword, presented in that way to its recipient, materialized the *oba*'s royal order: that is, the word itself was transformed into an object. Ashanti and Fon sovereigns proceeded in the same manner with their insignia. A misunderstanding of the meaning of these

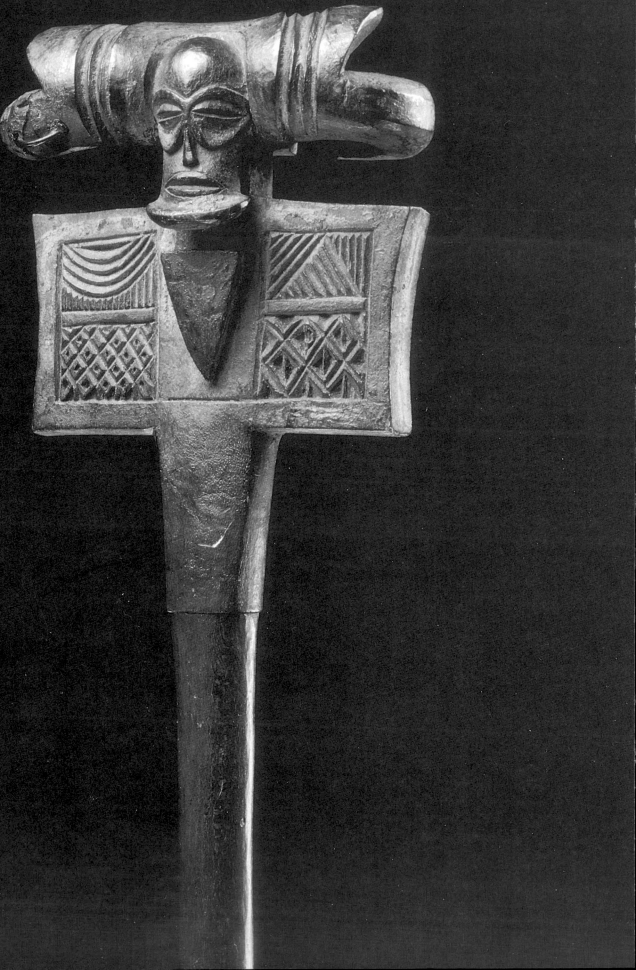

insignia could have grave consequences, as is illustrated by a famous story about the Ashanti. In 1881, an Ashanti sought refuge with the English, who had settled on the coast. The next day, a delegation of the *asantehene* arrived, equipped with one of the major regalia of the Ashanti, the golden ax, and demanded that the English have the refugee return to Kumasi, the capital of the confederacy. The English viewed the ax as a symbol of aggression and as a threat. Despite the new embassy sent by the *asantehene* and the advice of coastal residents, who explained the sense of the object to them, the Britons refused to back down. War was barely avoided, since the refusal of a demand made by an Ashanti delegation carrying the golden ax ought in principle to lead to a declaration of hostilities. According to the terms used at the time by an Ashanti prince, the golden ax is so old that no one knows its origin, and so precious that it must precede the Golden Stool, supreme symbol of Ashanti power, in any procession. Not only its form but also the materials that compose it recall its function and its nature. Fragments of leopard skin surround the handle, held in place by gold rings. The leopard skin gives the object the power possessed by the animal, a sort of counterpart in the wild of the king. Gold, the substance and solar color of Ashanti sovereignty, grants it the power of royalty, while the iron of the blade gives it strength (McLeod 1981, 106–7; Appiah 1979, 65–66).

Thus, the insignia are the materialized words of the king. Within the framework of societies without writing, that assertion takes on a very particular value. Recall the role of Edo high reliefs and the motifs appliqued on Fon hangings, which record certain of the acts or events in the kingdom's history. As we have mentioned, through the display of these images on palace walls, fabrics, and other objects, the sequence and greatness of the different reigns are expressed. Court chroniclers continue to sing of these reigns: their voices respond to the images, and the alliance between voice and image ensures the integrity of the narrative, as if the image always had to accompany the word. The word, since it bears the sovereign's order, is necessarily linked to the manipulation of the royal object. However, it can also appear in the form of the little vignettes I have described among the Fon, as a transcription of strong names. That same royal word, circulating in the form of an illustrated proverb, is also found among the Akan, inscribed in an image sculpted in the ornaments of swords, at the top of linguist or messenger staffs, called *okyeame poma* among the Ashanti (fig. 91), or on large parasols that protect the chiefs. It is also found among the Fon on the crook of the *recados* (fig. 83) and on the fabric of parasols, hangings, and banners.

The finials of Ashanti linguist staffs (fig. 91) display a very rich iconography, sometimes shared by other objects, such as weights for weighing gold. The role of

(facing page)
96. Top of scepter with chief's head. Wood. Angola-Zaire, Chokwe. Height: 44 cm. Brussels, private collection. Copyright Archives Musée Dapper.

(below)
97. Scepter. Wood. Tanzania, Nyamwezi. Height: 46.4 cm. Tervueren, Musée Royal de l'Afrique Centrale, R.G. 79.1.656.

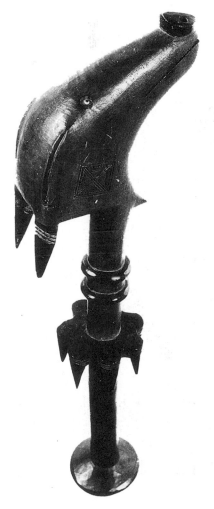

98. Arrow holder (upper part). Nineteenth century. Wood. Zaire, Luba. Height: 74 cm. Brussels, private collection.

linguist or messenger, *okyeame*, let us recall, is among the most important existing within the Ashanti confederacy. (The same is undoubtedly true for any kingdom.) In addition to dealing with court matters, the *okyeame* in Ashanti is responsible for transmitting the king's words and orders into different regions, among the various vassal or allied chieftaincies, and even to the enemy. The *okyeame* is more than an interpreter: the success of political operations undertaken by the *asantehene* depends on him, and he is the *asantehene*'s key adviser. "There are no bad chiefs, there are only bad messengers," says an Akan proverb. All the bellicose kingdoms of western Africa granted a very special place to these dignitaries who, equipped with their insignia, bore the heavy diplomatic responsibility of ensuring the success of royal policy and maintaining peace. The *asantehene* always had twelve of these ministers in his service, while the chiefs of lesser rank had between four and eight apiece (Cole and Ross 1977, 160). That indicates the importance even today of these bearers of the king's or chief's word. Among the Fanti, these interpreters were called "chief's wives," since, like his wives, they were the only ones who could come in at night and wake him up (Cole and Ross 1977, 160).

The history of the ornamentation of these linguist staffs and their diffusion, as of the Fon *recados* to be discussed below, seems in part linked to the encounter between the Ashanti, and the Akan more generally, and the Europeans. There are two reasons for this. On one hand, when the Europeans introduced themselves to the populations inhabiting the coastal regions where they came ashore, they were themselves amply endowed with emblems indicating their status: canes, weapons, and staffs. On the other hand, the use of the same vocabulary of objects possessing similar functions provided the Africans and the Europeans with objects at hand to palliate the deficiencies of communication, made delicate by poor linguistic comprehension, by the absence of an African tradition of writing, and by the difficulties the Europeans had traveling to the interior of the continent.[2] Thus, the development of relations between the Europeans and the great kingdoms of western Africa—Benin, Ashanti, and Dahomey—may have favored the transmission of insignia, whose diffusion allowed kings to found their power visually and symbolically, particularly through the intermediary of these emblems accompanying embassies, which became very active during that time. The Europeans themselves never visited the different sovereigns without equipping themselves with flags, canes, and other staffs of prestige, the possession of which legitimated their own presence in these places. Malcolm D. McLeod recalls several anecdotes illustrating the attention that both Europeans and the Ashanti gave to these emblems, the exchange of which varied in proportion to the frequency of encounters between the two groups. Hence, in the

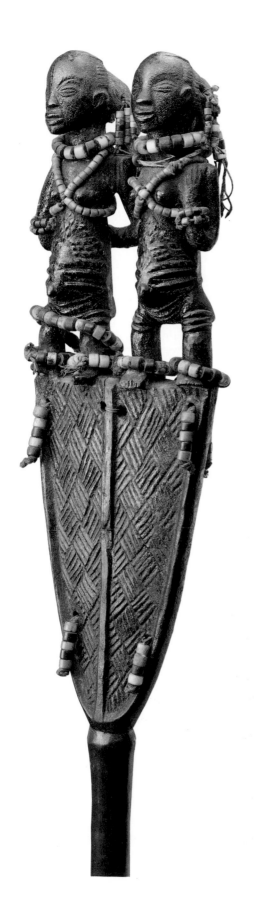

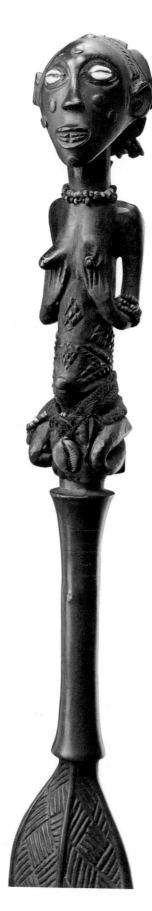

(left)

99. Handles of ceremonial canes, or *kibango*. Wood, iron, copper, brass, cowrie shell, crushed glass, fibers. Zaire, Luba. Height: (left) 151 cm (height of human figures, 12 cm); (right) 151.1 cm (height of human figure, 25.5 cm). Brussels, private collection. The cane on the left was photographed in 1916–18, being held by the chief to whom it belonged, adorned in his regalia (Neyt 1993, 124). These canes, veritable scepters, habitually include an iron rod at their base, which allows them to be planted in the ground. Luba statuary privileged the female figure, which is found on numerous objects of prestige: seats, pipes, arrow holders, ceremonial canes and axes, headrests, etc. The persistent feminine theme in iconography must be linked in part to the matrilinear organization of Luba society, with each effigy representing the founder of one of the dynasties. The *kibango*, or ceremonial swords, were part of the regalia and were passed on from generation to generation within the royal lineage. The sovereign did not move without that emblem, which was planted in the ground during ceremonies. At war, a scepter planted vertically in the battlefield signified victory. Each of these scepters has two broad, flattened parts adorned with geometrical patterns, one on top and one on the bottom, sculpted in the wood of the shaft. These patterns varied depending on the lineage. These flattened parts in the shape of diamonds, triangles, or hourglasses referred to the royal capital or center (cf. *Trésors d'Afrique* 1995, 356–57).

(below)

100. Canes. Wood, copper, iron (right); wood (left). South Africa, northern Nguni (Zulu). Height: 140 cm. (left); 89.5 cm. (right). South Africa, Johannesburg Art Gallery, Brenthurst Collection of Southern African Art, JC-C-64 and JL-C-10.

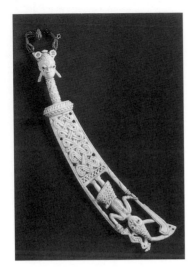

101. Ceremonial sword, *udamalore*. Nineteenth century (?). Ivory, wood or coconut shell, beads. Nigeria, Owo, Yoruba. Length: 51 cm. London, Museum of Mankind, + 897. Sword carried on certain occasions by the *olowo* and the great chiefs of Owo. The figure represents an Owo chief in ceremonial dress. On the left hip, he wears his own *udamalore*. With the right hand, he brandishes a sword; a bird is perched on his left. The term *udamalore* means "sword of the well-born" (cf. Ezra 1992, 282).

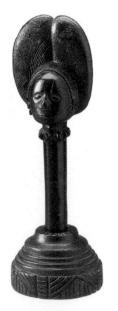

102. Ceremonial club. Wood. Angola, Ovimbundu. Height: 26.7 cm. Tervueren, Musée Royal de l'Afrique Centrale. R.G. 67.63.721¹/²⁻²/².

nineteenth century, one of the officers of a Dutch governor wrote: "The staff has not yet come back, I sent it yesterday but have not yet had a reply" (McLeod 1981, 97). The Europeans fabricated canes, staffs, and flags, which different chiefs received as a sign of their submission. Certain of these canes were adorned with figurines; the Akan turned that tradition to their own account to decorate *their* staffs. In the nineteenth century, the British created royal staffs, which they then handed over to the Ashanti chiefs and which served to designate their function during any dealings with the colonial government. As a result, even today some of these staffs, surmounted with heraldic figures such as the lion rampant, can still be seen (Cole and Ross 1977, fig. 331).

Even though the figurative character of the Ashanti linguist staffs or other objects, such as swords of the *afenatene* type, is the result of a European influence, it developed within a context in which figurative art already existed. The Akan use of funerary portraits in terra cotta, already observable at the very beginning of the seventeenth century, and the tradition of weights for weighing gold (fig. 86), attest to a clear tendency toward realism in Akan art. It would seem, however, that a certain historical context of great diplomatic activity encouraged the production of the images on linguist staffs. These images changed nothing in the function of the staffs, which were used well before the arrival of the Europeans; they simply specified their meaning in accordance with the circumstances, in that every envoy of the king had to be accompanied by his insignia. The Akan linguist staffs preceded their bearer, who held them up, exhibiting the royal word expressed by the sculpted end even before articulating it.

The images depicted at the top of the staffs, parasols, or sword hilts did not differ, in the manner in which they were conceived, from those we have already studied among the Fon; they were closely associated with proverbs—were, in fact, a visual transposition of them. Some may find it disconcerting that proverbs were so often the pretext for creating images, but this fact only reveals the position held by that form of discourse in social life, not only among the Akan and the Fon, but in African cultures as a whole. In such societies, the proverb does not play the role simply of a popular moral truth; it is closer to aphorism, and allows one to articulate social, political, or intellectual principles calling for commentary and reflection. In the Akan world, where the linguist is recognized as essential for maintaining the prosperity of the kingdom, the knowledge of numerous proverbs and the art of interpreting and assembling them are indissociable from the function of orator. The art of speaking well is therefore based on that of knowing how to manipulate proverbs to construct an argument: "We speak to a wise man in proverbs and not in plain language," confirm the Akan (Ross 1982, 56).

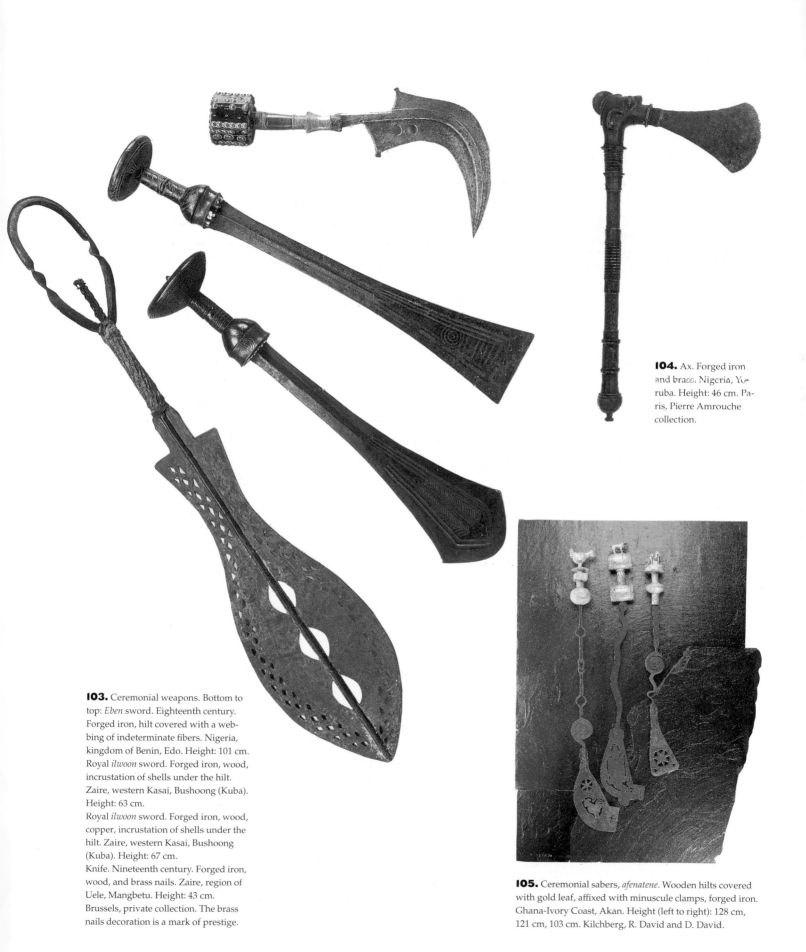

103. Ceremonial weapons. Bottom to top: *Eben* sword. Eighteenth century. Forged iron, hilt covered with a webbing of indeterminate fibers. Nigeria, kingdom of Benin, Edo. Height: 101 cm. Royal *ilwoon* sword. Forged iron, wood, incrustation of shells under the hilt. Zaire, western Kasai, Bushoong (Kuba). Height: 63 cm.
Royal *ilwoon* sword. Forged iron, wood, copper, incrustation of shells under the hilt. Zaire, western Kasai, Bushoong (Kuba). Height: 67 cm.
Knife. Nineteenth century. Forged iron, wood, and brass nails. Zaire, region of Uele, Mangbetu. Height: 43 cm. Brussels, private collection. The brass nails decoration is a mark of prestige.

104. Ax. Forged iron and brass. Nigeria, Yoruba. Height: 46 cm. Paris, Pierre Amrouche collection.

105. Ceremonial sabers, *afenatene*. Wooden hilts covered with gold leaf, affixed with minuscule clamps, forged iron. Ghana-Ivory Coast, Akan. Height (left to right): 128 cm, 121 cm, 103 cm. Kilchberg, R. David and D. David.

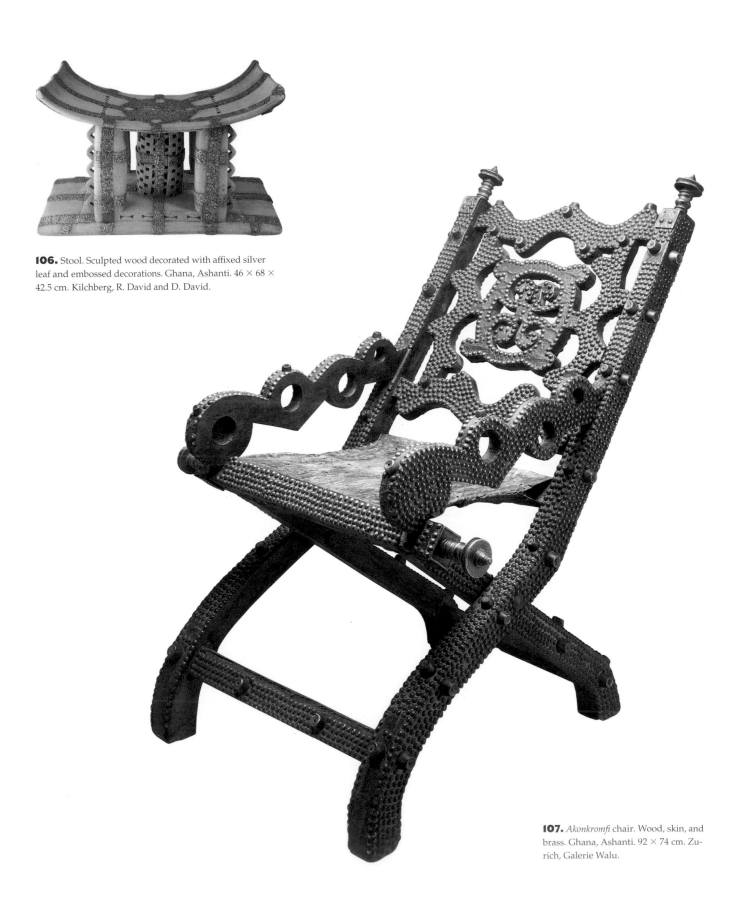

106. Stool. Sculpted wood decorated with affixed silver leaf and embossed decorations. Ghana, Ashanti. 46 × 68 × 42.5 cm. Kilchberg, R. David and D. David.

107. *Akonkromfi* chair. Wood, skin, and brass. Ghana, Ashanti. 92 × 74 cm. Zurich, Galerie Walu.

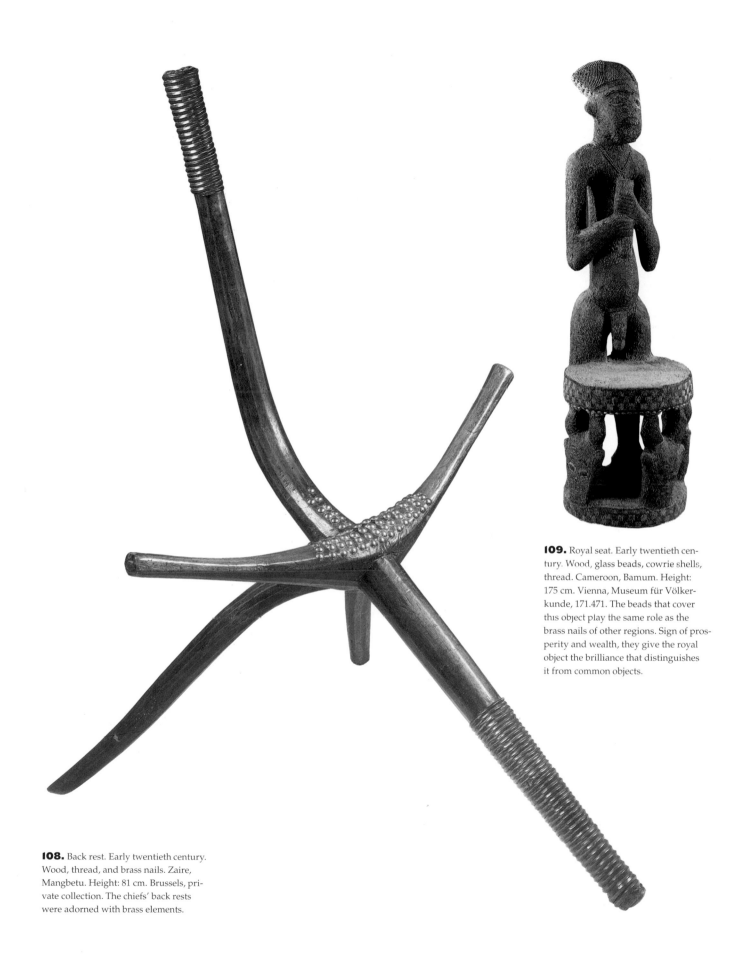

109. Royal seat. Early twentieth century. Wood, glass beads, cowrie shells, thread. Cameroon, Bamum. Height: 175 cm. Vienna, Museum für Völkerkunde, 171.471. The beads that cover this object play the same role as the brass nails of other regions. Sign of prosperity and wealth, they give the royal object the brilliance that distinguishes it from common objects.

108. Back rest. Early twentieth century. Wood, thread, and brass nails. Zaire, Mangbetu. Height: 81 cm. Brussels, private collection. The chiefs' back rests were adorned with brass elements.

110. Stool. Sixteenth century. Brass, lost-wax casting. Nigeria, kingdom of Benin, Edo. Height: 34 cm. Nigeria, Lagos, National Museum, 53.22.11. The motif of the silurids, fish belonging to the realm of the god of waters, Olokun, is one of the symbols of Edo royalty.

111. Stool. Twelfth to fifteenth century. Quartz. Nigeria, Ile-Ife, Oluotorogho Island. Height: 53 cm. London, The Trustees of the British Museum, 1896.11.22.1. This stool, given by the *oni* Adelekan Olubushe to the English in 1896, is from the religious material of an altar dedicated to the god Oluorogbo. The form of this seat is found in a few other art works of Ile-Ife, in metal (zinc and copper) and in terra cotta.

The linguist staffs can thus be regarded as emblems for proper speaking. The knowledge of the meaning of the image adorning the top of each staff allows the recipient of the message to immediately seize at least a part of the meaning, since the staff is chosen on the basis of the mission that the one bearing it must accomplish. One might even say that in this case of a "word" exhibited at the end of a cane, the image that takes the place of the word provides the key to interpreting what accompanies it. In this context of the transmission of a discourse, the historiated part of the staff performs a completely different function from that performed when it adorns the top of a parasol; in the former case, it is liable to intervene directly, through the meaning effects it produces, in the exchanges and negotiations between the different parties. That property of the historiated staff did not escape either the Akan or the Fon.

It is not possible to present the iconographic repertoire of these staffs here. I will describe only a few of them by way of example.[3] Among the most common scenes is that of two birds of prey, one of which sits on her eggs while the other stands over her, perched on a sort of handle (fig. 91). Other representations adopt the same composition, in which different elements are superposed: thus, a lion is seen drinking from a pot placed on the head of a leopard, while an antelope looks at the scene; or a small antelope climbs on the back of an elephant. The Akan may use that rule of superposition to express a single fundamental idea, which is then applied to different situations evoked by the figures used. The figure placed in the dominant position always refers to the omnipotence of the king and the state. Although the elephant (fig. 91) and the leopard are the most common emblems for it, they may sometimes occupy lower positions and thus change in meaning. Hence, the motif of the elephant bearing an antelope on its back visually transcribes a proverb recalling the superiority of intelligence over brute force. In the case of the motif of the two birds of prey, one of them sitting on her eggs, the birds are also associated with the royal person. This is an allusion to the eternal nature of dynastic continuity, which is assured whatever the circumstances. In other words, there is always a chief at the head of the state. The scene depicted may not be a superposed composition, but may refer indirectly to a single conception of royal superiority. The motif of the chicken and her chicks alludes both to the chief's dominant position and to his responsibility toward his subjects. The Akan use other rules of composition, visually translating the idea of unity either through a sculpted scene or, more simply, through a symbolic motif.

The first case is a scene in which three men have a necklace depicting the rainbow around their necks. This scene depicts the role of the *asantehene* as similar to the

112. Caryatid stool. Wood, Katanga, Luba. Height: 48.5 cm. Tervueren, Musée Royal de l'Afrique Centrale, R.G. 17193.

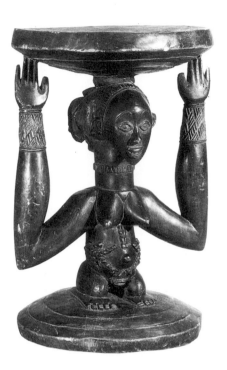

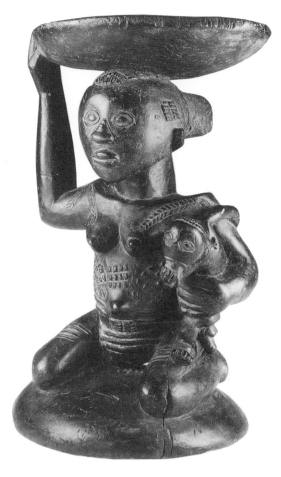

113. Caryatid stool. Early twentieth century. Wood. Zaire, Luba. Height: 34 cm. Brussels, private collection. Seats in sculpted wood are reserved for kings and mediums. They were brought out only rarely and were considered the receptacles of the royal spirit. The ceremony of investiture ended when the sovereign sat on his seat to take an oath and address his people.

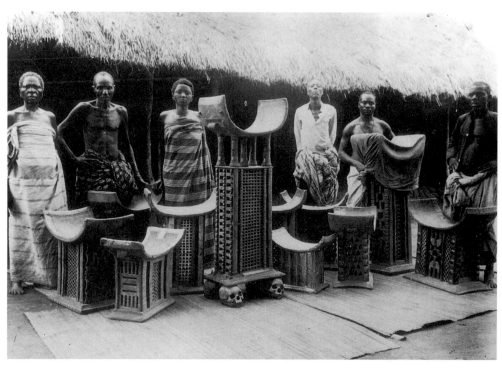

114. Presentation of the thrones of Fon kings. Benin, palace of Abomey. Paris, photo library of the Musée de l'Homme. In the center, the throne of Guezo.

115. Double royal goblet. Nineteenth century. Wood. Zaire, Luba (Kalundwe). Height: 11.5 cm. Brussels, private collection. The function of these anthropomorphic goblets is still largely unknown. They may have been used during rituals of enthronement, when the future king had to drink human blood from the skull of his predecessor. It is possible that these goblets, carefully kept safe from human eyes within the royal treasury, replaced the skull during these ceremonies (cf. *Trésors d'Afrique* 1995, 354).

116. *Kiteya*, or royal goblet. Wood. Zaire, Shaba, Luba. 28 × 44 cm. Tervueren, Musée Royal de l'Afrique Centrale, R.G. 3861. This goblet may have been used in a similar manner to that described previously (fig. 115). The cruciform headdress worn by the female effigy, called *kaposhi*, was reserved for chiefs and certain of their spouses (cf. *Trésors d'Afrique* 1995, 354–55).

rainbow; he holds each of his subjects enclosed within the bounds of his power. The same reference, not only to the unity of the people, necessary for the kingdom's stability, but also to the indestructibility of the link that unites the king to his subjects, appears frequently in the motifs of the reef knot and the chain, which adorn the shafts of linguist staffs (fig. 91). Among the Ashanti, the reef knot is also found on chiefs' chairs of the *asipim* type, generally sculpted in the wood of the bars, and on certain stools. Other scenes with more heterogeneous compositions recall that power is "food" that is not to be shared. Two men seated face to face at the same table suggest the following proverb: "Food is for the man who owns it, not for the one who is hungry" (fig. 91). Certain compositions evoke the force of power, which must not be underestimated—a young boy, symbol of naivete and inexperience, clings to a lion's tail. On other linguist staff finials, there are situations or figures from tales, in which the same principles are demonstrated. Finally, certain motifs make more precise reference to the history of the state's foundation, becoming for that very reason an immediately recognizable emblem of the state. The emblem of one of the Ashanti states, Ezumeja, is a dog carrying in its mouth a firebrand, which it holds over the three stones of a kitchen hearth. According to legend, it was a dog who, leading the future people of Ezumeja with a firebrand in its teeth, stopped and set it down on a hearth, thus founding the new state.

A few rules of combination, linked to the function attributed to the figure represented—such as the superposition of a lion on a leopard to express the superiority of one chieftaincy over another—make it possible to interpret the image. In addition, as is the case for the Fon, the system of allegorical signification used by the Ashanti allows them to create an infinite number of scenes or motifs, whose polysemy also seems unlimited. The general interpretations I have given do not do justice to them. This system of creating proverbs based on the same micronarrative has a great verbal and visual suppleness, adaptable to the contexts within which the interpreters are required to act. It serves the cause of the state in a particularly effective manner. The state remains the primary reference point for any interpretation of these motifs, through the multiplicity of model situations evoked by the images corresponding to the proverbs. To depict affairs of state, the Akan use a language both visual and verbal, grounded in the universally shared experiences provided by daily life.

In addition to the cane or staff, the Fon adapted another instrument to similar functions—namely, the *recado*. Travelers wishing to reach Abomey, the capital of Dahomey, had to wait in Ouidah, the port of the kingdom, until the royal *recado* arrived. They then took it back to the palace, the object serving as their passport

throughout their trip. The royal *recado*, a substitute for the king himself, was sent veiled, and was then uncovered at the site where the envoy uttered the message. As he listened to these words, the recipient of the message had to prostrate himself before the object (Mercier and Lombard 1959, 32–33).

Just as Akan linguist staffs are morphologically descended from the simple staff, the Fon *recado* may trace its origin to part of a common object, the wooden handle of the farmer's hoe. In fact, Fon sovereigns carry them in the same way, suspended from their left shoulder (fig. 2). The hoes used by peasants of western Africa are all composed of a wooden handle with one curved end, into which the metal blade is inserted and secured. The form of the blade differs according to use and region. That agricultural tool, which occasionally serves as a weapon or a seat, can be considered the external mark of the farmer's role: Its primary users consider it not a simple tool but a true insignia of their function. The Fon adapted that tradition by sculpting the curved end of the handle and adding metal or ivory ornaments to it. As we have seen, in the case of a royal *recado*, the whole object transcribes one of the king's strong names.[4]

The function of the *recados* is equivalent to that of the linguist staffs, though the iconography of the *recados* is less varied and less vivid than that of the staffs, as the examples reproduced in this book indicate (fig. 83). It is easy to recognize Agadja's *recado* by the stylized silhouette of the boat, whose two anchors mirror the three raised masts of the small craft. That silhouette suggests the famous taking of Ouidah by this same king. Glele's *recado* is also easily identifiable by the figure of the lion cut out of the metal part. Finally, the *recado* of Behanzin, who was dethroned by the French, takes a slightly different form: a wooden part depicting a fish replaces the usual metal part. This is the shark the king chose as his emblem during the conflict with the French. The French had their boats lying anchored in Cotonou, on the other side of the bar, and Behanzin decided to keep them from crossing the bar to come on land; in a war motto, he compared himself to the shark, who makes crossing the bar dangerous.

The general configuration of these objects suggests a creature equipped with a neck and head with an eye on each side, ending in a sort of muzzle into which the metal or ivory part is inserted. A similar adaptation of hoe handles can be found in other societies besides the Fon. Alexandre Adandé confirms this, describing a hoe in which the metal part is inserted into the back of the handle like a mane. The body of the *recado*, contrary to that of the Akan staff, thus reproduces that of a creature, perhaps an animal, from whose mouth the royal allegory emerges. That image proposes a visual transcription of the essential function of the *recado*, equivalent to that

117. Caryatid headrest. Nineteenth century. Wood. Zaire, Luba (Upemba). Height: 16 cm. Brussels, private collection. Only the sovereigns and great dignitaries possessed headrests. Among the Luba, headrests may have played a role of importance equal to that of the stool among the Akan. These objects were often buried with their owner, or in place of his body in cases where the cadaver could not be found. It is reported that the Yeke, during a conflict that set them against the Luba in the nineteenth century, burned their headrests without touching any other objects (*cf. Trésors d'Afrique* 1995, 363).

118. Bracelet. Nineteenth century. Silver. Benin, kingdom of Dahomey, Fon. Diameter: 14 cm. Paris, private collection. The lion, an emblem associated with the king, perhaps Glele, holds a man prisoner with its tail. Other motifs allude to royal power, such as the vultures and cannons.

119. Combs. Nineteenth century. Zaire-Angola, Chokwe. Left: Wood and brass nails. Height: 16 cm. Right: Wood. Height: 20 cm. Brussels, private collection. The comb on the right depicts both the chief and the *cihongo* mask, reserved for the *mwanangana*, or lord of the land.

of linguist staffs, namely, to circulate the royal word. The *recado* also depicts the word in motion which, as such, is represented by the allegorical part of the object coming from the "mouth" of the creature sculpted in the handle. *Recados* express a royal word always uttered in the imperative mood, a word that sounds like a threat. The chief or king's word becomes a weapon. If, in the case of the *recado* or staff, the weapon disappears behind its representative function, other objects of prestige transcribe perfectly that visual metaphor of the king or chief's word dispensing justice, and sometimes committing murder. Examples abound in Africa (central Africa in particular) of these instruments—axes, adzes, sabers, or swords—in which the blade emerges from the mouth of a figure sculpted in the handle (fig. 104). These weapons, whose use is always reserved for chiefs, frequently perform the function of insignia for messengers.

The emblems of royalty, in particular the regalia, are by definition sites of strong symbolic investment. These include royal staffs, weapons, and *recados*, as well as seats, headdresses, costumes, adornments, or certain materials, such as gold powder among the Akan or kaolin among the Kuba. All these emblems gravitate around the royal body. Others maintain no relation of physical proximity to him, even though, as substitutes for royalty, their importance is equal to that of the other regalia. These external marks covering the royal body do not simply glorify the power of the man who wears them. Through the images sculpted on the staffs used by the Akan or the Fon, they visually represent different classes of beings or things as they are manifested to man in the universe. Thus, they also inscribe the king at the center of the system of symbolic relations that governs the world and makes it intelligible.

The sovereign never sits on the bare ground for reasons already mentioned, among them the presence of the power he carries within himself, which is likely to burn or dry out what he touches. In numerous African societies, leopard or bull skins are used as the support on which he sits, and may be considered "seats," inasmuch as they prevent the royal body from having any direct contact with the ground. When the Gourmantche (Burkina Faso) say of the chief that "he is seated on his skins," they are expressing the idea that the exercise of power is assimilated to a position, the seated position, on a support, in this case the skins (Cartry 1987, 136). Other "seats" also receive the bodies of kings: mounds of earth, platforms, or slaves. Ancient documents attest to this practice. An engraving from the seventeenth century shows the queen of a small state located in a region of present-day Angola, seated on the back of a slave on all fours, as she receives a Portuguese embassy (Cavazzi 1690). A famous photo taken in 1908 of the Kuba king Kot a-Pe captured him in an identical posture, surrounded by members of his court.

The attitude of royal sovereignty is the seated position. It is in that position that the king or chief directs, judges, and receives delegations of his own people and of foreigners. When the king moves, he remains seated, in a litter or on horseback; if that is not the case, his "seat" follows him. Akan or Chokwe chiefs do not move without their stool bearer. The representative function of the supreme authority proper to the seated position is also found in images. The *ndop* of Kuba kings depict the sovereign seated cross-legged on the royal platform. Fon kings use the image of their stools in visualizations of their strong names. The *oba* of Benin appears in the bas-reliefs of the palace seated either on a stool or on a horse; when he is standing up, he always leans on the two dignitaries, who accompany him and seem to support him as a seat would do. Similarly, the effigies of chiefs from the Cameroon Grasslands show them all seated on their seats, brandishing the insignia of their power.

"When seated, a man uses another's legs." That reflection by Elias Canetti takes on all its meaning when we consider African practices in which men and animals are likely to become the master's "seats." "When someone was seated, it was because he had taken a place over the others, his subjects and slaves," continues Canetti. "While he was seated, they had to remain standing" (Canetti 1966, 413–14). The seated king or chief dominates his subjects. He also dominates them visually, in that the seats are frequently placed on a platform. That position allows him to remain completely motionless, an immobility that is further accentuated by the heavy regalia covering his body, which presses down with all its weight, real and symbolic, on the seat. Sometimes, other parts of the body, the feet for example, also have a right to a "seat." The feet of the *asantehene* and other great Ashanti chiefs also rest on a support (fig. 7). The seated position, as Elias Canetti notes, accentuates the weight of the body and inscribes it in time, unlike the standing body designed for mobility. In Egyptian statuary, the bodies of gods and men, pharaohs and dignitaries, have their feet joined when they are seated, but their left leg forward when they are standing. Michel Cartry notes the meaning of the term *kali* in Gourma; it signifies "to sit down" but also "to fix one's residence" (Cartry 1987, 136). Seated on his skins, the king is located on his seat in the center of his kingdom, and becomes the very sign of that center. To sit down is to fix oneself in a place, and the quintessential place can only be the royal "seat." In Africa, it is often on this seat that the king or chief is enthroned and receives the insignia of his office. Wherever the chief sits down, he is enclosed within an area that circumscribes his person. This area is often marked in another way: the great parasols the Akan or Fon hold over their chiefs or their regalia do not serve so much to shelter them from the sun as to draw

120. Crown. Gold, lost-wax casting, and red felt of European origin (inside). Ivory Coast, Baule. Height: 8 cm; diameter: 18 cm. Kilchberg, R. David and D. David. Four bird motifs adorn the periphery.

(facing page)
121. Necklace. Gold-plated copper alloy, lost-wax casting, beads. Ghana, Ashanti. 75 × 27 cm. Kilchberg, R. David and D. David.

around them the invisible borders of that sacred space, in the center of which they are seated or carried (figs. 7 and 14). Just as the chief must be separated from the ground by the leather of his sandals, so his head, always covered, must be "isolated" as it were from the sky extending over it. The chief moves in a sort of intermediate space, protected from excessive light and from contact with the two expanses formed by land and sky. In fact, Akan chiefs never move without being protected by a parasol. The shields raised by dignitaries on each side of the *oba* and his mother may have an identical function.

The same rules of attribution prevail for the seats as for other insignia of office. Among the Bamum, for example, the king sits on a throne covered with beads; the queen mother, the king's maternal uncle, his half-brothers by his mother, and his advisers have the right to hippopotamus or buffalo skulls; his key aides to unsculpted logs; and all others to the bare ground (Tardits 1980, 746). The motifs adorning the Bamum royal seats all represent human beings or animals associated with royalty—the two-headed snake, the leopard, the human figure holding his chin in a sign of respect, and so on.[5] An identical principle of distribution is applied to Akan seats, but at a greater degree of complexity, which takes into account their number and diversity.[6] Akan seats are objects all of a piece, all corresponding to the same general model, two parallel pieces of wood linked by a central vertical trunk (fig. 106); this model was also adopted by the Fon for their own royal seats (fig. 114). It is the central, more elaborate part that allows one to identify the recipient of the honorific seats. Each chieftaincy has a recognized motif, and gives its name to the seat as a function of the motif sculpted. Certain of the motifs of the central column were once reserved for the *asantehene*. There are repeated references to him in this context: the leopard, the elephant, the circular rainbow, or the porcupine, a war emblem. The seats belonging to the *asantehene* and the queen mother have plating of gold or silver leaf with embossed decoration; certain chiefs also have the right to these decorations in silver leaf.

Akan seats do not deviate from the practice which, in that region, seems to dictate that every object be associated with a proverb. However, contrary to what occurs for the linguist staffs or for weights for weighing gold, the visual language used only rarely resorts to a figurative expression, with the exception of the royal seats, on which the elephant and leopard appear. Cut into certain central parts, the motif of the reef knot can be found on the shaft of linguist staffs. All the other motifs belong to a vocabulary of abstract signs, perhaps reminiscent of the *adinkra* motifs the Ashanti print on fabrics for funerary use. Robert S. Rattray and other authors have proposed an Islamic influence for these patterns (Rattray 1927, 265). That influence

122. Royal crowns, or *ade*. Fabric, glass beads, thread. Nigeria, Yoruba. Height (left to right): 42 cm (120 cm with fringe), 46 cm (85 cm with fringe), 49 cm (110 cm with fringe). Zurich, Galerie Walu. Among the Yoruba, the use of beaded objects is reserved for those who represent gods or communicate with them: kings, priests, diviners, and healers. According to custom, it is the god of creation Oduduwa, dwelling in the forests of Ile-Ife, who first wore the crown with beaded fringe curtain and established it as the supreme image of royalty. He placed similar crowns on the heads of his sixteen sons and sent them to found the different kingdoms of the Yoruba world. Traditionally, one or several birds are perched on the top of these crowns. Other motifs are sometimes found, such as chameleons, elephants, and human figures. Faces with prominent eyes appear on the sides of the conical part. The fringe hides the face of the king in public ceremonies so that any face-to-face encounter will be avoided. Such encounters are thought to be dangerous both for the king himself and for the one who looks at him. The same idea is also expressed in the fringed headdress of the *mwami* of Rwanda (fig. 4). The birds adorning the tops of these crowns are found on forged iron canes used for divining and on brass sculptures used in the cult of the earth. The figure of the bird was also once linked to witchcraft. The fact that the king's head was topped with one or several birds might bring to mind his clearsightedness and his capacity to manipulate supernatural powers for the benefit of his people (cf. Thompson 1972). The motif of the eyes dispersed around the periphery of the crown may refer to the sovereign's gift of second sight.

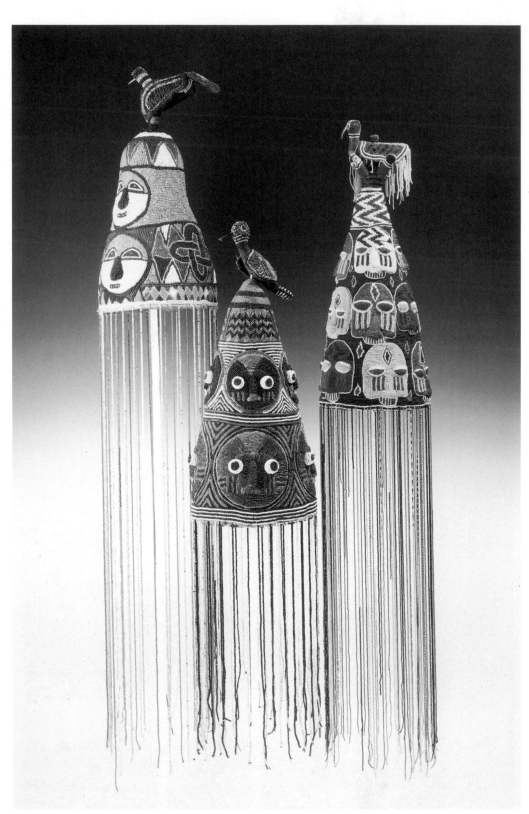

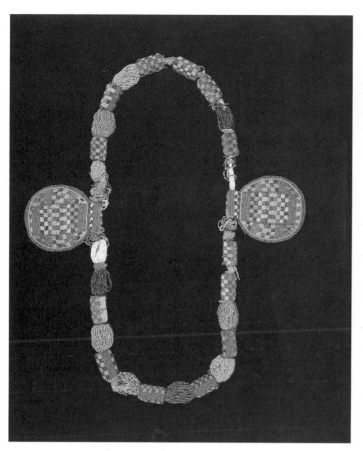

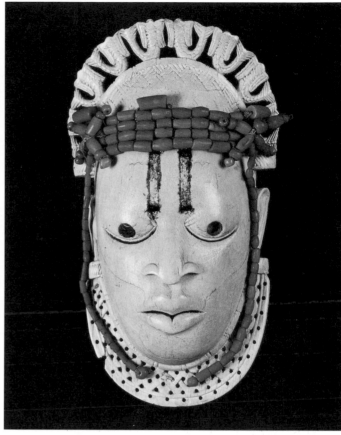

123. Necklace. Beads and thread. Nigeria, Yoruba. Circumference: 175 cm; diameter of medallions: 16 cm. Paris, Archives Leloup.

(above)

124. Costume ornament. Early sixteenth century. Ivory, coral and glass beads, traces on the forehead of iron ornaments, bits of encrusted stone or fruit (on pupils). Nigeria, kingdom of Benin, Edo. Height: 20.3 cm. Stuttgart, Linden Museum, 1954, F 50 565. Unlike that of Ile-Ife, the gaze is expressed in the brass and ivory statuary of Benin. A series of silurids, emblems of sovereignty, forms the top of the headdress. The materials (ivory and coral) confirm that this is a royal object. Like the mask in the British Museum, it represents a queen mother and may have been used by her son during commemorative ceremonies. Worn by the *oba* and dignitaries on the left hip, these masks camouflaged the pagne knot.

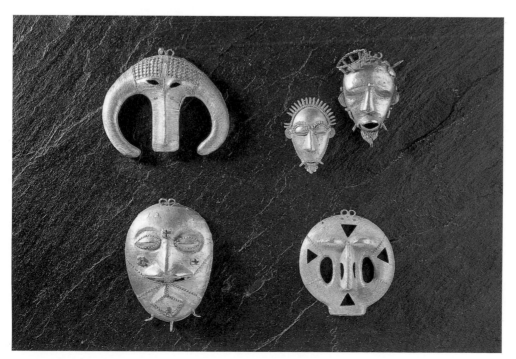

(left)

125. Pendants. Gold, lost-wax casting. Ivory Coast, Akan. Left to right, beginning upper row: ram's head, 8.5 × 10 cm; face (Baule), height: 6 cm; face (Baule), 7.5 × 5 cm; face, 10 × 7.5 cm; face (Ebrie), 8.5 × 7.5 cm. Kilchberg, R. David and D. David.

appears more obviously in the decorations fashioned by embossing the metal leaf fixed onto these seats. Nonetheless, the proverbs or aphorisms to which both the motifs of the central column and those in gold or silver leaf refer are indistinguishable from the adages represented on linguist staffs and weights. The motif of the circular chain on the seat of Chief Kwaku Dua recalls that a chief must display the potency of his power to his subjects. The motif of the seat chosen by the *asantehene* Prempeh II, a reef knot or "wisdom knot," signifies that this *asantehene* preferred to govern by relying on perspicacity and moderation rather than brute force (Fraser 1972, 144).

Among the Akan, the seat does not play merely a utilitarian role, however prestigious it might be. It also performs precise political and spiritual functions. The Akan, whatever their status, maintain a very particular relationship with their stools, which the Ashanti express by asserting that "there are no secrets between a man and his stool" (Fraser 1972, 143). That object plays a role in all the important moments of the individual's life. A first stool is given to the child when he begins to walk; a stool is conferred on the young girl during the rites of puberty; and the young bride receives one from her husband. As the individual's personal property, it can be used only by that person. All these provisions, moreover, are not confined to the Akan. What may be more particular to them is the fact that the personal seat is conceived as the site where one of the spiritual principles of its user dwells. This principle is called *sunsum* by the Ashanti. Each time he sits on it, the owner transmits a little of this principle to the object. In this respect, the Akan chief's stool is doubly vested with *sunsum*: that of its owner and that of the founder of the lineage the chief represents. In that sense, the stool must also be regarded both as the receptacle of the spiritual principle of *sunsum*, which all the chiefs of the same lineage transmit from one to the other, and as the receptacle of power itself. Thus, among the Ashanti, the same term, *dua*, designates both the power and the stool. The term designating the stool can also serve to name a power that is not essentially political: the guilds of court artisans in Abomey each have at their head a chief who, as such, is "master of a stool" (Mercier 1962, 203). The possession of a stool legitimates the Akan chief's authority over a territory and over the people who inhabit it. In contrast, chairs of European inspiration—such as the *asipim* or the *akonkromfi* (fig. 107)—used by Akan chiefs and dignitaries do not play any role of this kind. Each lineage also possesses a stool in which the founder's spiritual principle of *sunsum* resides, and the founder thus protects all his living descendants. The function of the Akan stool may suggest that attributed to the head among the Edo; however, while the function is comparable, its representation differs. The altar to the Head which the *oba* wor-

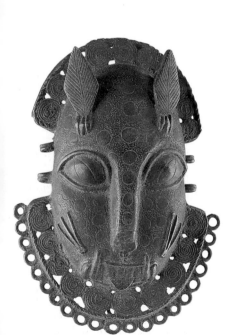

126. Costume ornament. Sixteenth century. Brass, lost-wax casting. Nigeria, kingdom of Benin, Edo. Height: 17 cm. Zurich, Galerie Walu. Same use as in fig. 124. The leopard-head pendants seem to have been worn for the most part by military chiefs. The motif of that animal, conceived as the double of the *oba* in the savage world of the forest, was reserved for men of war (it is found on other parts of their costume). This is easily explained: warriors, invested with the redoubtable force of the king, are then able to carry out their work under his protection.

ships is a metal effigy depicting a part of the king's body. The Akan also honor their stools; in this case, however, these stools do not reproduce a corporeal element but rather an object whose form is conceived as a function of a corporeal use.

The most important of the regalia in the Ashanti confederacy is a seat, the Golden Stool, *sika dua kofi*, or "golden stool born on a Friday," whose general shape resembles that of the Akan seats. The history of that stool, the receptacle of the *sunsum* of the entire Ashanti people, is the history of the Ashanti nation's foundation, the work of Chief Osei Tutu, who reigned in the early eighteenth century (Rattray 1932, 288). Following a war that liberated it from the suzerainty of the kingdom of Denkyira, a priest of this kingdom, called Anotchi, revealed the stool to Osei Tutu. As with numerous consecrated objects, the origin of the Golden Stool is supernatural. Myth tells us that the object came down from the sky one Friday, enveloped in a black cloud rumbling with thunder, in the midst of dust. The stool did not touch the ground but set itself on the knees of Osei Tutu. Anotchi decreed the set of rules governing the use of the sacred stool and the prohibitions its ownership imposed on the Ashanti: the stool could not be used as such, could not touch the ground, and could not be destroyed or stolen, without bringing about the destruction of the Ashanti nation, whose power and prosperity were so to speak contained within that object (Rattray 1923, 289).[7]

The Golden Stool cannot bear anything but the spiritual principle of *sunsum* of the Ashanti nation; on certain great occasions, the *asantehene* pretends to sit down on it three times before using his own stool. As the other guarantor of the power and prosperity of the nation, only the chief, in whom royalty is incarnated as it were, can recall through a simulated gesture the function the sacred object implies by its form, that of a support. But that occasion is above all a fleeting conjunction between the Golden Stool, the most sacred manifestation of royalty, and the person on whom the mystic responsibility of representing it falls. The stool is brought out only on rare occasions: during the enthronement of the new *asantehene*; at moments when he summons the most important chiefs to deal with affairs of state; and during the *odwira* and *adae* ceremonies bringing together the Ashanti people. At such times, the Golden Stool lies on its side on a particular chair devoted to it, which is covered with silver plating. It is placed next to the stool on which the *asantehene* sits. This special chair bears a name, *hwedomtea*; *hwedom* means "that which looks at the retreat of the enemy." On these solemn occasions, the presentation of the Golden Stool on its own throne posits it as the true chief of the Ashanti nation; as such, regalia are attributed to it—parasols, elephant skin shields, blanket, drum, lute—as well as a personal guard (Fraser 1972, 142). That exhibition of the Golden Stool,

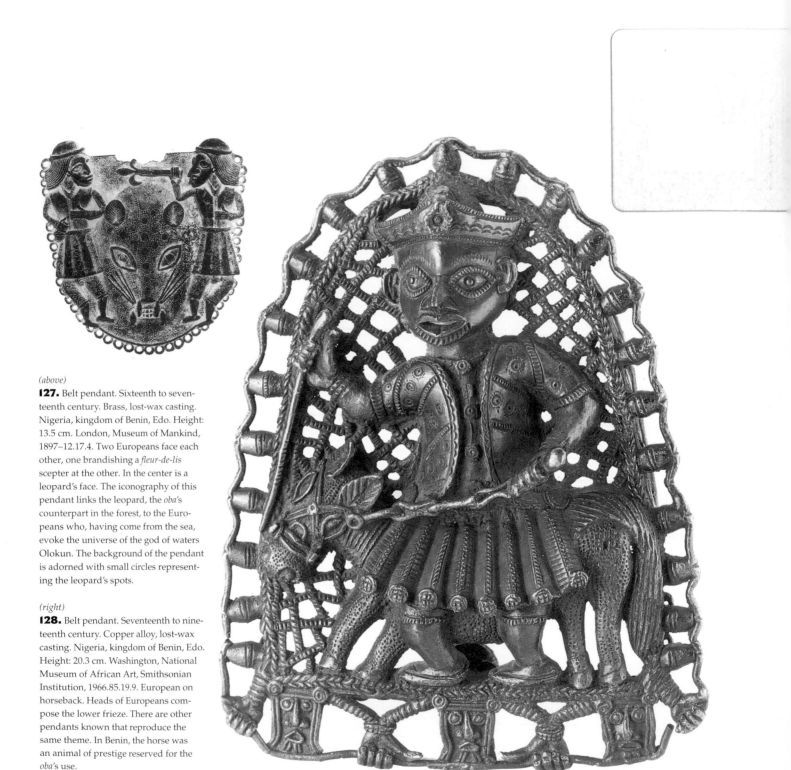

(above)

127. Belt pendant. Sixteenth to seventeenth century. Brass, lost-wax casting. Nigeria, kingdom of Benin, Edo. Height: 13.5 cm. London, Museum of Mankind, 1897–12.17.4. Two Europeans face each other, one brandishing a *fleur-de-lis* scepter at the other. In the center is a leopard's face. The iconography of this pendant links the leopard, the *oba*'s counterpart in the forest, to the Europeans who, having come from the sea, evoke the universe of the god of waters Olokun. The background of the pendant is adorned with small circles representing the leopard's spots.

(right)

128. Belt pendant. Seventeenth to nineteenth century. Copper alloy, lost-wax casting. Nigeria, kingdom of Benin, Edo. Height: 20.3 cm. Washington, National Museum of African Art, Smithsonian Institution, 1966.85.19.9. European on horseback. Heads of Europeans compose the lower frieze. There are other pendants known that reproduce the same theme. In Benin, the horse was an animal of prestige reserved for the *oba*'s use.

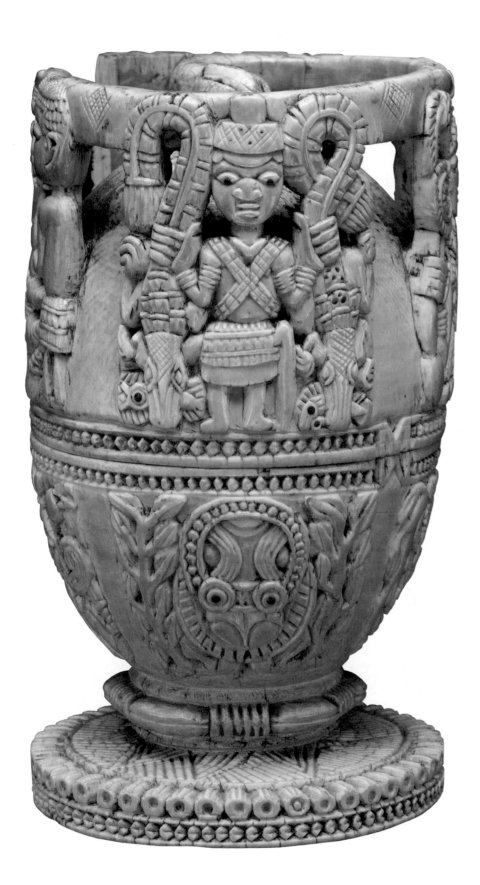

(above)

129. Receptacle. Seventeenth century. Copper alloy, lost-wax casting. Nigeria, kingdom of Benin, Edo. Height: 32 cm. Kilchberg, R. David and D. David. The National Museum of Lagos possesses a similar receptacle. This one originally had a hinged cover. The handles depict snakes with human beings held by the waist in their mouths. On each side is a human figure with crossed legs.

(left)

130. Goblet with lid. Seventeenth to eighteenth century. Ivory, wood or coconut shell. Nigeria, Owo, Yoruba. Height: 21 cm. New York, Metropolitan Museum of Art, 1991.17.126ab. The cover is visible through openings made in the upper part, which divide the body of the goblet into four faces. Appearing on the upper register: one man standing, while another, his head down, has his legs engulfed in the enormous mouth of a snake; a chief with crossed bandoliers on his chest, holding in each hand the tail of a crocodile (the crocodiles' jaws, at the chief's feet, are biting a fish, a symbolic motif widespread in the southwest of Nigeria, where a human or animal face is joined to bird's wings and snake body); finally, the king, or *olowo*, with legs shaped like silurids, wearing the two-feather headdress (identical to that worn today by the *olowo* of Owo— fig. 12) and surrounded, as in Benin, by two chiefs, each brandishing a fish in one hand. As in Edo iconography, this imagery depicts the powers of the *olowo*, who is also linked to the watery world (cf. Ezra 1992, 278–79).

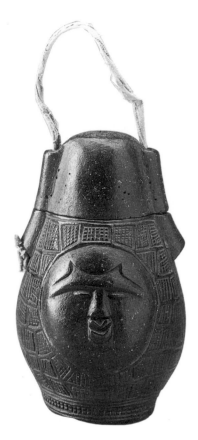

131. Powder box. Wood. Zaire, Sambi, Kongo. Height: 17.9 cm. Tervueren, Musée Royal de l'Afrique Centrale, R.G. 43631.

presented in a magistral manner, only underscores the depth of the mystery proper to the object, a chair lying on its side, without visible purpose. Every piece of furniture implicitly invokes, through the role it is supposed to play, the hand or body that legitimates its function. The exhibition of a seat without occupant can only make the absence all the more striking. "In the presence of objects, the mind is kept awake and prodded by the need to develop itself, only inasmuch as something about these objects that has not yet been revealed remains mysterious," writes André Breton in *L'Amour fou*, citing a line from Hegel. It is that very absence suggested by the Golden Stool that differentiates it so profoundly from the Edo brass head, whose similarity of function I have pointed out. The brass head, like any effigy, obliges the person looking at it to adopt a dual relationship, that imposed by the face-to-face encounter. For its part, the empty seat appeals to a third party. That difference in the relation to the object reveals different intellectual attitudes. In the art of old Benin, the royal effigy is omnipresent in the image; in fact, quite logically, the Edo made a part of that effigy, the head, into an altar, on which the well-being of the nation depends. Conversely, among the Ashanti, the royal effigy never appears, not even, it seems, in ceramic statuary, which is unknown to them. The sovereign is not represented, except, as with the Fon, by an emblem, or in the little profane scenes observed on the weights for weighing gold. He is symbolized only by objects such as the stool which, by their function and form, allude to the reality of the royal person as a singular person, without ever reproducing his appearance.

The Ashanti consider the Golden Stool to be the "black stool" of Osei Tutu, the founder of the Ashanti confederacy. Custom dictates that, upon the death of the chief of a lineage, or a fortiori of a regional chief or *asantehene*, in cases where no inauspicious event has tainted the chief's life, his stool must be conserved along with those of all the chiefs who preceded him in that office.[8] Akan honorific stools are kept and become altars devoted to the cult of the ancestors of the lineage, unlike, for example, stools of chiefs from the Cameroon Grasslands, which "die" with their owner and disappear into the grave. Akan stools are blackened with a mixture of fat and egg yolk, becoming black stools, called *apun dua* by the Ashanti, which are regularly "fed" libations of blood and other substances. The spirit, or *sunsum*, of the dead man dwells in this blackened stool and watches over his descendants, so that the black stool can be considered both an altar and the representation of the ancestor to which it belonged. The black stools of the reigning Ashanti dynasty are all stored in a building devoted to them, lying in a semicircle on a platform, the base of the chair turned outward during public ceremonies. In the center stands the Golden Stool, the black stool of the *asantehene* Osei Tutu.

The strange fate the Akan reserve for their chairs, as receptacles of the spirits of those dead who are destined to attain the status of ancestors, might in some way already be inscribed within the modes of use for any seat whatever and the way its form itself dictates it be handled. Two of the functions of the seated position already mentioned—that of requiring the weight of a body, and that of suspending or stopping time in the immobility of repose—are expressed here. The position of these reclining black stools suggests they are not reserved for anyone standing who might wish to sit down, but rather for the spirit of a deceased man. Transformed by the thick coating that envelops them, they manifest the everlasting quality needed to represent the permanence of power, and the "weight," not of a body, but of the power attached to the spirit of the deceased. These two functions are combined and confused in that object.

Stools are not the only objects among the Akan destined to become the material support of the spiritual principles of their owners. In the center of the upper piece of wood of the black stools, that which includes gold or silver plating, is a circular motif, which the Ashanti sometimes call an *atadee*, "like a hole of water" (McLeod 1981, 115). It is also present on other objects: chairs (*asipim, akonkromfi*), ceremonial swords, metal boxes called *kuduo*, and so on. These circles made of metal, on which the owners of the chairs necessarily sit, are found in identical form as pendants, finely crafted disks made of gold (fig. 121) and called *akrafokonmu*, "disks of the *kra*" or "insignia of those who wash the *kra*." During public appearances, young servants wearing these disks around their necks, with the *kra* of their masters held in them, surround the great Ashanti chiefs. The dignitaries responsible for these objects have the ritual function of "cleansing," that is, of purifying the *kra* of the *asantehene* or of other chiefs. The operation is carried out frequently to maintain the vigor of their vital force and the union with the supreme being Nyame, who dispenses *kra* to each human being. In reality, every man honors his *kra* every week, on the day of the week he was born.

The *kra*, vital principle of divine origin, circulates in the blood of every living human being; every king and queen mother inherits *kra* from those who have preceded. After death, the *kra* leaves to reunite with the supreme divine entity called Nyame. The *sunsum*, a sort of double that constitutes the person as a unique, thinking being, dwells in the stool, even though, in the case of honorific seats, the *kra* seems to be invoked as well. A number of the regalia of the *asantehene* represent that duality of spiritual principles constitutive of the human person; hence, each *asantehene* possesses in succession two sets of swords. The swords on the right, *akrafena*, represent his vital power, *kra*, while those on the left, *bosomfena*, represent

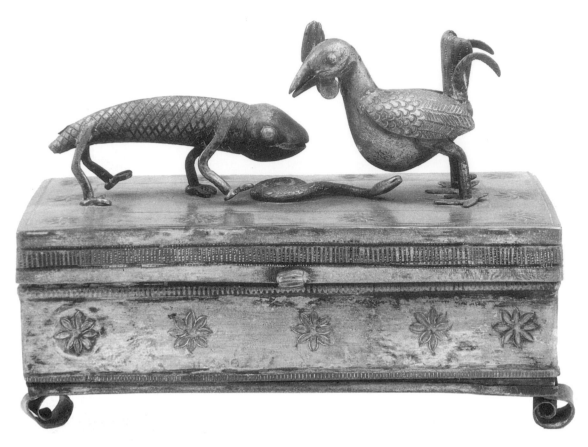

(above)

132. Box. Nineteenth century. Silver. Benin, kingdom of Dahomey, Fon. Length: 23 cm. Musée National des Arts d'Afrique et d'Océanie, AF 13100. Embossed motifs. A rooster and a chameleon face off; at their feet, a snake.

(right)

133. Box. Eighteenth to nineteenth century (?). Wood and brass nails. Nigeria, kingdom of Benin, Edo. Height: 24.5 cm. Berlin, Museum für Völkerkunde. Box, representing a cow or antelope, used by chiefs to offer the *oba* kola nuts during the *otue* ceremony. At that time, the king, seated in front of his father's altar, receives their tributes.

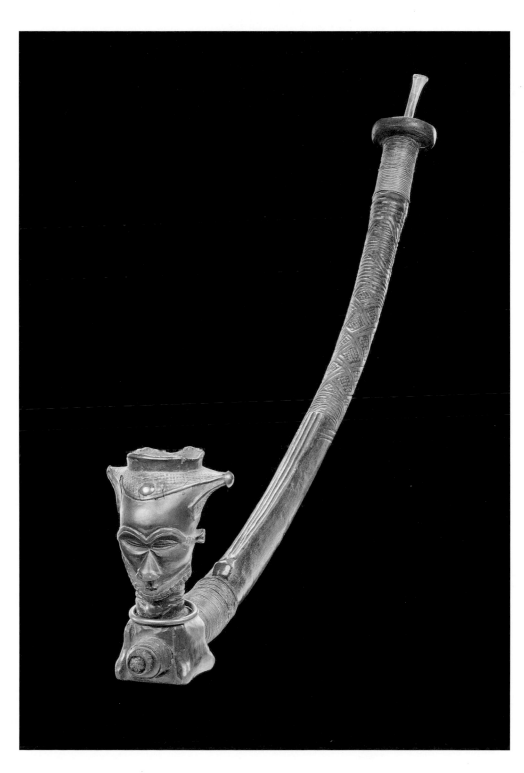

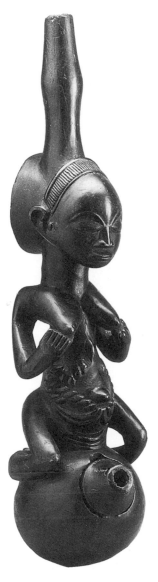

(above)

134. Water pipe. Nineteenth century
(?). Wood. Zaire, Shaba, Luba. Height:
61 cm. Tervueren, Musée Royal de
l'Afrique Centrale. R.G. 73.73.12. Ele-
ments are missing from this pipe,
namely, the clay bowl containing the
tobacco and the reed linking the bowl
to the pipe.

(left)

135. Pipe. Nineteenth to early twentieth
century. Wood, metal filament, brass.
Zaire, western Kasai, Kuba. Length:
62 cm. Tervueren, Musée Royal de
l'Afrique Centrale. R.G. 51.31.33. The
bowl, shaped like a human head, is
treated in the same manner as in palm
wine goblets.

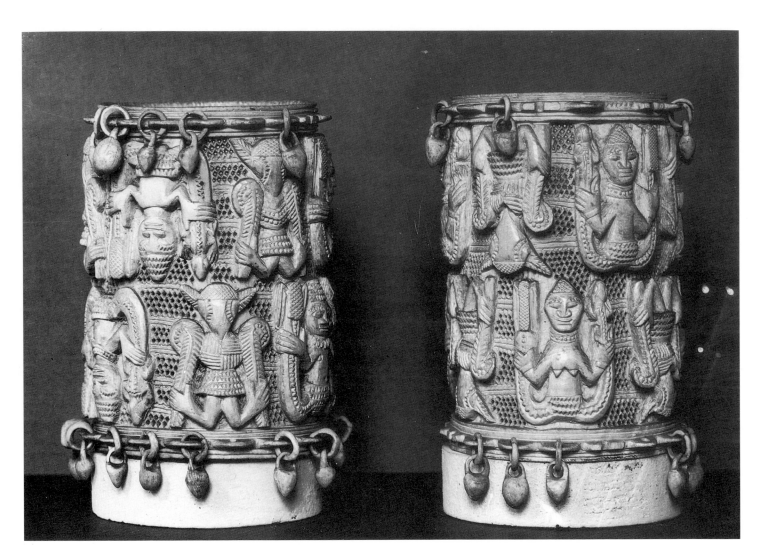

136. Bracelets. Sixteenth century (?).
Ivory. Nigeria, Owo, Yoruba. Copenha-
gen, Nationalmuseet. Motifs of human
figures with legs in the shape of fish or
snakes and symbols joining an animal
face to the body of a creature with bird's
wings.

his *sunsum*. Other objects also play this role of a substance one of the king's spiritual principles might come to inhabit. When set next to the black stools, the *kuduo*, a small receptacle cast in metal with a ritual use, performs a similar function as support of the *kra* (figs. 84 and 85). In the universe of the objects possessed by each Ashanti, in fact, the stool comes first in order of importance, followed by the *kra kuduo*, in which he "cleanses his soul," *kraduare*, and which accompanies him to the grave (Delange 1965, 200). In the mausoleum housing the bones of each *asantehene* were *kuduo* filled with gold powder, which were part of the state treasury. The *kuduo* were placed at the foot of the royal black stools and received offerings of food; sometimes, these seats were even set on metal boxes. In the past, the *asantehene* carried out a rite every week, during the ceremony called *adue*, perhaps linked to the purification of his soul. During that rite, mashed yams and boiled eggs were placed on a *kuduo* before they were eaten (Rattray 1923, 99–100).

Although information concerning these *kuduo* is sparse and does not permit us to grasp their exact meaning at this time, they demonstrate the central place occupied by these boxes and vases in the ritual concerns of their owners regarding the maintenance of that intimate relationship with their *kra*. This relationship, and that connecting every Akan to his stool, would require a more detailed study. A brief mention here, however, will allow us to recall that these relationships are often at the heart of the owner's attachment to the object. The Akan are not the only ones who think in that manner, and numerous examples confirm similar practices in other places. It would even be possible to advance the idea that numerous objects of prestige appearing in this book include such relationships in their conception and their mode of use. Such objects attest to the profoundly human need to give an essential function to our connection to objects that belong to us and through which our humanity is expressed. The function of that connection is to make the objects substitutes for ourselves.

Other objects much more modest in their workmanship, and which are sometimes part of the regalia, might have served just as well as examples. In effect, the things court art glorifies, such as stools, pendants, or *kuduo* within the Ashanti—and more broadly, the Akan—world, also exist in other objects, which are not in the least noteworthy at first sight: small forks of trees, bits of fabric, shards of pottery. In a certain way, and in the form of an amplified echo, what is revealed to us by these prestigious objects, reserved for the use of African kings—individuals unique because of their divine ancestry—and for members of their court, is what every object can become once it no longer stands as an undefined and autonomous thing, but rather responds to the singular use we require of it, always there before us as a

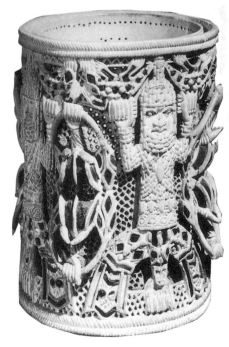

137. Royal bracelet. Sixteenth century. Ivory, incrustation of brass. Nigeria, kingdom of Benin, Edo. Diameter: 13.5 cm. London, Museum of Mankind, 1910.5.13.2. Motif of the *oba* with legs in the shape of silurids.

presence in the form of a riddle. What projection of the self onto the world can be more complete than that which impels human beings to see fragments of themselves contained or even dispersed in a stool, a small metal vase, in pendants, swords, and in other things as well? Such a peculiar connection explains in part why these objects bear decorations, though, as we have just said, certain of them, even among the regalia, remain very simple in their workmanship, despite the importance of their function.

The attention and energy required to produce any object, and even more so, its decoration, by the person who makes it, composes it, or creates it, the time spent at that work, are all factors that, when added together, make up an important share of the value of the finished object. When that object has no such decoration or when no particular care was devoted to finishing it, this lack in itself can only be significant. It is because the object is the materialized presence of elements that are by definition inexpressible and immaterial—energy, the pleasure of workmanship, the memory of forms, technical expertise, the concentration another person has instilled, even incorporated, into it—that it also produces fascination in us. When the Akan see a stool as the substitute for royalty, when they see a pendant or a vase as the support for the "soul" of a king, chief, or any human being, they are engaged in a strange operation that consists of allowing the essential—because vital—principles, *kra* or *sunsum*, to become symbolically fixed in an object marked by the imprint of another, that of the person who produced it. What is there to say about that fusion of one person with what another—the artisan or artist—has left behind in the fabrication process? The very high status that kings and chiefs of black Africa have generally accorded to their artisans, the fact that these same sovereigns—think in this regard of chiefs of the Cameroon Grasslands—sometimes wanted to fabricate objects themselves or at least to make people believe they had, demonstrates how well founded that question may be. Might not the attraction exerted on us by these objects also be linked to that feeling of a possible encounter with something ineffable, as the presentation of the Ashanti Golden Stool suggests? It is clear that, in the case of royal objects, the profusion of decoration and the attention given to their fabrication do not stem only from the desire to increase royal prestige by highlighting the virtuosity of artisans. There is also the idea that an object in which "care" has been taken during its creation is all the more likely to become the receptacle of a king's soul, in that the person who fabricated it left that added, inestimable value, that kernel of concentrated energy contained in every creation, which includes the best of himself.

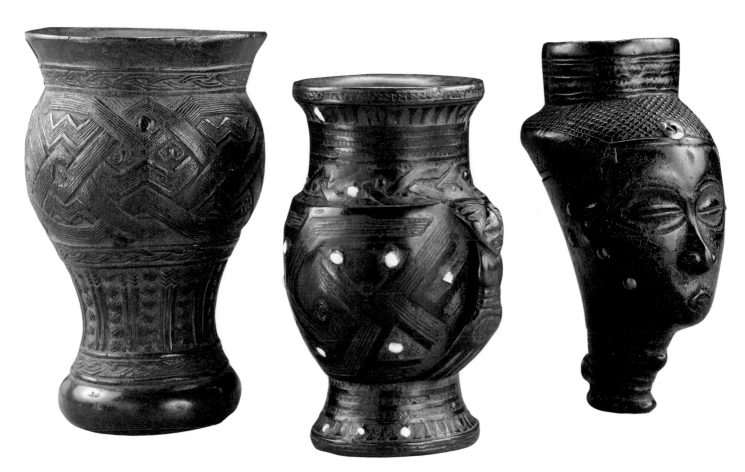

138. Goblets. Nineteenth century. Zaire, Kuba. Left to right: Wood, height: 16 cm; wood encrusted with shell fragments, height: 14 cm; wood and copper, height: 15 cm. Brussels, private collection. Palm wine goblets.

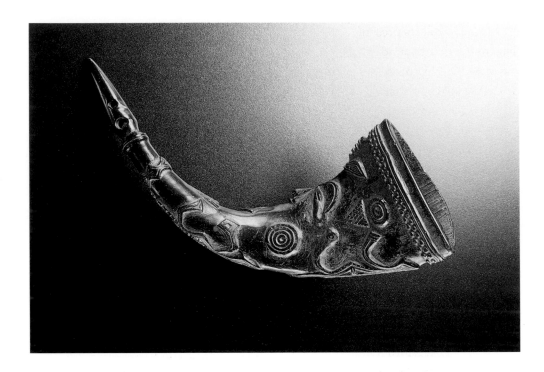

139. Drinking horn. Nineteenth to
twentieth century. Wild buffalo horn.
Zaire, western Kasai, Kuba. Height:
41 cm; width (at the base): 17 cm. Brus-
sels, private collection. Only warriors
had the right to use these horns to drink
palm wine, since the power and sav-
agery of the buffalo were compared to
their own valor.

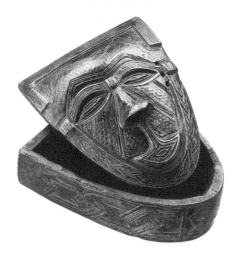

140. Box. Early twentieth century.
Wood. Zaire, Kuba. Height: 21 cm.
Brussels, private collection.

The court objects presented here give some idea of the variety of plastic and stylistic expressions found in black Africa. They also show that most of the personal property the king possesses is similar, though more richly adorned or of more precious materials, to that used by his subjects. That similarity reminds us that what distinguishes the sovereign from his people is not so much the amount of wealth he possesses, since this belongs in principle to the kingdom and not to the king as private individual, as the spiritual and mystical function he must perform. Just as the palace does not differ in general from ordinary houses except in its size or the number of buildings constituting the palace complex—recall the description of the palace of the Azande chief—so the workmanship of boxes, seats, royal staffs, and other objects created for the king or his dignitaries is not fundamentally different from that of the same objects used by the common people. In the case of royal objects, the work will be more finished, while common objects will be rougher. It is a question of degree: the difference is expressed in the codification of the right to certain materials, certain forms, or certain iconographic motifs. That property as a whole amounts to a few essential objects—staffs, stools, drinking goblets, boxes, weapons—whose forms may then be combined in a multitude of variations. The headrest is an extension of the stool, the staff becomes a scepter, effigy, snuffbox, flyswatter, or placard if need be.

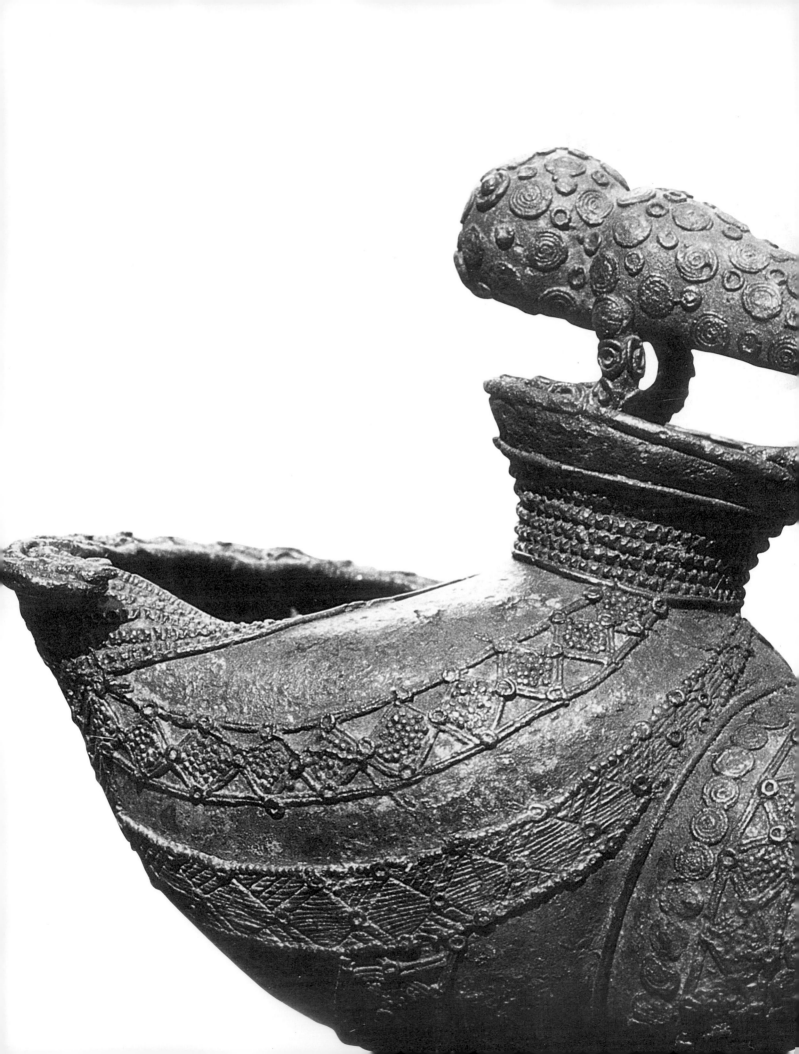

CHAPTER FIVE
Elements of Archaeology and History

Kingdoms are frequently mentioned in the writings we possess for the periods preceding the colonization of black Africa, works of Arabic or Islamized Africans, then European travelers, traders, and missionaries. In reading Olfert Dapper's *Description of Africa*, based on nearly a hundred publications of travel accounts reported by others, we sometimes have the impression that the populations of the continent were organized into a multitude of kingdoms located side by side. Whether large or small, they interested travelers very early on, and these travelers gave descriptions of them that were often as enthusiastic as they were far-fetched. As political organizations with a centralized power, these kingdoms attracted merchants and Muslim scholars to the western Sudan, then European traders to the coasts, because their institutions offered a certain stability favorable to exchanges, both commercial and ideological or religious.

The Europeans were fascinated by the African sovereigns and the spectacle of their court, and seem to have viewed these distant monarchies with the same amazement they showed for courts in their own countries. But their accounts also betray the ambivalent feelings lying behind them, a combination of admiration and fear. This is expressed in a passage taken from Olfert Dapper's book regarding the king of Benin:

> This prince appears in public once a year, on horseback, covered with his royal ornaments, with an entourage of three or four hundred gentlemen composing the infantry and cavalry and a troupe of musicians, some ahead of him, others following behind. The procession takes place around the palace, never straying far from it. A few tamed leopards are brought out in chains, and a good number of dwarves and deaf people, who serve as the king's entertainment. To conclude the solemn ceremony, ten, twelve, or fifteen slaves are strangled or beheaded, in the belief that these unfortunate victims will be going to another country where they will be resuscitated, and where their condition will be better, and that when they have arrived there, each will find his own slaves. On another day, all comers are shown the royal treasures, which consist of jasper, coral, and other rarities. (Dapper 1686, 310–11)

Objectivity sometimes gives way to extravagance and fantasy when it comes to describing the size of a kingdom, which, it seems, has to equal or even rival European models. Certain seventeenth-century commentaries regarding the palace and the habits of the sovereign, or *mwene mutapa*, of Mutapa (present-day Zimbabwe) attest to this: the floor of the palace is said to be "richly covered with gold laminae, cut into shapes, with large ivory chandeliers hanging from silver chains, chairs adorned in gold leaf. . . . [The king's dishes] are of porcelain, completely covered

(previous pages)
Detail of figure 144.

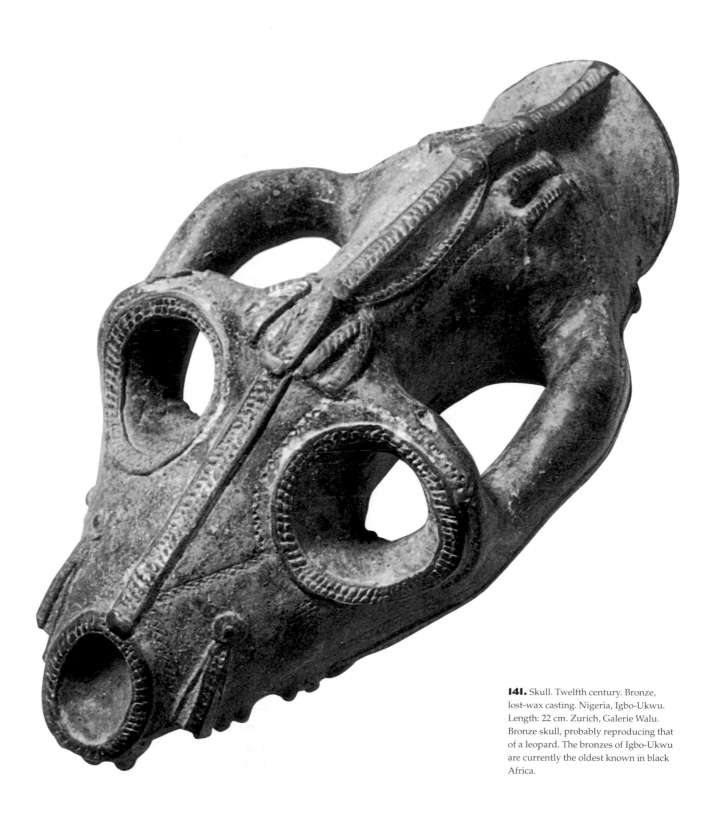

141. Skull. Twelfth century. Bronze, lost-wax casting. Nigeria, Igbo-Ukwu. Length: 22 cm. Zurich, Galerie Walu. Bronze skull, probably reproducing that of a leopard. The bronzes of Igbo-Ukwu are currently the oldest known in black Africa.

and surrounded by gold branches in the shape of coral."[1] In defense of the commentator, we might note the extent of the renown the empire of Mutapa had acquired in the sixteenth century among Portuguese navigators. When the Portuguese set up their trading posts on the Zambezi in the early sixteenth century, they thought they had found a new El Dorado, even richer than the empire of Mali. In fact, gold, iron, ivory, copper, and slaves arrived at the coast from kingdoms in the interior; in the hands of Arab and Swahili traffickers, trade in these goods accounted for the highly profitable trafficking on the Indian Ocean.

On the territory of the old empire of Mutapa, more than a hundred ruins of stone edifices stand today: the largest of these, famous for the quality of their architecture, are the edifices of Great Zimbabwe,[2] whose original foundations may date from the eleventh century. The structures of Great Zimbabwe, whose purpose has not yet been elucidated, may have been the work of the ancestors of the present-day Shona. We may assume that these structures are part of a complex of buildings that must have composed the capital of a powerful kingdom, Zimbabwe, whose existence is asserted by Arabic and Portuguese sources. Archaeologists discovered a monumental piece of architecture in Great Zimbabwe—one of the enclosing walls is two hundred and forty meters in circumference, nine meters high, and, in places, five meters wide at the base—and the material evidence of active, long-distance trade, essentially with the coast: beads from Malaysia dating from the eighth to tenth century, earthenware imported from Persia dating from the thirteenth century, and Chinese porcelain from the Ming Dynasty (fourteenth century) (Leiris and Delange 1967, 70). Gold—alluvial in origin—from the kingdom of Zimbabwe, then from the empire of Mutapa, was exported through the port of Sofala (present-day Mozambique), and marketed farther to the north at the port of Kilwa (Tanzania). The Chinese visited the Swahili in the fifteenth century; they described houses of four or five storeys in the port of Kilwa during that period and mentioned export products such as slaves, gold, yellow sandalwood, animal skins, and ivory. The Portuguese never reached Zimbabwe.

The oldest kingdoms known to us, thanks to Arabic chroniclers who mention them beginning in the eighth century, were called Tekrur and Ghana.[3] According to certain traditions, Ghana was called Wagadu, a term belonging to the language of the Soninke, who are believed to have been the founders of that kingdom. The ruins of the capital mentioned under the name "Kumbi" in the legends of Wagadu may lie in Kumbi-Saleh, in the heart of what is now desert country in southern Mauritania. In the eleventh century, Ghana was deeply shaken by the conquest of the

Almoravids, that is, of Berbers organized into a Muslim brotherhood. The following century, the kingdom was integrated into the empire of Mali by its founder, Soundiata Keita, as a vassal state. The people of the kingdom of Tekrur (this term is the origin of the word "Tukolor") were among the first to be Islamized, a fact explained in part by the kingdom's geographical position on the Senegal River, in constant contact with Berber populations.

The economy of Sudanese empires in the Middle Ages rested for the most part on the exploitation of the gold deposits in the area of Sudan, in particular those located on the upper Senegal, in the region of Bambouk, not far from the present-day city of Kayes, and on the upper Niger in the region of Boure: in exchange for gold and slaves, the empires of Ghana, then Mali, and finally Songhai obtained Saharan salt, copper, horses, and cloth in their commercial trade with the north. Owing to caravan trade, the principal cities of these three empires became flourishing commercial centers during the medieval era, indispensable crossroads for trade between the Maghreb and the forest zones south of the area of Sudan. Ghanian gold dazzled the geographer al-Bakri:

> [The king] gives an audience to repair injustices, in a house with a cupola. . . .
> Around that house ten horses are arranged, caparisoned in gold cloth. Behind
> the king stand ten pages bearing gold shields and swords; to his right the sons
> of the princes of his empire are lined up, with plaited hair mixed with gold. . . .
> In front of the door to the cupola, guard dogs, who almost never leave the king,
> are adorned with gold and silver collars sporting bells made of the same metals.
> (Cuoq 1975, 100)

The same author, writing in the eleventh century, explains that the king of Ghana could raise an army of two hundred thousand men, including forty thousand archers—more soldiers than were in the armies of the king of France during the same period. An identical description of the pomp of the court of the emperor of Mali is provided by Ibn Battuta three centuries later, in about 1350: the squires possess gold and silver quivers and spears, and "swords ornamented with gold" (Ibn Battuta 1983, 328). Several Arabic authors give an account of the trip to Mecca and Cairo in 1324 by the *mansa* Moussa, emperor of Mali and descendant of Soundiata Keita; Moussa handed out gold so generously that he lowered the price of it in the city of Cairo. A story was told that a retinue of thousands—slaves, soldiers, and dignitaries—accompanied him on his tour. At the time, his reputation extended as far as Portugal and the commercial cities of Italy, and his effigy appeared on the maps and portolanos of the period. A map in the *Atlas catalan* belonging to King Charles V,

made by cartographers from Majorca Island in 1375, depicts the emperor sitting on his throne, wearing a crown similar to that of the sovereigns of the European world, holding a scepter in one hand and a gold disk in the other. It was under the reign of the *mansa* Moussa that the empire of Mali attained its greatest territorial expanse. He converted to Islam, built mosques, and attracted numerous Muslim scholars to his court: in the Muslim world, Mali was considered a true Islamic state at the time.

Songhai, the last of the great empires of western Sudan, is mentioned as a kingdom in the Arabic writings of the eleventh century, where it appears to have been contemporary with Ghana. Its capital, Kawkaw, present-day Gao in Mali, maintained close commercial relations with the cities in the center of the Maghreb. At the time, the renown of the kingdom of Songhai even reached the court of the caliph of Baghdad. The golden age of the empire occurred in the sixteenth century, when the city of Tombouctou became one of the great centers of sub-Saharan Muslim culture. During the same century, the Spanish pillaged Tombouctou during an expedition mounted by the sultan of Morocco in search of Sudanese gold mines. Only a very few sumptuous "gold ornaments" from that period have come down to us, ornaments that Arabic authors spoke of enthusiastically. It would be easy to suppose that a number of sites—tombs and cities—long visited by treasure seekers of every era, like the pillagers of Egyptian tombs in the Valley of Kings, left little to be recovered by the picks of excavators. But we should also recall that almost no archaeology of African lands has as yet taken place. To this day, only tumuli near Saint-Louis in Senegal have provided gold jewelry, of Arabic-Berber inspiration, dating from the sixteenth century (Mauny 1952, 554). On the site of Djenné-Jeno (three kilometers south of the present-day city of Djenné, Mali), where the important trading city of the empire of Mali and then of Songhai stood, numerous objects have been discovered: copper and terra cotta ornaments expressing the power and pomp of these empires, using the recurrent motif of horsemen in harness. The gold route from the southern regions of Bambouk and Boure passed through that city. The salt imported from Tombouctou and the Sahara was traded for gold dust.[4] At its apogee, between 750 and 1150, Djenné-Jeno and neighboring villages had about twenty thousand inhabitants, a population greater than that of today.

Ghana, Mali, and Songhai were the gold lands in the western Sudan. Although we do not yet have the proof, it is possible to suppose that other kingdoms existed before the eighth century in western Africa and elsewhere on the continent. Archaeological discoveries such as that of the statuary of Nok in Nigeria (region of Bauchi-Benoue), attesting to a very developed art in terra cotta, are suggestive in

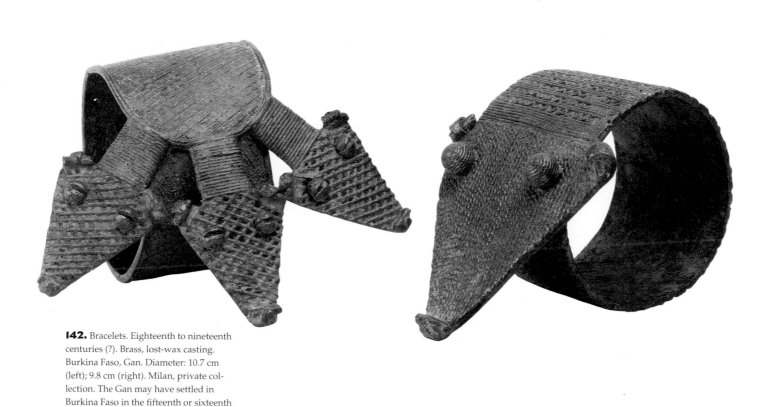

142. Bracelets. Eighteenth to nineteenth centuries (?). Brass, lost-wax casting. Burkina Faso, Gan. Diameter: 10.7 cm (left); 9.8 cm (right). Milan, private collection. The Gan may have settled in Burkina Faso in the fifteenth or sixteenth century. The objects shown here (figs. 142 and 143) were used in the cults linked to the monarchy.

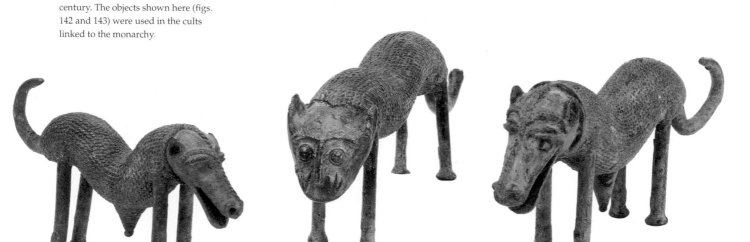

143. Animal figurines. Fifteenth century (?). Brass, lost-wax casting. Burkina Faso, Gan. Left to right: 11.5 × 18 cm, 10 × 29 cm, 8.7 × 17.7 cm. Milan, private collection.

this regard. Official estimates date Nok art to a period extending from 900 B.C. to A.D. 200. Recent discoveries allow us to posit an even earlier date. (Nok works do not appear in this book.) The ceramic statuary recently excavated seems to confirm certain of the propositions I have advanced on the subject of the art of the portrait. These are full-length effigies of richly adorned figures, their bodies, hands, and elements of their costume modeled with a clear concern for realism. Also in Nigeria, on the site of the village of Igbo-Ukwu, in the territory of the present-day Igbo, nearly eight hundred works in bronze have been found, works of exceptional craftsmanship, remarkable for the sophistication and finesse of their decoration (figs. 141, 144–46). For the moment, these are the only pieces in that style known. On one of these sites, archaeologists have uncovered an urban complex that included a palace and sanctuaries. In one of the rooms of this palace lay dishes and cult objects; in another, which served as a funerary chamber, were spread the bones of a figure seated on a stool, wearing a crown, breastplate, and bracelets. Behind him stood a cane with a leopard skull at the top, an insignia of power if ever there was one. More than ten thousand beads surrounded his bones, some of them belonging to the clothing that covered him. Remains of other persons on the roof of the chamber have been identified; they were probably sacrificed during the funeral (Eyo 1984, 22). The identity of the deceased remains a riddle, but the abundance and quality of the objects that accompany him and the bones of sacrifice victims indicate his high status. The date for the art works as a whole might be as early as the ninth, tenth, and eleventh centuries.

In the fifteenth century, when the Portuguese arrived on the coast of the Gulf of Guinea, they established contact with the kingdom of Benin, whose considerable prosperity made it one of the Portuguese's principal partners, from both the diplomatic and the commercial point of view. Benin was at that time a bellicose monarchy in the midst of expansion. The size and urbanism of the capital struck the first observers: the population of the capital of Benin in the eighteenth century was estimated at eighty thousand. The king's palace is depicted by observers as

> an assemblage of buildings that occupy as much space as the city of Haarlem and which is enclosed by walls. There are several apartments for the prince's ministers and beautiful galleries, most of them as large as the Amsterdam stock exchange. They are supported by wood pillars set in copper, on which their victories are engraved, and which they are careful to keep very clean. Most of these royal houses are covered with palm branches arranged like square boards; each corner is embellished with a small pyramid tower, with a copper bird perched at the point, its wings spread. (Dapper 1686, 307–8)

The accuracy of the description regarding the ornamentation of the roofs is confirmed by certain brass plaques in high relief and bas-relief that have been found in the palace.

The wealth of the kingdom of Benin depended in part on its geographical position at the crossroads of navigable waterways, between the Atlantic and Lake Chad, from which the River Niger and its tributary, the Benue, flow. On its territory, sea salt, smoked fish from the Niger delta, cloth, leather, coral and glass beads from the interior, brass and iron utensils, palm products, and slaves were traded for other commodities, using the coin of the realm—cowrie shells, and iron and small copper rods. The Portuguese brought copper, cloth, and firearms to the kingdom, and exported spices (a variety of pepper called *maniguette*) and ivory to Europe, and slaves to the Gold Coast (present-day Ghana), where they were traded for gold. The slave trade with the kingdom rapidly became the primary element in Portuguese transactions. Duarte Pacheco Pereira, a Portuguese visiting Benin in about 1490, wrote that the kingdom was "usually at war with its neighbours and [took] many captives, whom we [bought] at twelve or fifteen brass bracelets each, or for copper bracelets, which they prize[d] more" (*Esmeraldo de Situ Orbis*, cited in Ben-Amos 1995, 9). In the following centuries, the kingdom, with the help of firearms, increased the trade in slaves by leading raids on its neighbors, to such a point that the coast of Benin was rebaptized the "Slave Coast" by the Dutch, French, and English, who followed the Portuguese.

It was the English who put an end to Benin's hegemony and independence. In the nineteenth century, the kingdom represented an obstacle to British expansion toward the interior. Following an ambush set by the *oba*'s armies against an English column, during which the British ambassador was killed, England organized a punitive expedition. In 1897, British troops occupied the capital. At that time, the English brought back to their country a few thousand objects seized during the sack of the palace. Museums discovered the art of Benin, at the time almost unknown. The treasury of the kingdom of Benin was then dispersed into European collections.

Legend has it that in about the thirteenth century, the Edo (the name of the people of Benin), after a period of anarchy, appeared before the *oni*, or sovereign, of the Yoruba city-state of Ile-Ife, located about two hundred kilometers north of the capital of Benin. They asked him to send them a king to govern them. After reorganizing the state, the king from Ife, Oranyan, gave Benin a son, who become the first *oba* of the second Benin dynasty. Then Oranyan left to found another city-state, Oyo, which played a prominent role in the region, economically and militarily, from the sixteenth to the eighteenth century. The city of Ile-Ife was the spiritual and mythical

center of the Yoruba world. It was there that the Yoruba monarchy is believed to have first developed. The first *oni* of Ile-Ife is said to have been the son of the Yoruba god of creation, Olorun. Certain elements of the enthronement of the *alafin* of Oyo and of the *oba* of Benin reveal the primacy of that city in the Yoruba and Edo universe. The sovereign of Oyo cannot be vested before obtaining certain insignia from the *oni* of Ife, such as the *idi Oranyan*, the sword of Oranyan (founder of the second Benin dynasty), which allows him to dispense justice, or the *igba iwa*, the divining calabashes. In the sixteenth century, an observer compared the *oni's* power to that of the Supreme Pontiff in the West. When the king of Benin was enthroned, the *oni* indicated his consent by sending him

144. Receptacle. Ninth to tenth century. Bronze with lead content, lost-wax casting. Nigeria, Igbo-Ukwu, presumed to be by Igbo Isaiah. Length: 10.6 cm. Nigeria, Lagos, National Museum, 39.1.13. Animal, probably a leopard, and buccinum shell.

> a cane and headdress of shining brass . . . in lieu of cane and scepter. He also sends him a cross . . . which is worn around his neck. . . . Without these emblems, the people do not recognize him as legitimate sovereign, and he cannot really call himself the king. All the time the ambassador is at the court [of the king of Ife], he never sees the prince, but only the silk curtains behind which he is seated, since he is considered sacred. (Mercier 1962, 59)

Works in terra cotta or metal, which attest to the stylistic influence of Ile-Ife, have been discovered in places other than Ile-Ife, but still in the Yoruba world—for example, in Owo.

On the coast, beginning in the seventeenth century, the Europeans undertook new commercial exchanges with small kingdoms—Porto-Novo, Dahomey, Alada, and Ouidah—that emerged to compete with the commercial trade controlled by the *oba*. All these kingdoms are said to have been founded by the Adja[5] from the kingdom of Tado, which was believed to have been created by a brother of the Yoruba sovereign of the city-state of Oyo. Throughout the sixteenth century, the kingdom of Dahomey waged incessant war against Oyo. The war allegories, figures in bas-relief, that adorn the façades of the palaces in Abomey have to do with events relating to the struggles between Dahomey and Oyo. In the nineteenth century, the prosperous Dahomey possessed a port, engaged in trade with the Europeans, and, through its military conquests in the interior of lands in Yoruba country, broke away from the guardianship of Oyo. The kingdom actively participated in the slave trade, which, as in the kingdom of Benin, led to a certain decadence due to the growing military need for men and a permanent state of war with its neighbors. On several occasions, Benin faced civil wars. In Dahomey, human sacrifice became more common, demonstrating a contempt for human life that had not existed previously. In

the early nineteenth century, hundreds of men were put to death during the great annual feast, while thousands of slaves went to the port of Ouidah every year.

The Edo (Benin), Yoruba (Oyo, Ile-Ife), and Adja kingdoms belong to a single civilization: their founders originated in the Yoruba world, and when that was not the case, their traditions always evoked Ile-Ife, the spiritual center of the Yoruba world and mythical center of the earth, where the gods and first kings had come into being. All these kings, whether of Dahomey, Ife, Oyo, or Benin, had gods for ancestors. Hence Shango, the third king of Oyo, was also the god of thunder and fire.

After reaching western Sudan, the Europeans penetrated another gold-supplying region, located at the heart of the forest zone in the hinterland of the coast on the Gulf of Guinea, the famous Gold Coast, west of the Yoruba world, where they encountered the Akan peoples.

In passing through the Akan coastal cities and villages, the Europeans were struck by the profusion of gold ornaments worn by their inhabitants. As we have seen, gold was so abundant there that it served as currency. In one of his letters, Willem Bosman, a Dutchman posted on the coast in the late seventeenth century, wrote that the people "make little curls in their hair. . . . As embellishment, they put between two of them gold fetishes and a certain kind of coral. . . . Around their arms, legs, and body, they wear a quantity of gold or coral as ornament. . . . They also wear very finely made ivory rings on their arms, and a few have them in gold, silver, etc. At their neck, they have several gold necklaces and all varieties of coral" (Bosman 1705, 126).

In exchange for slaves, the Europeans engaged in intensive gold trade with the Akan. European dealers very quickly complained of the "malice" of the autochthonous peoples, who were prompt to adulterate the gold "by mixing copper and silver with it" or by pouring gold onto these metals "on all sides, so that the whole appears to be pure gold, it seems right to the touch, and one does not perceive the mixture except by digging with a burin" (Dapper 1686, 301). In another of his letters, Bosman adds: "Most people in Europe think we are the masters of the gold mine and that we draw out the gold ourselves, as the Spanish do in America. But, as you well know, sir, that is mistaken, and we do not even have access to these mines. I do not believe, moreover, that any of us has seen them, since the Negroes, holding them as something sacred, will always do everything they can to prevent anyone besides them from approaching" (Bosman 1705, 89–90). The same situation existed during the colonial period, when the administrators of Anyi country expressed regret that the inhabitants "jealously hid the product of their searches,

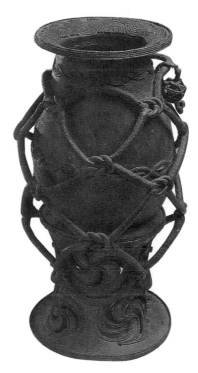

145. Vase. Ninth to tenth century. Bronze with lead content, lost-wax casting. Nigeria, Igbo-Ukwu, Igbo Isaiah. Height: 32.3 cm. Nigeria, Lagos, National Museum, 79.R.4. This vase is set on a holder with a perforated decoration. Both are covered in netting, whose mesh is interlaced in a double knot. This same knot is found in numerous decorations of objects in Africa, among the Ashanti, for example. The creation of that object was a very delicate operation: the different parts were cast separately, then joined through a final addition of molten bronze.

deceiving one another about the yield of their mines" (Perrot 1982, 149). This commentary suggests that the Anyi also sought to hide the location of their lodes from the new occupants.

Even today, on certain public occasions, particularly during feasts in which great personages such as the *asantehene* of the Ashanti appear, dignitaries exhibit sumptuous solid gold art works: rings, bracelets, chains, torques, and necklaces, and emblems of their office, generally made up of a piece of sculpted wood with gold leaf.[6] The display of wealth is reserved for the most important individuals. Baule notables demonstrate this by organizing public exhibitions of their treasuries of gold adornments every year.

The powerful Ashanti confederacy came into being during the first half of the eighteenth century, at the initiative of Osei Tutu, chief of the city of Kumasi. In the following century, the Ashanti attempted to control trade in the coastal ports, during numerous campaigns conducted against the British and their own neighbors, the Fanti in particular. The Ashanti expansionist enterprise met with more success in the interior of the country and, in the end, Ashanti territory encompassed two-thirds of present-day Ghana, the eastern part of the Ivory Coast, and the western part of Togo. During these military campaigns, the English lost a few battles. In fact, for half a century, the head of a colonial governor adorned the great war drum of Kumasi. But in 1874, twenty-two years before the Benin expedition, a British column occupied Kumasi; as in Benin a little later, it first burned the palace and the city and pillaged the royal treasury. Despite that event, the English did not definitively conquer the Ashanti until 1900, which demonstrates the military and structural force of the confederacy.

In the late fifteenth century, shortly after they had discovered Benin, the Portuguese came upon another kingdom, Kongo. The history of the encounter between the Portuguese and the kingdom of Kongo is unique. In 1482, the Portuguese anchored their ships at the mouth of a large river, which was none other than the present-day Zaire. At the time, the kingdom of Kongo had already extended its suzerainty to other monarchies such as the Loango, north of the estuary. The Portuguese proceeded in Kongo as they had done in Benin; they sought to build the kingdom into an economic partner, even while maintaining their own advantage. At the same time, they undertook a vast effort to Christianize the population, an undertaking that had more success there than it did in Benin. In 1491, the *manikongo*, Nzinga a Nkuwu (unlike the *oba* of Benin, who refused to convert), was baptized under the name of João I (figs. 147 and 149). In 1517, his son was ordained bishop of

the capital of the kingdom, Mbanza Kongo, rebaptized San Salvador (present-day Angola), where stone churches and a cathedral were rapidly built.

Christianization, attempted with only relative success among the Edo in Benin, took root in a more lasting way among the Kongo: a Kongo was even ordained bishop in Rome and a son of Alfonso I, successor of João I, settled in Portugal, where he taught at the University of Coimbra.

Portuguese navigators took young people to Lisbon, sent by the *manikongo* to receive an education in Europe. An ambassador, Cacuta, traveled with them, charged with asking that missionaries and artisans be sent to Kongo. Cacuta's stay in Lisbon took place under the best auspices: "Cacuta learned both Portuguese and religion so well that he was baptized with his entire retinue and left King Juan after receiving a thousand marks of friendship, taking with him priests, images, crosses, and other church ornaments, which his Negroes received with transports of admiration and pleasure, because of their novelty" (Dapper 1686, 356).

Alfonso I sought to make Catholicism the state religion and to integrate it into the royal cult, in order to reinforce his personal authority. The new king read and wrote Portuguese (his letters addressed to the king of Portugal are conserved in the Lisbon archives); he reorganized court functions and the administration of the kingdom on the Portuguese model, and granted titles of nobility patterned on those in force among his new allies. With Alfonso I, following the proposal of King Manuel of Portugal, dukes, counts, and marquis appeared in Kongo, and their names were later printed in European texts. With the military support of the Portuguese, Kongo grew and became a veritable empire.

Following Alfonso I, the sovereigns of Kongo used the new religion to reinforce their power. But the age of relative prosperity inaugurated under the reign of Alfonso I did not last; missionaries engaged in intrigues at court and sought to intervene in matters of succession. Conflicts and struggles for access to supreme authority shook the kingdom. The real factor of destabilization of Kongo, however, has to be sought in the slave trade, whose scope, beginning in the sixteenth century, only increased. Thus began a long period of social and political disorder, comparable to that which emerged for the same reasons in Benin. Under the pressure of the Portuguese, who fed the conflicts in the interior and at the borders of the empire, Kongo sank into anarchy. It was within that context that a young woman of aristocratic blood, Kimpa Vita—Dona Beatrice was her Christian name—in 1704 proclaimed herself sent by God and Saint Antony to reestablish the splendor of the former Kongo and put an end to the misfortunes of her people. She taught a new

146. Vase holder. Ninth to tenth century. Bronze, lost-wax casting. Nigeria, Igbo-Ukwu. Height: 27.4 cm. Nigeria, Lagos, National Museum. Two effigies, one male, the other female, adorn each side of the cylinder. A perforated decoration composed of snakes holding frogs in their mouths links the two figures.

religion, inspired both by the Old Testament and by Kongo tradition, in which white missionaries were accused of lying, the kingdom was described as the true Holy Land, and Christ was said to be originally of Kongo origin, a native of San Salvador. Thousands of Kongo rallied behind her cause. Under pressure from Capuchin missionaries, this black Joan of Arc was burned alive "with the name of Jesus in her mouth," as Bernardo de Gallo, one of her inquisitors, expressed it. The episode of Dona Beatrice marked the end of the history of the Kongo kingdom.

The Portuguese's primary interest in Kongo was economic: in exchange for cloth, iron knives, mirrors, Venetian beads, and glazed porcelain, controlled and redistributed by the *manikongo*'s court, the Portuguese procured raffia fabric, ivory, and copper, which, especially on the Gold Coast, they reconverted into gold destined for Lisbon. Initially, the kings of Portugal decided to develop Kongo economically, to make it a dynamic ally with a view toward future expansion in Africa. Artisans (smiths, masons, and joiners), clerks, peasants, two German printers, priests, and monks (both Franciscan and Dominican) arrived in Kongo. But the devastating effects of the slave trade on the internal balance of the kingdom and its surrounding areas, then the discovery of India, distracted the Portuguese. High military and administrative costs prevented them from maintaining the order required for the proper functioning of their commercial enterprises. Progressively, the Portuguese reduced their military protection, leaving the empire open to the reprisals of the neighboring peoples, who were tired of enduring the pressure of wars started by the Kongo. In the nineteenth century, nothing remained of Christian Kongo except a few objects, in particular crucifixes and statues of saints—Saint Antony and Saint Peter—which were still associated with certain beliefs inspired by Catholicism, and the stone tombs of Christian kings.

In addition to the empire of Kongo, central Africa had two other states, the Luba and Lunda empires. The Europeans entered into contact with them quite late, at the end of the nineteenth century, as they penetrated into the interior of the continent. David Livingstone passed through the center of Angola only in 1850. Even though the expanse and political and economic importance of these states were comparable to those of the Sudanese empires, both archaeological and historical data are lacking for them. In contrast, the art that has been left us by the Luba reveals the refinement of their courts.

The Luba probably came from the east. In the sixteenth century, after crossing the Kivu, they settled in Katanga, to the south of present-day Zaire, near the Lunda. A people of conquerors, the Luba extended their hegemony over the peasant societies they invaded, up until the nineteenth century. The diversity of "Luba" populations

explains the stylistic variety of their art works. They had a king at the head of their empire, comparable to those found in the great lakes kingdoms of Rwanda, Bunyoro, Buganda, Burundi or, farther to the south, Mutapa. They shared with these kingdoms the cult of sacred fire, which signified the power and vitality of the sovereign; they also shared a kind of monarchy, which they might have then transmitted to the Lunda.[7] In about the seventeenth century, the Lunda in turn formed an immense empire.

In about 1600, certain members of the Lunda military aristocracy left Katanga and came to the center of present-day Angola. The new arrivals took the name of a small river, Chokwe. They organized the autochthonous populations into chieftaincies and extended their suzerainty to the subjects of other small kingdoms, the Ovimbundu, which had inherited Kongo institutions. The two empires, the Luba and the Lunda, entered into rivalry for the political and economic domination of central Africa.

Unlike the Luba, the Lunda have not passed any original art works down to us, despite the economic and military force of their empire. The Lunda court, however, benefited from products from the coasts of both oceans. The kingdom of Kazembe, founded by a Lunda chief in the early eighteenth century, to the south of Lake Mwero (now located in Zambia), became the crossroads for commercial routes in the interior. At the end of a perilous journey of thousands of kilometers, caravans led by Portuguese traders from Mozambique, and Arabic and Swahili merchants, arrived there. "Lunda" art, in fact, exists only in the center of Angola, through the intermediary of "Chokwe" creations; chiefs of Lunda origin, anxious to demonstrate their prestige, encouraged art among the autochthonous artists in that country, where the Chokwe chieftaincies were formed (Bastin 1988, 58). In the last quarter of the nineteenth century, Europeans reached the court of the Chokwe *mwanangana*, Ndumba Tembo, at the source of the River Kwango. Travelers found the king dressed in a black cloth jacket covering a checked cotton undergarment; he was adorned with headbands made of small beads, and was wearing a brass crown in a form vaguely reminiscent of European crowns. This clothing and these ornaments demonstrate the importance of trade with the coasts. A portrait made during that stay depicts him in his garb, copper rings covering his fingers, which end in long nails, also made of copper (fig. 150) (Capello and Ivens 1969, 176–77). The Chokwe, though they did not yet know the whites, were already using import products that had reached their territory during the eighteenth century. Among these objects were seventeenth-century Western chairs, which the Chokwe imitated and from which they made royal chairs (Bastin 1988, 49–50).

147. Crucifix. Sixteenth to eighteenth century. Brass. Zaire, Kongo. Height: 35 cm. Brussels, private collection.

The kinship of these three peoples is manifested in their dynastic history, as it is reported in legend. As in the Yoruba and Adja kingdoms, a single tradition runs through the Luba, Lunda, and Chokwe epics. The three founders seem to have belonged to the same lineage. The founder of the Luba empire was named Kalala Ilunga. One of his brothers or sons, Tshibinda Ilunga, was the founder of the Lunda monarchy. Both hunter and smith, he introduced to the Lunda a technical knowledge unknown by them until that time, the bow and arrow and metallurgy. Brothers of the Lunda princess Lweji, unhappy about her union with Tshibinda, left at that time for the west to found new states, following the principles of sacred royalty introduced into Lunda country by the Luba prince Tshibinda. The Chokwe chiefs recognized these dissident brothers as their dynastic ancestors and claimed the same mythical ancestor, Tshibinda, great hunter and possessor of effective charms. To celebrate the great deeds of Tshibinda Ilunga, Chokwe artisans represented him abundantly in statuary.

In about 1860, the Chokwe, driven by illness and hunger, undertook a migration; following the course of the rivers, they went as far north as Zaire, and toward the south of Angola. In the first quarter of the twentieth century, that forced dispersion of the Chokwe people and the impoverishment of their economy led to the decline of the institutions of the chieftaincy and the progressive disappearance of the court arts that were emblems of it (Bastin 1988, 66).

Yet another kingdom of central Africa, that of the Kuba, was situated in the region of Kasai in present-day Zaire. It emerged near the end of the sixteenth century and has survived until today. Organized as a federation of eighteen chieftaincies, it has a *nyim*, or sacred king, at its head, chief of the dominant group of the Bushoong, who once conquered the populations of the region. In the seventeenth century, the kingdom underwent profound changes under the aegis of an innovative *nyim*, Shyaam a-Mbul a-Ngoong. He founded the present dynasty and unified the chieftaincies into a single kingdom. He stimulated agriculture by introducing new plants—corn, tobacco, beans, and cassava—created a capital city which attracted important traders, formed a royal guard and army, and finally, instituted rules of succession. In the eighteenth century, the Kuba empire was a state with a varied economy, based on flourishing commercial trade, both internal and external. The kingdom reached the height of its power between 1870 and 1890. The Kuba became the principal suppliers of ivory in their trade with Angola. Among the imports obtained in exchange were a great number of slaves who, having become the property of the important persons of the kingdom, increased the fortune and prestige of the latter through the fruits of their labor.

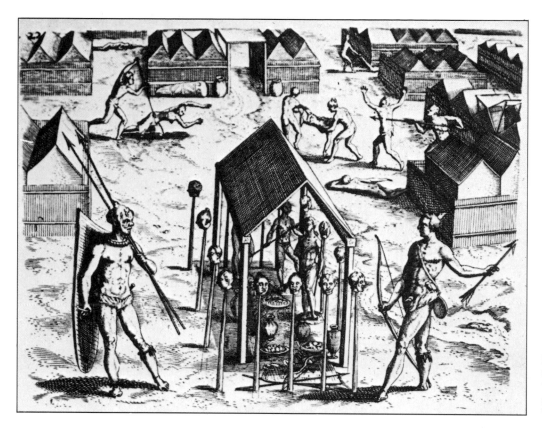

148. Funeral of the king of Benin, after Pieter de Marees. Engraving, 1620. "Wahrhaftige und Eigentliche Abbildungen" (part 6). Frankfurt-am-Main: Petits Voyages.

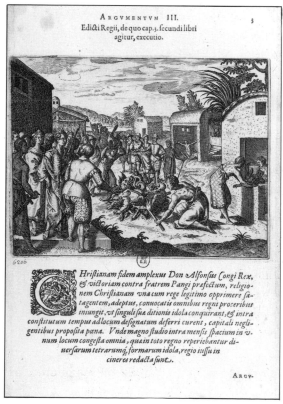

149. Abjuration of the king of Kongo, by Théodore de Bry. Engraving, 1598. Paris, Bibliothèque Nationale de France.

This brief overview of the history of the former kingdoms of the African continent gives only a very incomplete sense of a history that was as rich and eventful as that of European monarchies. Some kingdoms, which also had their hour of glory, have not been mentioned at all: the coastal kingdoms of Wolof, Temne, and Serer; the Haussa kingdoms of Kano, Gobir, Zaria, Katsina, and so on (there were seven in all); the empire of Kanem-Bornu in the region of Lake Chad, at the crossroads of Saharan trails leading back to the Maghreb and Egypt (early on, it was a major supplier of slaves and, at the time of the colonial partition in 1900, had already existed for twelve centuries); the Bambara kingdom of Ségou, which was built on the remnants of the great empires of Mali and Songhai; and the Nupe kingdom, which appeared in the sixteenth century within the confines of the Yoruba world. In the nineteenth century, with the push toward a Muslim revival led by the Fulani, other states came into being, such as the empires of Macina and Sokoto, which covered the northern half of present-day Nigeria and the northwest of Cameroon, encompassing the Haussa kingdoms.

Many of these kingdoms and empires disappeared during the upheavals that shook the societies of the African continent over the centuries. In contrast, some of those confronted with the rise of colonialism are still in place, since the new arrivals often relied on existing state structures to establish their own power. African sovereigns, however, met different fates at the beginning of colonization. Some, such as Behanzin, king of Dahomey, were deposed; others, such as Mwanga and Kabarega, kings of Buganda and Bunyoro, respectively, the *asantehene* Kwaku Dua Prempeh, and the *oba* Ovorramwen, were sent into exile. Those who were able to hold on to their thrones could hardly do more than perform a ritual and religious function, while all political authority was denied them. The *asantehene* had the good luck to come back to Kumasi and resume his duties, but under English domination. Other kings disappeared in the turmoil that followed the creation of new African states; that was the case for sovereigns of kingdoms in the interlacustrine region of eastern Africa. After being restored to their office within the framework of a constitutional monarchy, the king of Buganda and three other sovereigns of Uganda, including the king of Bunyoro, were removed from office, the monarchy was abolished, and they were definitively sent into exile. In Rwanda, the Tutsi monarchy was also suppressed a few years after independence, following a popular uprising. Others survive within the borders of the new nations, and the person of the king still remains the site of strong symbolic and mystical investment. The *asantehene* in Ghana, the *oba* of the Edo, the Yoruba *oni* of Nigeria, the king of Abomey, the sultans of the

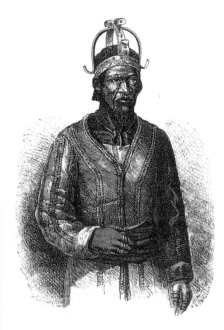

150. The *mwanangana* Ndumba Tembo, in Capello and Ivens 1969, 176.

empire of Sokoto in Nigeria and Cameroon, the *mogho naaba*, king of Ouagadougou in Burkina Faso, the *nyim* of the Kuba in Zaire, whose court has managed to preserve part of its pomp from earlier times, all play a significant role in the political life of their countries. We might add that black Africa still has two monarchies, both located in the south of the continent and founded in the nineteenth century, Lesotho and Swaziland.

Map of Ethnic Groups Cited

1. Akan (Ivory Coast–Ghana)
2. Ashanti (Akan) (Ghana)
3. Azande (Zaire–Central African Republic)
4. Bambara (Mali)
5. Bamileke (Cameroon)
6. Bamum (Cameroon)
7. Chokwe (Angola-Zaire)
8. Edo (Nigeria)
9. Fanti (Ghana)
10. Fon (Benin)
11. Gan (Burkina Faso)
12. Gourmantche (Burkina Faso)
13. Igala (Nigeria)
14. Jukun (Nigeria)
15. Kongo (Congo-Angola-Zaire)
16. Kotoko (Cameroon-Chad)
17. Kotokoli (Togo)
18. Kuba (Zaire)
19. Luba (Zaire)
20. Lunda (Angola-Zaire)
21. Mahi (Benin)
22. Mangbetu (Zaire)
23. Mossi (Burkina Faso)
24. Moundang (Chad-Cameroon)
25. Nafana (Ivory Coast–Ghana)
26. Nupe (Nigeria)
27. Nyakyusa (Tanzania)
28. Nyamwezi (Tanzania)
29. Ovimbundu (Angola)
30. Rukuba (Nigeria)
31. Sapi (Sierra Leone)
32. Shilluk (Sudan)
33. Shona (Zimbabwe)
34. Swazi (Swaziland)
35. Tukolor (Senegal)
36. Tswana (South Africa)
37. Tutsi (Rwanda-Burundi)
38. Vai (Liberia)
39. Wolof (Senegal)
40. Yoruba (Nigeria-Benin)
41. Zulu (Tsonga–northern Nguni) (South Africa)

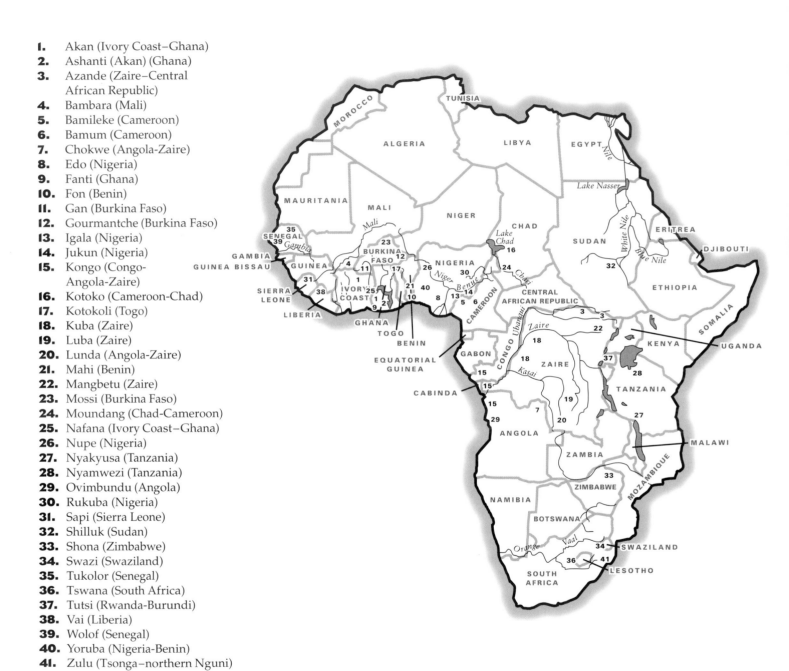

Notes

Introduction

1. The term "Sapi" designates the people of the former Temne monarchy of Sape, whose territory extended into what is today Sierra Leone. For the Edo, see chapter 1, note 3.

Chapter One

1. The term "Sudan" designates the entire intertropical region beyond the lands of the Saharan desert, from Senegal to Sudan proper and to a part of Egypt; it includes Guinea, Mali, Burkina Faso, Niger, Nigeria, Chad, and Cameroon.

2. My use of the term "chieftaincy" will follow that in current use in texts dealing with the societies cited in this book. Tradition dictates that when, within a single ethnic group, a society is splintered into autonomous political groups with a centralized authority, these are called chieftaincies. They may sometimes recognize the higher authority of a king. This explains the fact that certain kingdoms can encompass several chieftaincies, each maintaining a certain autonomy in relation to the central power.

3. Note that the term "Benin" comes from *bini*, and is taken from the name the Portuguese gave to the residents of the kingdom and to the kingdom itself. *Bini* is from *Ile Ibinu* or "country of clashes," an expression the Edo used to designate the kingdom. The inhabitants of Benin use the term "Edo" to refer to themselves, their language, and the capital of the kingdom.

4. Two palaces were conserved after the restoration, that of King Glele and that of King Guezo, both of whom reigned in the nineteenth century. The Musée Historique d'Abomey was established on the site.

5. Page numbers refer to the original French edition.

Chapter Two

1. Leo Frobenius, a German anthropologist (1873–1938), was one of the first discoverers of the art of Ile-Ife, and brought back examples of it to the Berlin museum (figs. 28 and 29).

2. Numerous examples in terra cotta are currently known to us. In contrast, there are fewer than thirty heads in brass and copper (Drewal 1993, 44).

3. In reference to this sculpture, Henry J. Drewal reminds us that, in Ile-Ife, deformed individuals were given the responsibility of serving the gods and could also be offered to them. Their infirmity attested to the intervention of the god Obatala-Orishanla, protector of dwarves, hunchbacks, albinos, and all persons whose abnormal physical form confirmed their nature as extraordinary creatures (Drewal 1993, 46).

4. These axes were used for ritual purposes in western Africa and no doubt on the entire continent. Called "thunder stones," they were supposed to have been left on the earth by thunder, which in many African societies was thought to be the manifestation of a god. The fact that the *oba* is represented with such objects in hand demonstrates the extent of his power.

5. In an article published on this subject, Barbara W. Blackmun (1990) inventories three types of portraits in the art of Benin: the "conventional" portrait, in which the king is depicted with his attributes; the portrait in which the *oba* appears as one of the protagonists in a historical situation known by all; and the "emblematic" portrait, in which a single sign condenses a certain number of allusions to a particular *oba* and makes attitudes and ideas explicit. That thesis seems far from satisfactory: on one hand, the "conventional" portrait is founded on the use of emblematic motifs; on the other, the "emblematic" portrait as it is defined in Blackmun's analysis is reduced to a mere symbol, without any figuration of the monarch. It would be difficult to speak of a "portrait" in such a case.

6. For a detailed description of *ndop* statues, see Cornet 1982.

7. Kuba sculptors still make *ndop*, which are then put up for sale.

8. *Mabol* is the plural form of *ibol*.

9. This game is also widespread in western Africa, where it is called *wuri* or *awele*.

10. That root was used during the ordeals designed to test persons accused of witchcraft. It is said that if the chief indicated someone with his *munkwiza*, the latter would soon die.

11. There are also full-length portraits of the chief's wife in her personal kitchen. The sculptures in question here belong to the most elaborate Chokwe style, which Marie-Louise Bastin calls the "style of the country of origin," the region of Moxico or Muzamba in Angola.

12. "All his Gentlemen that served him, have every one of them their Pictures made of Clay, after the life, and fairely painted, which are set and placed orderly round about his grave, one by the other; so that their Kings Sepulchers are like houses, and as well stuft as if they still lived" (quoted in Cole and Ross 1977, 119).

13. The finest of these heads in terra cotta date from the seventeenth and eighteenth centuries. The oldest ones known to us may have been fabricated in the early seventeenth century. The tradition of the portrait in terra cotta does not seem to have been practiced by the Ashanti; conversely, it was widespread among the Akan in the south of Ghana, among the Fanti, and even among the lake populations of the Ivory Coast. Even though the production of them declined toward the beginning of this century, the practice of making a ceramic portrait of the deceased sovereign, destined to be exhibited at his funeral, has not been completely abandoned by the Akan in the south of Ghana. Among the Aowin, where there are a large number of statuette sites, they are still the object of a cult in certain places (Coronel 1979). Some of these heads are reminiscent of those found on the lids of more common funerary pottery, in a style similar to that of the Akuaba dolls.

14. George N. Preston also recalls that the royal portraits are not sculpted in wood, unlike numerous other Akan art works. One of the reasons for this might be the symbolic conformity between the two rites, which are, moreover, closely related, that celebrating birth and that celebrating the departure of the royal soul for his ancestors.

15. I discuss that problematic in an article entitled "L'envers du regard," published in *Journal des Africanistes* (Coquet 1994). In it, I put forward an interpretation of the Bwaba of Burkina Faso, who consider the pupil a well filled with water leading to the world of the dead.

16. The cult of the Head is indissociable from two other cults regarding the human person and its fate: that of the Hand and that of *ehi*, a term that can be translated as "destiny." The cult of the Hand, associated with the right arm, has to do with prowess, strength, and personal initiative. When someone judges that he has realized his own destiny in a fruitful manner, he can erect an altar of the Hand (Bradbury 1973, 251–70).

17. According to another version by Joseph Nevadomsky, these sculptures of heads were placed on the war altar, *aro-okua* (cf. Ben-Amos 1995). Some of these sculptures may also represent the heads of sacrificial victims (Paula Ben-Amos, cited in Schaefer 1983, 71).

Chapter Three

1. I borrow this definition from Robert E. Bradbury, who uses it in reference to the art of the kingdom of Benin (Bradbury 1973, 251).

2. The casting of the last plaque probably dates from the end of the seventeenth century, the beginning of the kingdom's decline.

3. As Jean Laude has pointed out, in the pages he devotes to that art (Laude 1988, 143–49).

4. This motif is called *ebe-ame*, "river leaf." There are three types of ornamental motifs for the background of the plaques. Symbols of the god of waters Olokun, they recall that the power of the *oba* comes from this god, whose reign over the aquatic world is the counterpart of the Edo sovereign's reign over the earthly world. Beginning in the sixteenth century, the Edo associated the Portuguese with the realm of Olokun, because they came from the sea; figurations of Portuguese were then integrated into this ornamental background (Ben-Amos 1995). For chronological and historical interpretations of the different styles of these plaques and the scenes found on them, see Ben-Amos 1995 and Ezra 1992.

5. The Edo have advanced a different interpretation, which does not contradict the first,

concerning these legs in the shape of a fish. They are said to represent the crippled legs of the *oba* Ohen, who reigned in the fifteenth century. He reportedly concealed his handicap from his people and was killed because of his deformity. Note that this motif evokes that of ancient European amulets in which "sirens" held one of their curved fishtails in each hand.

6. The use of the number 3, symbolically associated with the masculine in western Africa, also underscores the *oba*'s power.

7. The Edo, however, bore scarifications on the face and body that distinguished them from their neighbors.

8. The tree may be a cotton plant; during rituals, the two dancers had to give the illusion of flying into the tree. The dance of *amufi* took place during a ceremony, called *isiokuo*, in honor of Ogun, god of war and iron. The *oba* and chiefs attended the ceremony, all dressed in their military attire. The whirling and pirouettes of the acrobats in the tree may be a depiction of battles (Ben-Amos 1995, 117).

9. This scene clearly has a symbolic meaning, but I do not possess all the elements of it. On another plaque, Europeans are depicted capturing leopards. The animals and human figures are arranged in a manner reminiscent of Western playing cards, with a vegetal motif. The leopard, the counterpart in the wild of the *oba* in the human world, and the long-beaked bird with spread wings (perhaps an ibis), belong to the bestiary very frequently represented as maintaining a relation with the monarchy.

10. The Edo consider the leopard to be equal in the wild spaces of brush and forest to the *oba* in the human world. Only the king can put it to death. The captured leopards were destined to be sacrificed during royal ceremonies, or to be tamed. In the latter case, they then took part in the parades the *oba* led through his city (Ben-Amos 1995, 15), an ancient custom that contemporaries of Olfert Dapper were able to observe and that Dapper himself described in his *Description of Africa*. See p. 148 below.

11. For a more detailed description, see Bradbury 1973, 254–61.

12. Other tusks may simply have animals or abstract motifs as decorations.

13. This task was undertaken by Blackmun (1983; 1991).

14. The Portuguese term *recado*, meaning "messenger," designates a wooden crook, originally probably a simple hoe handle, which represents the king. Beginning with King Guezo, the end of the handle was sculpted to depict the king's strong names. In Fon, that object is called a *makpo* (fig. 83).

15. The saber reproduced on the upper part of the door leaf is similar in form to certain sacrificial sabers, such as those kept by the king's executioner, or *migaa* (Palau Marti 1967, 283–84).

16. The Fon use the term *Nago* to designate the Yoruba people as a whole, who live east of the kingdom.

17. There is a statuette in the Musée d'Abomey of a hornbill holding an object, perhaps a piece of fruit, in its beak. Edo idiophones also depict the bird of prophecy of the *oba* Esigie holding a small spherical object in its beak. Even though it is not the same bird, the iconographic theme is similar and would merit study. In each case, this little object the bird holds might allude to destiny.

18. I have considered only royal emblems up to this point. Dignitaries, military regiments, and even villages used the same system of heraldry.

19. I borrow in part the description from Lombard and Mercier 1959, 37.

20. The fabrication of the hanging does not date from that event, but is much more recent. It may be a reproduction from the 1950s of a nineteenth-century hanging.

21. I borrow the definition proposed by André Leroi-Gourhan regarding paleolithic art, which I believe can also be applied to Fon art. He contrasts the pictogram to the "pictographical sequence" or the "linearized assemblage of pictograms translating successive moments of an operative sequence" (Leroi-Gourhan 1992, 261).

22. On this question, see the analysis in Kauenhoven-Janzen 1981.

23. I draw from the different descriptions provided in Bastin 1961, 347; Bastin 1982; Bastin 1992; and Kauenhoven-Janzen 1981. For a complete view of the chair reproduced in figure 89, see Bastin 1961.

24. "C" is pronounced "ch."

25. Unfortunately, I do not possess a detailed description of this other chair.

Chapter Four

1. On this matter, see Perrois 1993b.

2. On the history of these staffs, see Cole and Ross 1977, 160–62; McLeod 1981, 95–100.

3. I am relying on examples cited in Ross 1982 and Cole and Ross 1977, 162.

4. There are other types of *recados* besides those reserved for the king or his messengers; members of the royal family also have a right to them. One also finds military *recados* with distinctive emblems for various regiments; religious *recados* with priests' insignia for the cult of Hebiosso, god of thunder; and *recados* that anyone can fabricate for personal use, to display on certain festive occasions. Among the Fon, ceremonial sabers can also be adorned with similar motifs. For Fon legends concerning the origin of these objects and the stages of their fabrication, see Adandé 1962.

5. On this matter, see Geary 1981.

6. Rattray (1927) inventoried about thirty types of these in the 1920s.

7. The context within which Rattray was obliged to remind people of the function and nature of the Golden Stool was particularly tragic. The Golden Stool had been profaned in 1920, after the *asantehene* Prempeh I was sent into exile by the English. The sacred stool was hidden from the British and from potential pretenders, and was then found buried the same year by road workers, who stripped it of its ornaments and its gold plating. Upon the return of Prempeh I, the stool had to be reconstituted from a wooden shell of the original stool, which had somehow been saved; that shell was incorporated into the new stool. See also Cole and Ross 1977, 138.

8. Other individuals had the right to have their stools conserved: queen mothers, war chiefs, and sometimes certain persons within the lineage who led an exemplary life.

Chapter Five

1. The text dates from 1648 and was written by Vincent Le Blanc, cited in Randles 1975, 86 n. 24. Dapper reprints the description in his writings.

2. In the Shona language, "Zimbabwe" means "great stone house."

3. The present-day republic of Ghana took its name from this ancient kingdom in an allusion to its past splendor.

4. A ninety-kilogram block of salt was worth 454 grams of gold dust during medieval times (*The Cambridge History of Africa* 1978, 3:488).

5. The principal ethnic groups of the Adja, located between the Yoruba and the Akan, are the Fon and the Ewe, whose languages are linguistically similar. The Fon were the founders of the kingdom of Dahomey.

6. Ghana remains an important producer of gold, the third largest on the African continent, and fourth in the world.

7. This cult of sacred fire is found even on the Atlantic coast. It is attested to in the kingdom of Loango, where the king's authority was signified by a fire that was to be put out only upon his death.

Bibliography

Adams, Monni. 1980. Fon Appliqued Cloths. *African Arts* 13, no. 2 (February): 28–41.

———. 1988. Eighteenth-Century Kuba King Figures. *African Arts* 21, no. 3 (May): 32–38.

Adandé, Alexandre. 1962. *Les récades des rois du Dahomey*. Dakar: IFAN.

Adler, Alfred. 1978. Le pouvoir et l'interdit. In *Systèmes de signes: Textes réunis en hommage à Germaine Dieterlen*, 25–40. Paris: Hermann.

———. 1982. *La mort est le masque du roi: La royauté sacrée des Moundang du Tchad*. Paris: Payot.

———. 1991. Royauté. In *Dictionnaire de l'ethnologie et de l'anthropologie*. Edited by Pierre Bonte and Michel Izard, 636–39. Paris: PUF.

Aniakor, Chike C. *See* Cole, Herbert M.

Antongini, Giovanna, and Tito Spini. 1989. Reiterazione di spazi e segni come conferma di potere: Il regno Dahomey. In *La trasmissione del sapere: Aspetti linguistici e antropologici. A cura di Giorgio R. Cardona*, 17–34. Rome: Bagatto Libri.

Appiah, Peggy. 1979. Akan Symbolism. *African Arts* 13, no. 1:64–67.

Art et mythologie—Figures tshokwé. 1988. Paris: Fondation Dapper.

Art tribal. 1992. Geneva: Musée Barbier-Mueller.

Arts de la Côte-d'Ivoire. 1993. Vol. 1. Geneva: Musée Barbier-Mueller.

Balandier, Georges. 1965. *La vie quotidienne au royaume de Kongo du XVIe au XVIIIe siècle*. Paris: Hachette.

Balandier, Georges, and Jacques Maquet. 1974. *Dictionary of Black Africa Civilization*. New York: Leon Amiel.

Bastin, Marie-Louise. 1961. *Art décoratif tshokwé*. Lisbon: Museu do Dundo.

———. 1968. L'art d'un peuple d'Angola—I: Chokwe. *African Arts* 2, no. 1 (autumn): 40–47 and 63–64.

———. 1969. L'art d'un peuple d'Angola—IV: Mbundu. *African Arts* 2, no. 4 (summer): 30–37 and 70–76.

———. 1982. *La sculpture tshokwé*. Meudon: Alain et Françoise Chaffin.

———. 1988. Les Tshokwé du pays d'origine. In *Art et mythologie—Figures tshokwé*, 49–68.

———. 1992. The Mwanangana Chokwe Chief and Art (Angola). In *Kings of Africa*, 65–70.

Ben-Amos, Paula. 1975. Professionals and Amateurs in Benin Court Carving. In *African Images: Essays in African Iconology*. Edited by Daniel F. McCall and Edna G. Bay. New York and London: Africana.

———. 1983. In Honor of Queen Mothers. In Ben-Amos and Rubin, eds., *The Art of Power, The Power of Art*, 79–83.

———. 1995. *The Art of Benin*. Rev. ed. London: The Trustees of the British Museum, British Museum Press.

Ben-Amos, Paula, and Arnold Rubin, eds. 1983. *The Art of Power, the Power of Art*. Los Angeles: University of California Press.

Beumers, Erna, and Hans-Joachim Koloss, eds. 1992. *Kings of Africa: Art and Authority in Central Africa*. Maastricht: Foundation Kings of Africa.

Blackmun, Barbara W. 1983. Reading a Royal Altar Tusk. In Ben-Amos and Rubin, eds., *The Art of Power, the Power of Art*, 59–70.

———. 1990. Obas' Portraits in Benin. *African Arts* 23, no. 3 (July): 61–69.

———. 1991. Who Commissioned the Queen Mother Tusks? A Problem in the Chronology of Benin Ivories. *African Arts* 24, no. 2 (April): 55–65.

Bosman, Willem. 1705. *Voyage de Guinée contenant une Description nouvelle et très exacte de cette Côte où l'on trouve et où l'on trafique l'or, les dents d'Eléphant, et les Esclaves*. Autrecht: Chès Antoine Schouten, Marchand Libraire.

Bradbury, Robert E. 1970. *The Benin Kingdom and the Edo-Speaking Peoples of South-Western Nigeria*. 2d ed. London: International African Institute.

———. 1973. *Benin Studies*. Oxford: Oxford University Press.

Braunholtz, H. J. *See* Wild, R. P.

Bravmann, René A. 1972. The Diffusion of Ashanti Political Art. In Fraser and Cole, eds., *African Art and Leadership*, 153–71.

Canetti, Elias. 1966. *Masse et puissance*. Paris: Gallimard.

Capello, H., and R. Ivens. 1969. *From Benguella to the Territory of Yacca: Decription of a Journey into Central and West Africa—Expedition Organized in the Years 1877–1880*. 1882. Reprint, New York: Negro Universities Press.

Cartry, Michel. 1987. Le suaire du chef. In *Sous le masque de l'animal: Essais sur le sacrifice en Afrique noire*, 131–231. Paris: PUF.

Cavazzi da Montecuccolo, Antonio C. 1690. *Istorica descrizione dei tre regni Congo, Matamba ed Angola situati nell'Etiopia inferiore occidentale e delle missioni apostoloche esercitatevi da religiosi Capuccini, accuratamente compilata dal P. Gio. Ant. Cavazzi . . . e nel presente stile ridotta dal P. Fortunato Alamandini*. Milan: Stampe dell'Agnelli.

Cole, Herbert M., and Chike C. Aniakor. 1984. *Igbo Arts—Community and Cosmos*. Los Angeles: Museum of Cultural History, University of California Los Angeles.

Cole, Herbert M., and Doran H. Ross. 1977. *The Arts of Ghana*. Los Angeles: Museum of Cultural History, University of California Los Angeles.

Coquet, Michèle. 1993. *Textiles africains*. Paris: Editions Adam Biro.

———. 1994. L'envers du regard. *Journal des Africanistes* 64, no. 2: 39–63.

Cornet, Joseph. 1982. *Art royal kuba*. Milan: Edizioni Sipiel.

Coronel, Patricia C. 1979. Aowin Terracotta Sculpture. *African Arts* 13, no. 1 (November): 30–35.

Coupez, André, and Thomas Kamanzi. 1970. *Littérature de cour au Rwanda*. Oxford: Oxford University at the Clarendon Press.

Cuoq, Joseph M., ed. 1975. *Recueil des sources arabes concernant l'Afrique occidentale du VIIIᵉ siècle au XVIᵉ siècle (Bilad Al-Sudan)*. Paris: Editions du CNRS.

Dapper, Olfert D. M. 1686. *Description de l'Afrique*. Amsterdam: Wolfang, Waesberge, Boom and van Someren. Reprinted in 1989 in *Objets interdits*. Paris: Editions Dapper.

Dark, Philip J. C. 1973. *Introduction to Benin Art and Technology*. Oxford: Oxford University at the Clarendon Press.

Delange, Jacqueline. 1965. Un kuduo exceptionnel. *Objets et Mondes* 5, no. 3 (autumn): 197–204.

Delange, Jacqueline. *See* Leiris, Michel.

Drewal, Henry J. 1993. L'art d'Ilé-Ifé: Sources et significations du réalisme. *Arts d'Afrique Noire* 87 (autumn): 41–51.

Duchâteau, Armand. 1990. *Bénin, trésor royal—Collection du Museum für Völkerkunde, Vienne*. Paris: Editions Dapper.

Eyo, Ekpo. 1984. Archéologie du Nigeria. In *Trésors de l'ancien Nigeria*, 17–35.

Ezra, Kate. 1992. *Royal Art of Benin—The Perls Collection in the Metropolitan Museum of Art*. New York: Metropolitan Museum of Art.

Fage, J. D., ed. 1978. *The Cambridge History of Africa*. Vols. 2–4. Cambridge, London, New York, Melbourne: Cambridge University Press.

Fagg, Bernard, and William Fagg. 1960. The Ritual Stools of Ancient Ife. *Man* 60: 113–15.

Fortes, Meyer, and Edward E. Evans-Pritchard, eds. 1947. *African Political Systems*. London and New York: Oxford University Press.

Fraser, Douglas. 1972. The Symbols of Ashanti Kingship. In Fraser and Cole, eds., *African Art and Leadership*, 137–51.

Fraser, Douglas, and Herbert M. Cole, eds. 1972. *African Art and Leadership*. Madison, Milwaukee, and London: University of Wisconsin Press.

Frazer, James G. 1958. *The Golden Bough: A Study in Magic and Religion*. New York: Macmillan.

Garrard, Timothy F. 1979. Akan Metal Arts. *African Arts* 13, no. 1 (November): 36–43.

Geary, Christraud. 1981. Bamum Thrones and Stools. *African Arts* 14, no. 4 (August): 32–43.

Geary, Christraud, and Adamou Ndam Njoya. 1985. *Mandou Yenou—Photographies du pays bamoum, royaume ouest-africain—1902–1915*. Munich: Trickster Verlag.

Gebauer, Paul. 1979. *Art of Cameroon*. Portland, Ore.: Portland Art Museum, in association with the Metropolitan Museum of Art, New York.

Girchick Ben-Amos, Paula. *See* Ben-Amos, Paula.

Gluckman, Max. 1947. The Kingdom of the Zulu of South Africa. In Fortes and Evans-Pritchard, eds., *African Political Systems*, 25–55.

Heusch, Luc de. 1963. Afrique noire. In *L'art et les sociétés primitives*, 13–115. Paris: Hachette.

———. 1982. *Rois nés d'un coeur de vache: Mythes et rites bantous*. Paris: Gallimard.

———. 1987. *Ecrits sur la royauté sacrée*. Brussels: Editions de l'Université de Bruxelles.

———. 1989. La vipère et la cigogne: Notes sur le symbolisme tshokwé. In *Art et mythologie—Figures tshokwé*, 19–47.

———. 1990. Introduction. In Heusch, ed., *Chefs et rois sacrés*, 7–33.

———, ed. 1990. *Chefs et rois sacrés*. Paris: CNRS.

Ibn Battuta. 1983. *Travels in Asia and Africa, 1325–1354*. 1929. London and Boston: Routledge and Kegan Paul.

Inneh, Daniel E. *See* Nevadomsky, Joseph.

Izard, Michel. 1985. *Gens du pouvoir, gens de la terre: Les institutions politiques de l'ancien royaume du Yatenga (Volta blanche)*. Paris: Cambridge University Press and Maison des Sciences de l'Homme.

———. 1990. De quelques paramètres de la souveraineté. In Heusch, ed., *Chefs et rois sacrés*, 69–91.

———. 1992. *L'odyssée du pouvoir—Un royaume africain: Etat, société, destin individuel*. Paris: Editions de l'Ecole des Hautes Etudes en Sciences Sociales.

Johnson, Marion. 1979. Ashanti Craft Organization. *African Arts* 13, no. 1 (November): 61–82.

Joyce, Thomas A. *See* Torday, Emil.

Kaehr, Roland. *See* Rodrigues de Areia, Manuel L.

Kamanzi, Thomas. *See* Coupez, A.

Kauenhoven-Janzen, Reinhild. 1981. Chokwe Thrones. *African Arts* 14, no. 3 (May): 69–74.

Kyerematen, A. 1969. The Royal Stools of Ashanti. *Africa: Journal of the International African Institute* 39, no. 1:1–10.

Kwasi Sarpong, Peter. 1967. The Sacred Stools of Ashanti. *Anthropos* 62:1–60.

Laude, Jean. 1965. Problèmes du portrait: Images funéraires et images royales. *Journal de Psychologie Normale et Pathologique* 4 (October–December): 401–20.

———. 1988. *Les arts de l'Afrique noire*. Paris: Chêne. First edition published by Librairie Générale Française, 1966.

Leiris, Michel, and Jacqueline Delange. 1976. *Afrique noire: L'univers des formes*. Paris: Gallimard.

Leroi-Gourhan, André. 1943. *Documents pour l'art comparé de l'Eurasie septentrionale*. Paris: Editions d'art et d'histoire.

———. 1992. *L'art pariétal: Langage de la préhistoire*. Grenoble: Jérôme Millon.

Lombard, Jacques. *See* Mercier, Paul.

McLeod, Malcolm D. 1981. *The Asante*. London: The Trustees of the British Museum, British Museum Publications.

Mair, Lucy. 1977. *African Kingdoms*. Oxford: Oxford University at the Clarendon Press.

Maquet, Jacques. 1954. *Le système des relations sociales dans le Ruanda ancien*. Tervueren: Annales du Musée Royal du Congo Belge.

Marin, Louis. 1981. *Le portrait du roi*. Paris: Minuit.

Mauny, Raymond. 1952. Essai sur l'histoire des métaux en Afrique occidentale. *Bulletin de l'Institut Français d'Afrique Noire* 14, no. 2:545–95.

Mercier, Paul. 1962. *Civilisations du Bénin*. Paris: Société Continentale d'Editions Modernes Illustrées.

Mercier, Paul, and Jacques Lombard. 1959. *Guide du musée d'Abomey: Etudes dahoméennes*. Republic of Dahomey: IFAN.

Meyerowitz, Eva L. R. 1951. Concepts of the Soul among the Akan of the Gold Coast. *Africa: Journal of the International African Institute* 21, no. 1 (January): 24–31.

Muller, Jean-Claude. 1990. Transgression, rites de rajeunissement et mort culturelle du roi chez les Jukun et les Rukuba (Nigeria central). In Heusch, ed., *Chefs et rois sacrés*, 49–67.

Nevadomsky, Joseph. 1984a. Kingship Succession Rituals in Benin—2: The Big Things. *African Arts* 17, no. 2 (February): 21–47.

———. 1984b. Kingship Succession Rituals in Benin—3: The Coronation of the Oba. *African Arts* 17, no. 3 (May): 48–57.

Nevadomsky, Joseph, and Daniel E. Inneh. 1983. Kingship Succession Rituals in Benin—1: Becoming a Crown Prince. *African Arts* 17, no. 1 (November): 47–54.

Neyt, François. 1993. *Luba: Aux sources du Zaïre*. Paris: Editions Dapper.

Njoya, Adamou Ndam. *See* Geary, Christraud.

Njoya, Sultan. 1952. *Histoires et coutumes des Bamum*. Edited by Sultan Njoya. Cameroon: Mémoires de l'Institut Français d'Afrique Noire.

Oberg, Kalervo. 1947. The Kingdom of Ankole in Uganda. In Fortes and Evans-Pritchard, eds., *African Political Systems*, 121–62.

Palau Marti, Monserrat. 1967. Sabres décorés du Dahomey. *Objets et Mondes* 7, no. 4 (winter): 279–306.

Patton, Sharon F. 1979. The Stool and Asante Chieftaincy. *African Arts* 13, no. 1 (November): 74–77.

Perrois, Louis. 1993a. Prestige et rayonnement: Les chefferies de l'Afrique centrale. In *Le grand atlas de l'art II*, 494–95. France: Encyclopaedia Universalis.

———. 1993b. *Les rois sculpteurs*. Paris: Réunion des Musées Nationaux.

Perrot, Claude-Hélène. 1982. *Les Anyi-Ndeneye et le pouvoir aux XVIIIᵉ et XIXᵉ siècles*. Paris: Publications CEDA Abidjan and Publications de la Sorbonne.

Pigafetta, Filippo, and Duarte Lopes. 1969. *A Report of the Kingdom of Congo and of the Surrounding Countries*. 1591. Reprint, New York: Negro Universities Press.

Pliny the Elder. 1947. *Natural History*. Vol. 9. Edited and translated by H. Rackham. Cambridge and London: Harvard University Press and William Heinemann.

Preston, George N. 1989–90. People Making Portraits Making People—Living Icons of the Akan. *African Arts* 23, no. 3 (July): 70–76.

Preston Blier, Susan. 1990. King Glele of Danhomè—Part One: Divination Portraits of a Lion King and Man of Iron. *African Arts* 23, no. 4 (October): 42–53.

———. 1991. King Glele of Danhomè—Part Two: Dynasty and Destiny. *African Arts* 24, no. 1 (January): 44–55.

Randles, William G. L. 1975. *L'empire du Monomotapa du XVᵉ au XIXᵉ siècle*. Paris and The Hague: Mouton.

Rattray, Captain Robert S. 1923. *Ashanti*. Oxford: Oxford University at the Clarendon Press.

———. 1927. *Religion and Art in Ashanti*. Oxford: Oxford University at the Clarendon Press.

Reinach, Adolphe. 1985. *Textes grecs et latins relatifs à l'histoire de la peinture ancienne: Recueil Millet*. 1921. Reprint, Paris: Macula.

Riegl, Aloïs. 1984. *Le culte moderne des monuments: Son essence et sa genèse*. Paris: Seuil.

Rodrigues de Areia, Manuel L., and Roland Kaehr. 1992. *Les signes du pouvoir*. Neuchâtel: Musée d'Ethnographie.

Rosenwald, Jean B. 1974. Kuba King Figures. *African Arts* 7, no. 3 (spring): 26–31.

Ross, Doran H. 1977. The Iconography of Asante Sword Ornaments. *African Arts* 11, no. 1 (October): 16–25.

———. 1982. The Verbal Art of Akan Linguist Staffs. *African Arts* 16, no. 1 (November): 56–66.

Ross, Doran H. *See* Cole, Herbert.

Roth, Henry L. 1903. *Great Benin, Its Customs, Art and Horrors*. Halifax, England: F. King and Sons.

Rudy, Suzanne. 1972. Royal Sculpture in the Cameroons Grasslands. In Fraser and Cole, eds., *African Art and Leadership*, 123–35.

Schaefer, Stacy. 1983. Benin Commemorative Heads. In Ben-Amos and Rubin, eds., *The Art of Power, the Power of Art*, 71–78.

Shaw, Thurstan. 1970. *Igbo-Ukwu: An Account of Archaeological Discoveries in Eastern Nigeria*. London: Faber and Faber.

Sieber, Roy. 1972. Kwahu Terracottas, Oral Traditions, and Ghanaian History. In

Fraser and Cole, eds., *African Art and Leadership*, 173–83.

Sièges africains. 1994. Paris: Réunion des Musée Nationaux.

Spini, Tito. See Antongini, Giovanna.

Tardits, Claude. 1962. Panneaux sculptés bamoum. *Objets et Mondes* 2, no. 4 (winter): 249–60.

———. 1980. *Le royaume bamoum*. Paris: Armand Colin.

———. 1992. The Kingdom of Bamum (Cameroun). In *Kings of Africa*, 43–55.

Thompson, Robert F. 1972. The Sign of the Divine King: Yoruba Bead-Embroidered Crowns with Veil and Bird Decorations. In Fraser and Cole, eds., *African Art and Leadership*, 227–59.

Torday, Emil, and Thomas A. Joyce. 1911. *Notes ethnographiques sur les peuples communément appelés Bakuba, ainsi que sur les peuplades apparentées, les Bushongo*. Tervueren: Annales du Musée Royal du Congo Belge.

Trésors d'Afrique—Musée de Tervuren. 1995. Tervueren: Musée Royal de l'Afrique Centrale.

Trésors de l'ancien Nigeria. 1984. Paris: Galeries Nationales du Grand Palais.

Vansina, Jan. 1962. A Comparison of African Kingdoms. *Africa: Journal of the International African Institute* 32:324–35.

———. 1964. *Le royaume Kuba*. Tervueren: Musée Royal de l'Afrique Centrale.

———. 1972. *Ndop*: Royal Statues among the Kuba. In Fraser and Cole, eds., *African Art and Leadership*, 41–55.

Waterlot, E. C. 1926. *Les bas-reliefs des bâtiments royaux d'Abomey (Dahomey)*. Paris: Institut d'Ethnologie.

Wild, R. P., and H. J. Braunholtz. 1934. Ashanti: Baked Clay Heads from Graves. *Man* 34 (January): 1–22.

Willett, Frank. 1967a. Ife in Nigerian Art. *African Arts* 1, no. 1 (autumn): 30–35.

———. 1967b. *Ife in the History of West African Sculpture*. London: Thames and Hudson.

———. 1971. *Ifé, une civilisation africaine*. Paris: Librairie Jules Tallandier.

Williams, Denis. 1974. *Icon and Image: A Study of Sacred and Secular Forms of African Classical Art*. London: Allen Lane.

Wittkower, Rudolf. 1995. *Qu'est-ce que la sculpture? Principes et procédures de l'Antiquité au XXe siècle*. Paris: Macula.

Yoyotte, Jean. 1968. *Les trésors des pharaons—Les hautes époques—Le Nouvel Empire—Les basses époques*. Paris: Skira.

Photographic Credits

Numbers refer to illustrations.

American Museum of Natural History, New York: 1

Antongini, G., and T. Spini, Rome: 63, 64, 65, 87

Asselberghs, R., Brussels: 135

Basler Mission, Basel: 11, 15

Beaulieux, D., Brussels: 48, 59, 94, 98, 108, 113, 115, 117

Beyeler, Zurich: 141

Bibliothèque Nationale de France, Paris: 149.

British Museum, London: 66, 67, 68, 69, 71, 72, 73, 74, 78, 111

Christol, Paris: 62

Darbois, D., Paris: 2

David, R., and D. David, Zurich: 7

Delaplanche, M., Paris: 83

Dubois, H., Brussels: 33, 47, 51, 52 (detail pp. 28–29), 53, 96, 99, 103, 119, 138, 139, 140, 147

Elisofon, E.: 5, 80

Fagg, W.: 12, 13

Ferrazzini, P.-A., Geneva: 57

Glawischnig, S., Vienna: 95

Grishaaver, B., Leiden: 45

Hatala, B., Paris: 20, 23, 34, 37, 55, 60, 79, 81, 82, 83, 84, 86, 104, 118 (detail pp. 104–5), 123, 132, 142, 143, 147

Johannesburg Art Gallery, South Africa: 100

Kanté, G.: 14

Khoury F., Washington D.C.: 128

Kimbell Art Museum, Fort Worth, Texas: 50

Lamote, C.: 10

Linden Museum, Stuttgart: 124

Metropolitan Museum of Art, New York: 70, 77, 130

Musée Africain, Lyon: 6

Musée Barbier-Müller, Geneva: 46

Musée Royal de l'Afrique Centrale, Tervueren: 4, 38, 39, 44, 58, 90, 92, 93, 97, 102, 112, 116, 131, 134

Museum for Ife Antiquities, Ife: 30, 32

Museum für Völkerkunde, Berlin: 28, 36, 133

Museum für Völkerkunde, Vienna: 8, 9, 109

Museum of Mankind, London: 17, 40, 56, 101, 127, 137

Nationalmuseet, Copenhagen: 136

National Museum, Lagos: 110, 145, 146

Passoa, J./Arquivo Nacional de Fotografia, Lisbon: 49.

Photothèque du Musée de l'Homme, Paris: 21, 82, 88, 89, 114

Rijksmuseum voor Volkenkunde, Leiden: 35, 43

Rodger, G./Magnum Photos: 3

Schneebeli, H., London: 16, 27

Schneider-Schütz, W., Berlin: 29

Varbanov, R., Uitikon: 85, 91, 105, 106, 107, 120, 121, 122, 125, 126, 129

Wallace Collection, London: 61

Werner Forman Archives, London: 19, 22, 25, 26, 75 (detail pp. 66–67), 76, 144 (detail pp. 146–47), 146

Index

Art Center College of Design
Library
1700 Lida Street
Pasadena, Calif. 91103